PHOTO TWO

ADVANCED PHOTO TEXT BY KEN MUSE

PRENTICE-HALL INC., ENGLEWOOD CLIFFS, N.J. 07632

Library of Congress Cataloging in Publication Data

MUSE, KEN, date
 Photo two.

 1. Photography. 2. Photography, Commercial.
I. Title.
TR145.M78 770′.23 76-51428
ISBN 0-13-665307-3

Printed in the United States of America

10 9 8 7 6 5 4 3 2 1

PRENTICE-HALL INTERNATIONAL, INC., London
PRENTICE-HALL OF AUSTRALIA PTY. LIMITED, Sydney
PRENTICE-HALL OF CANADA, LTD., Toronto
PRENTICE-HALL OF INDIA PRIVATE LIMITED, New Delhi
PRENTICE-HALL OF JAPAN, INC., Tokyo
PRENTICE-HALL OF SOUTHEAST ASIA PTE. LTD., Singapore
WHITEHALL BOOKS LIMITED, Wellington, New Zealand

KEN MUSE,
AUTHOR AND
ARTIST OF
PHOTO ONE
IS BACK
AGAIN THIS
TIME WITH
ANOTHER
EQUALLY
INTERESTING
PHOTO
INSTRUCTION
BOOK.
HIS UNIQUE
STYLE AND
PRESENTATION
HAS REALLY
CAPTURED
THE
ATTENTION OF
EAGER
STUDENTS OF
PHOTOGRAPHY.

THIS BOOK IS
DEDICATED TO ALL
THOSE PHOTOGRAPHERS
WHO BELIEVE DUST
ON THE ENLARGING
LENS WILL SHOW UP
ON THE PRINT

TABLE OF CONTENTS

FOREWORD

ARTISTS ARE PICTURE MAKERS, AND PHOTOGRAPHERS ARE PICTURE MAKERS, AND IF YOU WANT TO BE A COMMERCIAL PHOTOGRAPHER, THEN UNDERSTAND HOW ARTISTS THINK. I WOULD HIGHLY RECOMMEND TAKING A FEW ART COURSES AT YOUR LOCAL COMMUNITY COLLEGE ...LIKE ART COURSES THAT ARE CAREER ORIENTED AND TAUGHT BY WORKING PROFESSIONALS – COURSES LIKE ADVERTISING ART, DESIGN, LAYOUT, RETOUCHING, KEYLINE AND PHOTOGRAPHY.

...AND REMEMBER THIS:

"WHEN A COMPETENT ARTIST LEARNS PHOTOGRAPHY, IT'S A DAMN HARD COMBINATION TO BEAT."

KEN MUSE

WELL, HERE WE GO AGAIN WITH ANOTHER BOOK ON PHOTO INSTRUCTION. THE PHOTO ONE BOOK BROUGHT ME MANY NEW FRIENDS, INCLUDING SOME PROFESSIONALS IN THE BUSINESS OF TEACHING MANY EAGER STUDENTS THE FINER POINTS OF PHOTOGRAPHY! THESE BOOKS TAKE AN AMAZING AMOUNT OF WORK AND CORRELATION, NOT TO MENTION THE FINAL ART......BUT IT'S WORK I ENJOY!

FOREWORD TO STUDENTS...

WE ALL KNOW WHAT ADVERTISING IS FOR, DON'T WE? IT IS TO AROUSE ENOUGH INTEREST IN A PRODUCT TO MAKE PEOPLE WANT TO OWN IT... *AND THAT'S IT!*

THE PHOTOGRAPHER!

THAT'S THE PERSON WHO CREATES THE DESIRE THROUGH HIS PICTURES IN MAGAZINES, NEWSPAPERS, TELEVISION, BILLBOARDS, ETC, ETC. THIS MEANS THE PHOTOGRAPHER HAS TO GO BEYOND HIS SKILL AS A TECHNICIAN, BECAUSE ANYONE CAN LEARN TO SHOOT SNAPSHOTS AND DEVELOP AND PRINT THEM. WHAT REALLY SEPARATES THE PROFESSIONAL PHOTOGRAPHER FROM THE AMATEUR IS *IMAGINATION, CREATIVITY,* AND A UNIQUE ABILITY TO *COMMUNICATE.* THAT MEANS CONVEYING A VISUAL MESSAGE BY THE USE OF PHOTOGRAPHY!

THE ART DIRECTOR!

IF YOU ARE SERIOUS ABOUT ENTERING THE ADVERTISING PHOTOGRAPHY FIELD THEN WE SHOULD HAVE A SERIOUS TALK! *YOU'RE GOING TO BE WORKING FOR AN ART DIRECTOR!* AN ART DIRECTOR IS A PROFESSIONAL ARTIST – AND SOMETIMES A PHOTOGRAPHER. HE HAS EXPERIENCE IN ALL ASPECTS OF ADVERTISING ART. THIS IS THE PERSON YOU WILL WORK WITH. HE IS ALSO THE ONE, WHO IN MOST CASES, PICKS THE ARTIST OR PHOTOGRAPHER TO DO THE WORK FOR THE CLIENT. THE ART DIRECTOR, AFTER RECEIVING THE COPY AND SLOGAN FROM THE COPYWRITER, WILL MAKE ROUGH SKETCHES OF THE AD. THROUGH THESE SKETCHES THE ART DIRECTOR PRESENTS HIS IDEAS VISUALLY TO THE CLIENT!

THE TEAM!

NEXT, THE ART DIRECTOR AND PHOTOGRAPHER WORK WITH THE ROUGHS AS A TEAM FOR THE UTMOST IMPACT. THE ART DIRECTOR KNOWS

THAT THE PHOTOGRAPHER WILL ASSIST HIM TO CREATE AN AD THAT WILL HAVE SALES APPEAL, AND THAT IS THE GOAL!

THE SPACE!

BESIDES ALL THIS, THE SHAPE AND SIZE OF THE AD DICTATES THE SIZE OF THE PHOTOGRAPH, AND THE PHOTOGRAPHER MUST WORK TO THESE LIMITS. AFTER ALL, THE SPACE WHERE THE AD IS TO APPEAR HAS BY NOW BEEN PURCHASED, AND TO MESS AROUND WITH THE SIZE NOW IS TO COURT DISASTER! BUT THERE ARE MANY TIMES WHEN THE PHOTOGRAPHER HAS MORE FREEDOM - WHICH MEANS HE MUST BE MORE AWARE AND ALLOW ROOM FOR THE COPY!

THE MODELS!

ON RARE OCCASIONS THE ART DIRECTOR *MAY* CHOOSE MODELS, BUT IN MOST CASES IT'S THE JOB FOR THE PHOTOGRAPHER. SINCE THIS CAN BE TIME CONSUMING, HE USUALLY RELIES ON THE MODELING AGENCIES IN HELPING HIM TO MAKE FAST SELECTIONS.

HE CAN ALSO USE MODELS FROM OTHER SOURCES, SUCH AS ACTING SCHOOLS, DANCE STUDIOS, OR EVEN FRIENDS AND NEIGHBORS.

THE CAMERA!

THE MAJORITY OF PRODUCT SHOTS ARE MADE WITH 4X5 OR LARGER VIEW CAMERAS, WITH TILTS AND SWINGS. HOWEVER, BECAUSE OF DISTANT LOCATIONS ON ASSIGNMENT, THE $2\frac{1}{4}$ SLR OR $2\frac{1}{4} \times 2\frac{3}{4}$ SLR ARE USED. AND OCCASIONALLY THE 35mm SLR. *BUT NEVER FOR PRODUCT SHOTS.... BECAUSE THE NEGATIVE IS TOO SMALL!* ... AND DON'T YOU FORGET IT.

THE PORTFOLIO!

YOUR PORTFOLIO IS THE *ONLY* THING THAT WILL GET YOU A CHANCE FOR AN ASSIGNMENT! NO ART DIRECTOR WORTH HIS SALT WILL HIRE YOU BECAUSE OF YOUR DEGREE. THE DEGREE IS ONLY ANOTHER CREDENTIAL. YOUR PORTFOLIO *PROVES* WHAT YOU CAN DO - AND DON'T

GO INTO PHOTOGRAPHY OR ANY OTHER PROFESSION FOR THE WRONG REASON - FOR MAKING MONEY! BETTER YOU GO INTO IT BECAUSE YOU ENJOY IT. *EVERY FAMOUS PERSON IS DOING WHAT HE ENJOYS!*

YOUR CAREER!

THERE ARE IMPORTANT THINGS YOU MUST UNDERSTAND BEFORE YOU GO INTO PHOTOGRAPHY.... *ESPECIALLY ADVERTISING:* WHEN AN ASSIGNMENT HAS A DEADLINE FOR DELIVERY ON A CERTAIN DAY—THAT'S THE DAY YOU BRING IT IN - NOT THE DAY *AFTER!* STUDENTS IN PHOTO PROGRAMS, FOR SOME UNKNOWN REASON, DO NOT TAKE THIS DEADLINE SERIOUSLY—THEIR ASSIGNMENTS WILL BE ONE OR TWO DAYS LATE, OR THEY MAY JUST SKIP IT FOR SEVERAL WEEKS AND THEN TRY TO MAKE-IT-UP! *THERE IS NO SUCH THING AS MISSING THE DEADLINE, OR MAKE-UP ASSIGNMENTS IN THE REAL WORLD!*

YOU MUST CONDITION YOURSELF TO GETTING YOUR WORK IN ON TIME.....OTHERWISE YOU HAD BETTER FIND ANOTHER PLANET TO WORK ON!

THE PROCESSING!

YOUR EXPOSURE, DEVELOPING AND PRINTING, MUST BE THE VERY BEST- COMPETITION IS OUT THERE WAITING FOR YOU. MANY PROFESSIONALS USE A CUSTOM LAB FOR DEVELOPING AND PRINTING — AND THAT WAY THEY CAN CONCENTRATE ALL THEIR TIME ON *SHOOTING!*

AND THINK ABOUT THIS:

IF THE ART DIRECTOR, WITH ALL HIS EXPERIENCE AND ART ABILITY, PICKS UP A CAMERA— THE PHOTOGRAPHER IS IN TROUBLE!

PHOTOGRAPHERS SHOULD TAKE ART COURSES!

ACKNOWLEDGEMENTS!

THE AUTHOR APPRECIATES THE COURTESY OF THE FOLLOWING COMPANIES FOR ALLOWING USE OF THE PHOTOS OF THEIR PRODUCTS:

GILLETE SHAVE LOTION
BOSTON, MASS.

EASTMAN KODAK PRODUCTS
EASTMAN KODAK, ROCHESTER, N.Y.

SONY TAPE RECORDERS
LOS ANGELES, CALIFORNIA

HITACHI RADIOS
LOS ANGELES, CALIFORNIA

BUSHNELL BINOCULARS
PASADENA, CALIFORNIA

THAYER & CHANDLER AIR BRUSHES
NEW YORK

WILSON SPORTING GOODS
RIVERGROVE, ILLINOIS

BASS CAMERA COMPANY
CHICAGO, ILLINOIS

ROLLEIFLEX CAMERAS
ROLLIE OF AMERICA

CANON CAMERAS
BELL AND HOWELL, CHICAGO

DIAFINE FILM DEVELOPER
CHICAGO, ILLINOIS

POLAROID CAMERAS
POLAROID CORPORATION, MASS.

DORIC ORGANS
NEW YORK

MIRANDA CAMERAS
ALLIED IMPEX CORP., N.Y.

BRONICA CAMERAS
WOODBURY, N.Y.

SEARS TAPE RECORDERS
SEARS ROEBUCK CO., CHICAGO, ILL.

MONOLUX SCOPES
COMPASS INSTRUMENTS, N.Y.

PRIDE FURNITURE WAX
S.C. JOHNSON & CO., RACINE, WIS.

JOY DETERGENT
PROCTER & GAMBLE, CINCINNATI, OHIO

BRAUN ELECTRONIC FLASH
CAMBRIDGE, MASS.

NIKON CAMERAS
NIKON NIKKORMAT, N.Y.

AGFA- GEVAERT
NEW YORK / BELGIUM

PIONEER TAPE RECORDERS
WOODBRIDGE, NEW YORK

VIVITAR LENSES
SANTA MONICA, CALIFORNIA

PRODUCT COMPOSITION

THE COMMERCIAL ARTIST HAS THE ADVANTAGE OVER THE PHOTOGRAPHER BECAUSE HE CAN ADD OR TAKE AWAY WHAT HE PLEASES IN HIS PICTURE. HE MAY ONLY INDICATE OR SUGGEST A PART OF THE PICTURE, OR ADD STRENGTH TO WHAT EVER PART HE WISHES WITH HIS PAINT BRUSH.

ONLY UP TO A POINT CAN THE PHOTOGRAPHER EXERCISE THIS KIND OF CONTROL. HE CAN CHANGE HIS VIEWPOINT, HIS LIGHTING, HIS SHARPNESS, AND HIS ARRANGEMENT, BUT IN THE END HE MUST ACCEPT THE FINAL CONTENTS OF HIS PICTURE. WHEN HE REACHES THIS POINT, HE MUST EXPRESS HIS PERSONAL FEELINGS THROUGH *EMPHASIS!*

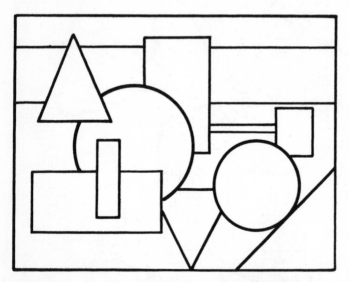 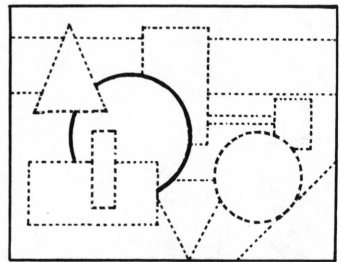

EVERY SHAPE IN THIS PICTURE HAS THE SAME *EMPHASIS*. THAT IS TO SAY, *EVERYTHING IS SHARP!* NOTHING STANDS OUT, AND THERE-FORE IT'S ONLY A TWO-DIMEN-SIONAL DESIGN. *UNINTERESTING.*

MAKING ONE THING SHARP IN THE PICTURE, SUCH AS WITH SELECTIVE FOCUSING WITH A CAMERA, WILL ISOLATE THE SHAPE. NOW THE CIRCLE HAS A THREE-DIMEN-SIONAL LOOK. *INTERESTING!*

WHAT IS COMPOSITION?

THAT'S A GOOD QUESTION. I'LL ANSWER IT FIRST AS AN ARTIST, THEN AS A PHOTOGRAPHER.... AND THEN AS A LAYMAN!

THE ARTIST

A PLEASING ARRANGEMENT OF THE PARTS OF A WORK OF ART THAT FORM A HARMONIOUS WHOLE!

THE PHOTOGRAPHER

USING TONE WITH SHARPNESS AND ARRANGEMENT TO CREATE *EMPHASIS!*

THE LAYMAN

HEY, AIN'T THAT PRETTY!

THE SOUND RULES OF COMPOSITION...

PHOTOGRAPHY, LIKE ART, OR LIKE MUSIC, IS A MEDIUM OF SELF-EXPRESSION, AND THIS MEDIUM IS VERY PERSONAL. THE SOUND RULES OF COMPOSITION ARE CRUCIAL, AND A FANTASTIC AID TO PROFESSIONAL WORK. YOU'VE PROBABLY HEARD THE EXPRESSION A MILLION TIMES THAT YOU CAN'T BREAK THE RULES UNLESS YOU UNDERSTAND THEM. *FOR EXAMPLE:* IF YOU GET A GOOD COMPOSITION BY BREAKING A RULE YOU DO NOT UNDERSTAND, IT WILL JUST BE AN ACCIDENT.... AND IF IT'S AN ACCIDENT YOU WON'T KNOW WHAT YOU DID, AND THEREFORE WILL FIND IT DIFFICULT TO DUPLICATE.

IN SIMPLE TERMS, YOU'RE JUST A LAYMAN WHO DOESN'T KNOW WHAT HE'S DOING.
THE GOAL IS TO FIND OUT!

STRANGE AS IT MAY SEEM, THE MORE OF A PROFESSIONAL YOU BECOME, THE MORE YOU KNOW *WHEN* TO KEEP THE RULES AND *WHEN* TO BREAK THEM.

REMEMBER....COMPOSITION IS COMPOSITION. EVEN IF YOU WERE RAISED FROM CHILDHOOD TO ACCEPT POOR COMPOSITION IT JUST WOULDN'T MAKE A BIT OF DIFFERENCE BECAUSE BALANCE IS STILL BALANCE. *A COMPOSITION HEAVY ON THE TOP IS OFF-BALANCE!*

4

EYE MOVEMENTS ON AN 8x10....

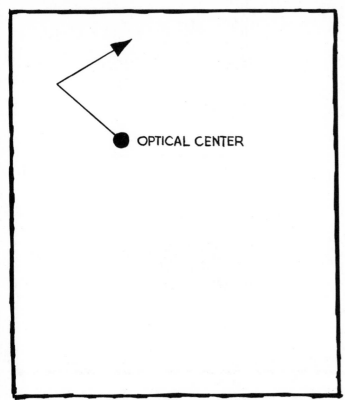

THE FIRST POINT THE EYE HITS ON THE PHOTO IS THE OPTICAL CENTER. *NOTE!*

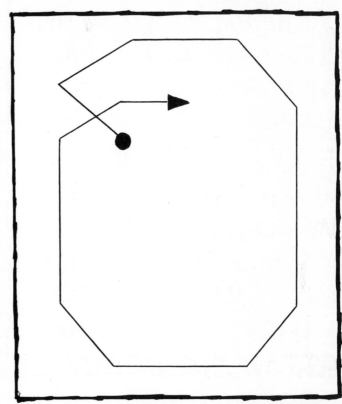

THEN IT FOLLOWS IN THIS DIRECTION AS INDICATED BY THE ARROW. *NOTE!*

AND FINALLY IT MAKES THIS SORT OF PATTERN OVER THE WHOLE PAGE! OF COURSE THIS PATH HAPPENS IN A FRACTION OF A SECOND. NOTE THAT THE EYE LEAVES ACROSS THE BOTTOM OF THE PAGE OR PHOTOGRAPH!

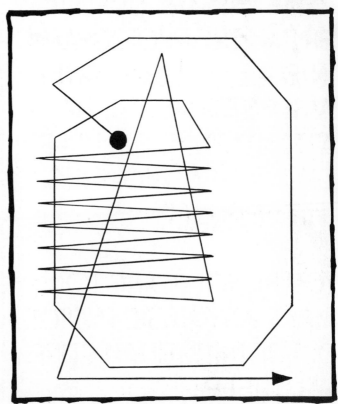

THE EYE MOVEMENT THAT TRAVELS THE PHOTOGRAPH CAN BE BROKEN DOWN IN SUCH A WAY AS TO GIVE THE PERCENTAGES OF AREAS!
IF THE PAGE OR PHOTO IS DIVIDED THROUGH THE MIDDLE, LIKE THIS, THE TOP HALF OF THE PHOTO WILL DEMAND THE MOST ATTENTION. *GET THE IMPORTANT PART UP THERE.*

NEXT, IF THE EYE PATTERNS ARE USED TO BREAK THE PHOTOGRAPH INTO 4 EQUAL PARTS, THE AREA GETTING THE MOST ATTENTION IS THE UPPER LEFT WITH A WHOPPING 41 PERCENT!

YOU'RE NOT GOING TO MAKE ANY MAGIC PHOTOS OUT OF THIS... BUT IT SURE WILL HELP!

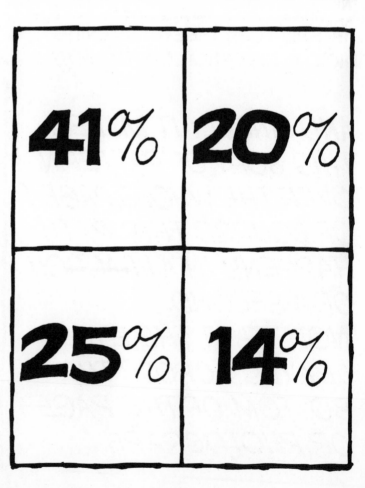

AS A GENERAL RULE, DO NOT DEAD-CENTER YOUR PRODUCT SHOTS. WE'RE SPEAKING HERE OF BASIC COMPOSITION, AND NOT SPECIAL LAYOUT ASSIGNMENTS WHERE THE ART DIRECTOR IS DOING A SPECIAL AD OR LAYOUT.

OFF-CENTER IS MORE PLEASING TO THE EYE BECAUSE IT IS NOT STATIC. HOWEVER, OFF-CENTER TO THE LEFT CAUSES THE EYE TO SEE THE PRODUCT FIRST, AND THEN JUMP TO THE RIGHT, OVER TO THE BLANK SPACE.

RIGHT OFF-CENTER IS MORE PLEASING BECAUSE THE EYE NATURALLY FALLS ON THE OPTICAL CENTER FIRST AND THEN FOLLOWS A LINE AS INDICATED BY THE ARROW, AND THEN OFF THE PAPER!

TONE IS THE MOST IMPORTANT PRODUCT IN YOUR PICTURE. HERE IS A LIGHT SUBJECT ON A DARK BACKGROUND. IT STANDS OUT VERY WELL.

NEXT IS A DARK SUBJECT AGAINST A DARK BACKGROUND, AND THE RESULT OF THIS COMBINATION IS VERY POOR DEFINITION. A NICE MESS.

A DARK SUBJECT AGAINST A LIGHT BACKGROUND MAKES THE SUBJECT STAND-OUT... JUST LIKE THE OPPOSITE SHOT. *TONE IS IMPORTANT.*

GEOMETRIC CENTER

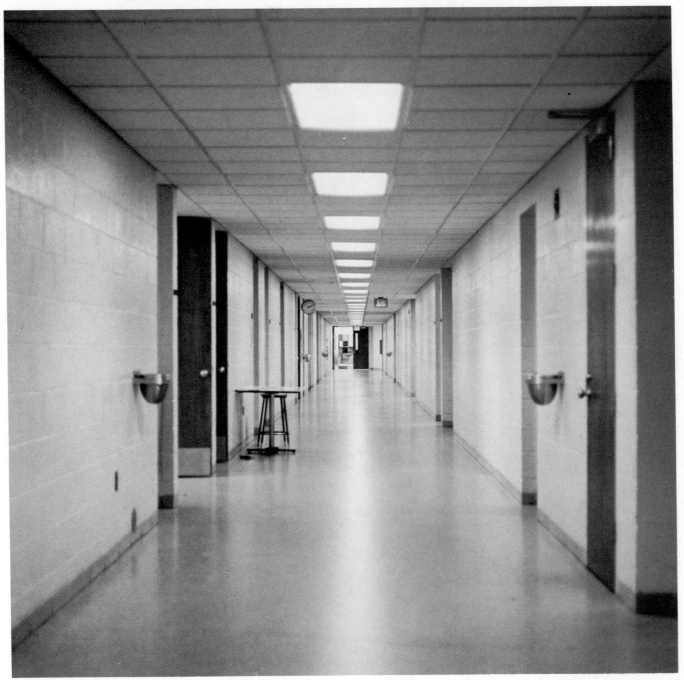

THIS PICTURE OF A MACOMB COLLEGE HALLWAY HAS IMPACT.....
MUCH AS WOULD A BULLSEYE. THIS TYPE OF SHOT LENDS ITSELF
TO A DEAD CENTER BECAUSE THE EYE AND BRAIN MAKE IT DO
JUST THAT. ACTUALLY, THE GEOMETRIC CENTER BOTHERS THE
EYE. IT IS AN IRRITATION, AND AN IRRITATION OF ANY KIND
WILL DRAW THE ATTENTION AWAY FROM A PLEASING PICTURE.

OPTICAL CENTER

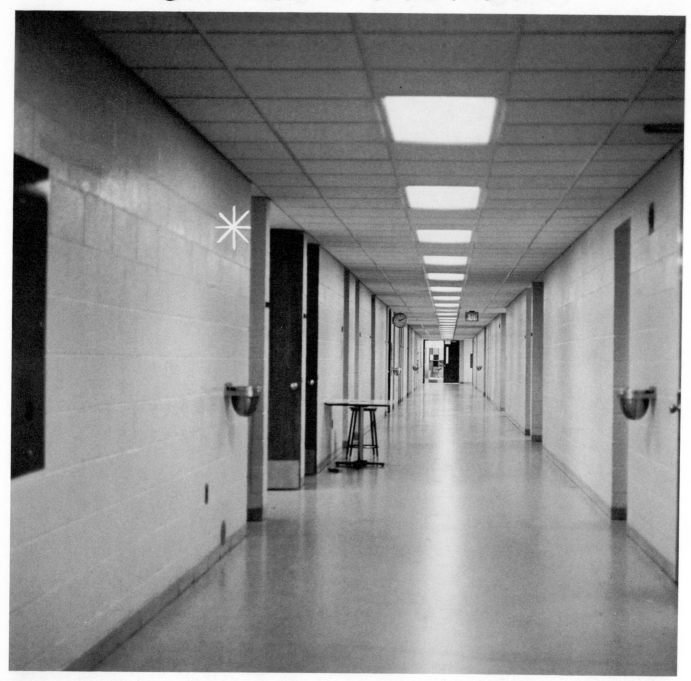

HERE'S THE SAME PICTURE, BUT THIS TIME AN UNIMPORTANT PART OF THE PICTURE PUT IN THE OPTICAL CENTER. (WHERE THE ASTERISK IS) THE EYE SEES THE OPTICAL CENTER FIRST AND SEES NOTHING THERE, SO IT WANDERS DOWN AND THEN TO THE RIGHT, AND THEN UP WHERE IT MEETS THE DOORWAY.... AND THE CEILING LIGHTS! IT MAKES FOR A PLEASANT PICTURE, *BUT NO IMAGINATION!*

STAY AWAY FROM THE DEAD CENTER OF THE PICTURE...... USUALLY CALLED THE GEOMETRIC CENTER!

OBJECTS IN THE CENTER ARE DULL AND BORING!

AVOID PUTTING YOUR PRODUCT NEAR THE EDGES OF YOUR PICTURE!

THIS IS TOO NEAR THE EDGE OF THE PICTURE...EVEN IF LETTERING OR ANOTHER ITEM WERE ON THE RIGHT IT WOULD STILL BE TOO CLOSE.

AND FOR GOODNESS SAKES,
LEAVE ENOUGH **"AIR"**
AROUND YOUR SUBJECT OR
PRODUCT FOR CROPPING
WHEN YOU PRINT.
NOTHING IS MORE TRAGIC
THAN A GOOD SHOT THAT
CAN'T BE CREATIVELY PRINTED.

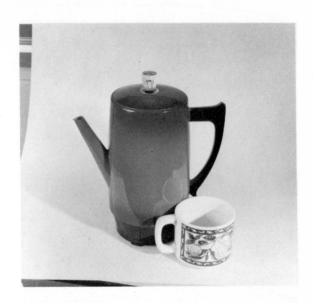

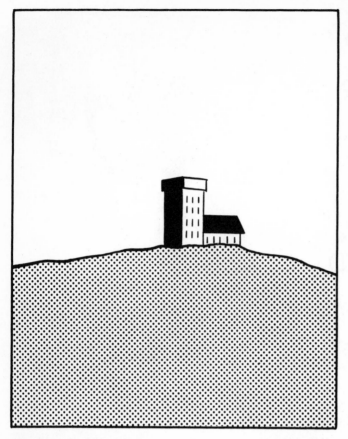

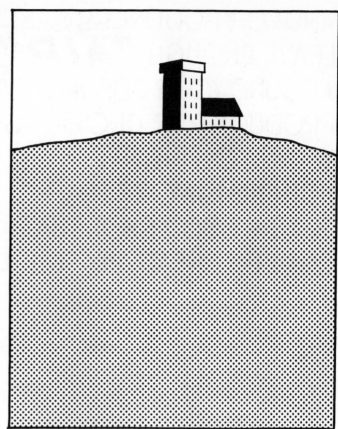

IF YOU PLACE THE HORIZON LINE ACROSS THE MIDDLE, LIKE THIS, IT CREATES TWO PICTURES.

NOTICE THAT WHEN THE HORIZON LINE IS HIGH OR LOW IT CREATES A FEELING OF DEPTH WITHIN THE PICTURE.
THIS WILL ALSO WORK WITH OTHER TYPES OF PHOTOGRAPHS. IF YOU PUT THE SUBJECT MATTER HIGH OR LOW ON THE COMPOSITION IT WILL CREATE DEPTH.

ANOTHER POINT I WANT YOU TO NOTICE IS THAT THE DARK AND LIGHT PORTIONS OF THE PICTURE ARE EVENLY BALANCED. THAT YOU SHOULD *NOT DO*....UNLESS YOU WANT YOUR PICTURE TO BE CUT IN HALF. IN THE OTHER TWO, ONE HAS MORE BLACK AND ONE HAS MORE WHITE. THAT CREATES MORE PLEASING BALANCE TO THE EYE.

HIGH OR LOW HORIZONS ARE BEST FOR GOOD COMPOSITIONS AND CERTAINLY MORE PLEASING.

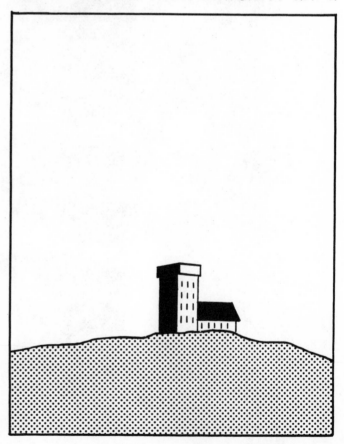

PUT MORE SPACE IN FRONT OF YOUR SUBJECT, NOT BEHIND IT.

FOR EXAMPLE, IN THIS PICTURE THERE IS MORE SPACE IN THE DIRECTION OF THE PERSON'S EYES.... AND A VERY LITTLE AMOUNT OF SPACE, IN COMPARISON, ON THE OPPOSITE SIDE! IF SOMETHING IS MOVING IN YOUR PICTURE, MOVE IT *INTO* YOUR PICTURE...NOT *OUT OF IT*........

THIS IS THE RESULT OF PUTTING MORE SPACE IN BACK OF THE SUBJECT. COMPARED TO THE FIRST PICTURE OF JOE, THIS IS RIDICULOUS. THE EMPTY SPACE IN BACK OF HIS HEAD WILL BOTHER PEOPLE. IT SHOULD.

GOOD COMPOSITION IS PLEASING TO THE EYE... ON THE OTHER HAND, THE BAD WILL BOTHER YOU.

PRODUCTS

INTRODUCTION TO PRODUCT PHOTOGRAPHY

THE PHOTOGRAPHER WHO GOES INTO PRODUCT PHOTOGRAPHY IS REALLY GOING INTO ADVERTISING, AND THE MAIN OBJECTIVE TO ADVERTISING IS THAT OF CREATING A DESIRE TO OWN A PRODUCT. SO THE PHOTOGRAPHER'S MAIN CONCERN IS TO..... *EXCITE!*.......YES, EXCITE HIS VIEWER INTO BUYING THE PRODUCT! *REMEMBER*...IT'S NOT JUST AN EXPENSIVE CAMERA OR TECHNICAL ABILITY... IT'S IMAGINATION AND CREATIVITY IN THE WAY HE SEES HIS PRODUCT.....AND HE RARELY WORKS ALONE. HIS TEAM CONSISTS OF THE CLIENT, THE AGENCY, AND THE ART DIRECTOR. *ONE THING YOU MUST UNDERSTAND*......THE AD AGENCY HAS INVESTED TIME AND MONEY... EVEN BEFORE THE JOB WAS ASSIGNED TO THE ARTIST.

ALL THIS TIME HAS BEEN SPENT IN MEETINGS FOR DISCUSSION OF COPY, OF MEDIA, IDEAS, LAYOUT, AND PRODUCTION COSTS. THE ART DIRECTOR WORKS WITH THE COPY DEPT. AND ACCOUNT EXECUTIVE WHO TELLS HIM WHAT THE SLOGAN OR HEADLINE IS TO BE THEN THE ART-DIRECTOR MAKES ALL HIS SKETCHES OF THE AD AND HAS THEM APPROVED BE-FORE HE GETS THE GO-AHEAD TO GIVE THE JOB TO THE PHOTOGRAPHER.

THE PHOTOGRAPHER THEN WORKS WITH ALL THESE ROUGH SKETCHES, ADDING HIS OWN IDEAS, IMAGIN-ATION, CREATIVITY, AND PHOTOGRAPHIC SKILL.

THEN THERE IS ANOTHER PROBLEM!

THE COMPOSITION THAT HAS BEEN WORKED OUT BY THE ART DIRECTOR HAS TO FIT INTO A CER-TAIN SIZE FORMAT, SUCH AS A FULL PAGE, HALF PAGE, QUARTER PAGE, ETC, ETC., AND ANY MARKED CHANGE FROM THIS LAYOUT CAN MEAN TOTAL DISASTER. SO THERE ARE FOUR QUESTIONS THAT THE PHOTOGRAPHER HAS TO ASK BEFORE THE JOB.

WHAT TYPE OF MODEL SHOULD BE USED?

WHAT MOOD IS TO BE CREATED?

WHAT STORY IS GOING TO BE TOLD?

WHAT REPRODUCTION SCREEN WILL BE USED?

ADS APPEAR IN MANY DIFFERENT PUBLICATIONS, AND ARE PHOTOGRAPHED THROUGH DIFFERENT SCREENS....... NOT KNOWING THE FINAL PRINTING RESULT......YOU MIGHT LIGHT THE PICTURE TOO SOFT OR TOO CONTRASTY FOR REPRODUCTION.... *FOR EXAMPLE :*

go after every source open to

So my company — Standard O
— and a partner company just
$105 million each to the U. S. G
rights to 5,000 acres of land in
Basin in Western Colorado to o
source of oil that's virtually un
Oil shale.

The oil shale on our leas
underground from 200
feet deep. And we'll h
mining techniques t
oil shale itself is sir
solid oil layered thr
There's so much oi
from Western Colo
actually burn. (Ma
cowboys used to b
in their campfires).

But to get the oil from th
and do it in a way that re
environment — will take
new technology.

HERE'S A NEWSPAPER ADVERTISEMENT.

THE NEWSPAPER STOCK IS UNCOATED AND THE PHOTOGRAPH IS SHOT THROUGH A COARSE SCREEN...SUCH AS A 65 LINE PER SQUARE INCH. THE PHOTO MUST HAVE CONTRAST AND HAVE NO MASSES OF BLACK.

AND FOR MAGAZINE ADS LIKE THIS ONE, WITH FINER SCREENS AND COATED PAPERS, THE PHOTO REPRODUCES JUST LIKE THE ORIGINAL, WITH ALL THE TONES..... PLUS BLACKS.

YOU'LL FIND YOURSELF IN TROUBLE IF YOU DON'T FIND OUT FIRST.

PERFECT PRINT FOR NEWSPAPERS!

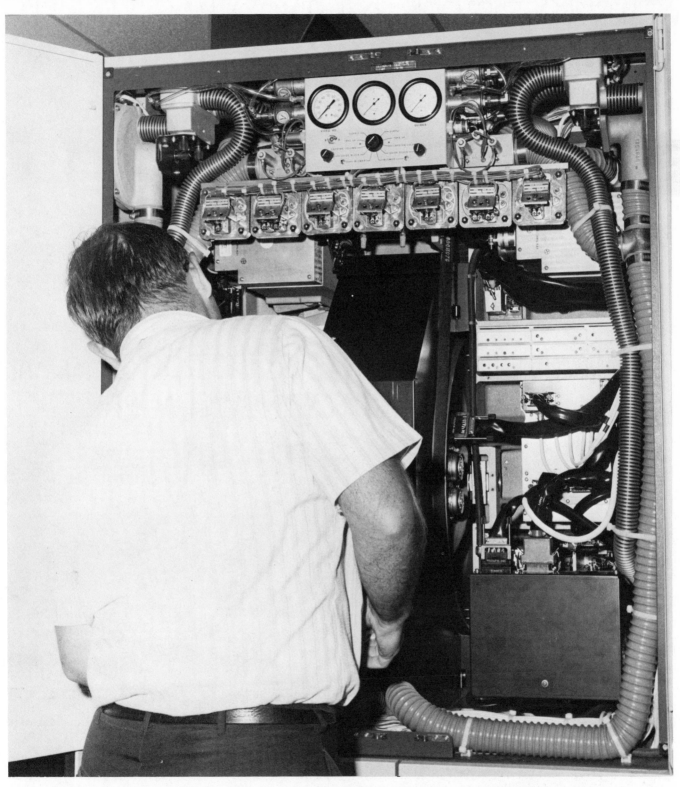

A CLASSIC EXAMPLE OF A PRINT WITH CHALKY WHITES AND JET BLACKS – WITH ALL THE TONES INBETWEEN! THIS IS AN ENGINEER FROM WJBK-TV, DETROIT GETTING READY A VIDEO TAPE CARTRIDGE SYSTEM.

YOU CAN MAKE A MUDDY PRINT SUITABLE FOR NEWSPAPER STOCK BY USING A HARD PAPER!

THIS PICTURE OF WJBK-TV, CBS DETROIT IS A REAL MUDDY PRINT—NOT FIT FOR NEWSPAPER STOCK!

BUT BY PRINTING ON A NO.5 KODABROMIDE, I'VE MADE IT PERFECT FOR NEWSPAPER REPRODUCTION

YOU NEED LESS MIDDLE TONES AND A LOT OF BLACK & WHITE!

WHAT DOES THE PRINTER DO?

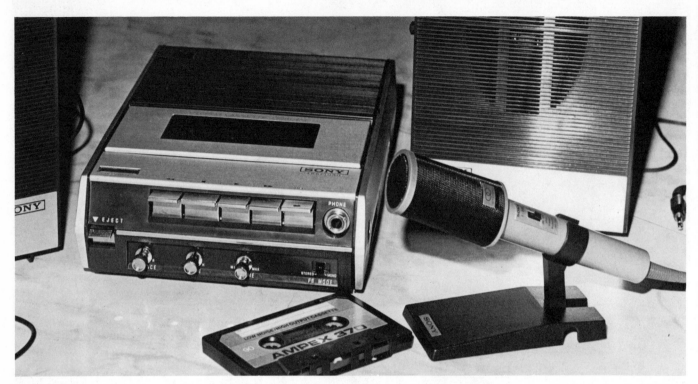

FIRST HE TAKES THE PRINT FROM THE PHOTOGRAPHER-LIKE THIS!

THEN HE SHOOTS IT THROUGH A TINT SCREEN! THIS BREAKS IT INTO DOTS, IN THIS CASE, 133 DOTS PER INCH!

HERE'S A SECTION BLOWN-UP TO A 16 X 20 PRINT.

AND THE SAME SECTION TO 20X40! *STUDY IT!*

SHOOTING FOR CATALOGS...

THERE ARE ALL KINDS OF CATALOGS IN THIS GREAT BIG WORLD OF OURS, AND THEY SUPPORT ALOT OF PHOTOGRAPHERS WHO SUPPLY THEM WITH PHOTOS!

AUTOMOTIVE PARTS• ELECTRICAL PARTS• OPTICAL INSTRUMENTS• MUSICAL INSTRUMENTS • ART SUPPLIES• FURNITURE CATALOGS• CLOTHING• TOYS• BOOKS• CAMERAS• LAMPS• JEWELRY•SHALL I USE THE WHOLE PAGE?

TRUE—SHOOTING PRODUCTS FOR CATALOGS MAY NOT BE VERY GLAMOROUS, BUT THE PAY ISN'T BAD— *BUT IT IS CHALLENGING!*

IN ANY EVENT, LET'S GO ABOUT THE THINGS THAT THE PHOTOGRAPHER DOES, AND HOW THE PHOTOGRAPH ENDS UP IN THE PUBLICATION!

MANY TIMES PRODUCTS ARE SHOT AS WE HAVE MENTIONED BEFORE, WITH ALOT OF CLUTTER IN THE BACKGROUND - LIKE THE PHOTO BELOW! THIS IS ESPECIALLY TRUE WHEN THERE ARE HUNDREDS OF PRODUCTS AND NO TIME TO MAKE ALL INDIVIDUAL SET-UPS

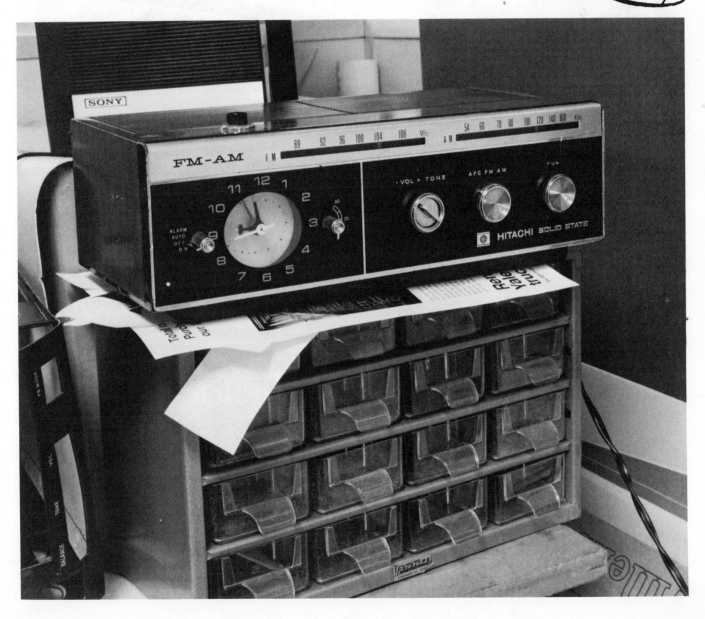

THE ARTIST WORKS FROM A NEGATIVE. THAT IS AT LEAST 4 X 5 OR *LARGER*......

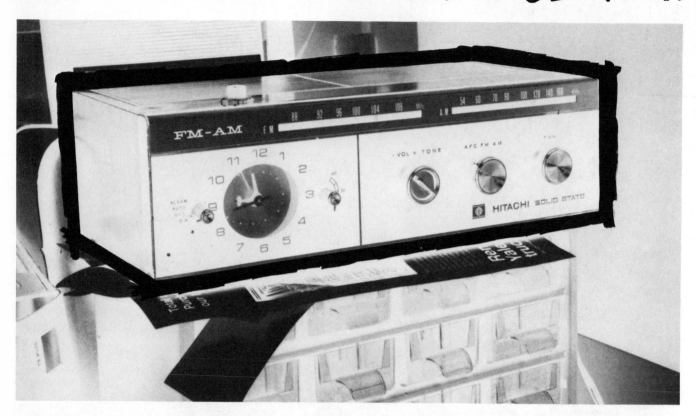

THEN HE PAINTS OUT THE BACKGROUND WITH A RED PAINT CALLED *"CRAFTINT NEGATIVE OPAQUE"* USED FOR JUST THAT PURPOSE.

...AND THEN THE ENGRAVER DROPS-OUT THE RADIO FROM THE BACKGROUND - *LIKE THIS!*

Bushnell TRIPODS

CAR WINDOW MOUNT
Clamps easily on car window to provide steady base for viewing or telephotography. Extremely sturdy. Pan head tilts for vertical use. **Height 4¾"; weight 20 oz.**
#78-4001

SHOOTER'S STAND TRIPOD
Designed especially for bench use or prone position on the firing line. Offers Micro-fine steady adjustments for critical target observation. **Height 10¾" to 13¹³⁄₁₆";** **weight 26 oz.**
#78-3010
#78-3006 —12" extender . . .
#78-3011 Cradle for 45°
Spacemaster

PAN HEAD FITS BINOCULARS, CAMERAS, TELESCOPES

SCOPE TRIPOD
Lightweight, compact lever-controlled adjustments, extendible tube for varying height, folding legs...black and chrome. **Height 9¹¹⁄₁₆" to 12¹³⁄₁₆"; weight 16¼ oz.**
#78-3003
#78-3005 Adapter required for Spacemaster II, Sentry II

TABLE TOP TRIPOD
Light and compact. Features ball-socket head adjustment. Standard thread mounting screw. Rubber tipped legs protect against scratching. **Height 7½";** **weight 10 oz.**
#78-3004

ALL PURPOSE TRIPOD
Extends to 57". Pan head tilts for ve use. Adjustable center post. Three se legs feature extra strength channel a num construction, with positive l **Weight 4 lbs., 12 oz.**
#78-3100 .

WHEN THERE ARE LITTLE PARTS – OR LONG PARTS ON PRODUCTS, SUCH AS TRIPOD LEGS, OR WIRES SHOWING, IT WILL BECOME EXTREMELY DIFFICULT TO PREVENT THE PARTS FROM BREAKING OFF DURING THE CUTTING-OUT PROCESS. IN THIS EVENT, THE PRODUCTS ARE PAINTED-OUT ON THE NEGATIVE, WHICH IN ALMOST ALL CASES ARE SHOT ON 4×5 OR LARGER NEGATIVES, MAKING THEM EASIER TO PAINT-OUT.

GO AHEAD – TRY AND PAINT-OUT YOUR BACKGROUND ON A 35mm NEGATIVE...

PAINTING OUT (OPAQUING) THE BACKGROUND, AS IN THIS SHOT, IS NOT THE BEST WAY TO GET RID OF A BUSY BACKGROUND BECAUSE THE SCREEN USED FOR REPRODUCING THE PHOTO FOR PRINTING WILL SHOW DOTS IN THE WHITE PART PAINTED IN. *INSTEAD, THE OPAQUING IS DONE ON THE NEGATIVE WITH A RED OPAQUING PAINT AND A BRUSH ON A "LIGHT BOX."*

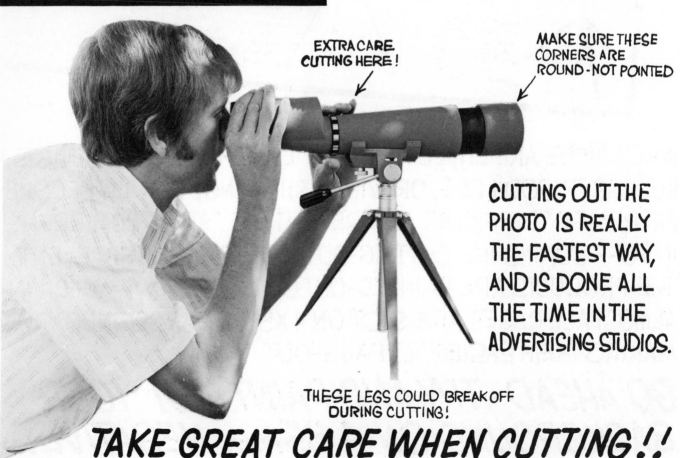

EXTRA CARE CUTTING HERE !

MAKE SURE THESE CORNERS ARE ROUND - NOT POINTED

CUTTING OUT THE PHOTO IS REALLY THE FASTEST WAY, AND IS DONE ALL THE TIME IN THE ADVERTISING STUDIOS.

THESE LEGS COULD BREAK OFF DURING CUTTING !

TAKE GREAT CARE WHEN CUTTING !!

THAYER & CHANDLER MODEL A: Excellent for portrait and mechanical retouching. Double-action gives fingertip control from a smooth hairline to a finely divided broad shading spray. Complete with attractive carrying case, side color cup, protection cap, hose connection nipple, holding bracket.

1144-01

Needles Model A only
Thayer & Chandler Model A

THAYER & CHANDLER MODEL AA: For showcard and display work. Throws twice as much color as Model A, yet will come down to almost as fine a line. Equally valuable for both free-hand and stencil work. Color openings are large enough to handle oil paint or opaque water color without clogging. Complete with side color cup, protection cap, hose connection nipple, brush holder (to attach to easel), in neat leatherette carrying case.

1144-02

Thayer & Chandler Model AA

THAYER & CHANDLER MODEL C: Popular for window decorating, signs, murals, etc. Used for spraying fine lacquers wherever the large industrial spray guns can't produce the finished workmanship and careful attention to detail required. Does not waste material as spray is closely confined.

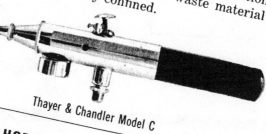

1144-03

Thayer & Chandler Model C

BADGER HOBBY KIT: Easy to use for amateur or professional craftsman or artist. Just fill jar with paint, screw jar to air brush, snap air valve lever on and press trigger to spray. Paint spray air brush, 5-ft. vinyl hose, air valve, mixing jar, instruction folder and plastic case.

1144-04

1144-05

Badger Hobby Kit
PROPEL: Air propellant for Badger Hobby Kit

THIS IS A PAGE FROM A LOCAL ART STORE CATALOG - SHOWING AIRBRUSHES WITH THE BACKGROUND TAKEN OUT. BECAUSE OF THE SMALL PROTRUDING PARTS ON THE BRUSHES, THEY WERE PROBABLY PAINTED-OUT!

GOSH... ARE YOU A PROFESSIONAL PHOTOGRAPHER?

NO, IT'S JUST A HOBBY WITH ME!

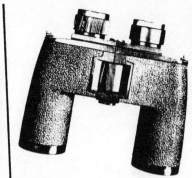

CUSTOM—9 power, 36mm
Excellent for advanced bird watchers and those who hunt in mountain country. Highest power recommended for hand-held use. Focuses down to 14 feet. Retractable nylon eyecups.
Field at 1,000 yards 420'; exit pupil 4mm; height 5⅜"; weight 26 oz.
#11-9362

CUSTOM—7 power, 50mm
The extra light transmission of this superior binocular makes it the outstanding choice for boat owners, night watchmen and others who use binoculars under minimum light conditions. There's heft to these well-balanced glasses that men of action go for. Retractable nylon eyecups. **Field at 1,000 yds. 394'; exit pupil 7.1mm; ht. 7⅛"; wt. 40 oz. #11-7502** . .

CUSTOM—10 power, 50mm
High efficiency glass for day or at dusk. Ideal for hunters glassing at long distances, ornithology and all other long-distance viewing. Retractable nylon eyecups.

Field at 1,000 yards 368'; exit pupil 5mm; height 6¹³⁄₁₆"; weight 42 oz.

#11-1052

EYECUPS EXTENDED EYECUPS RETRACTED

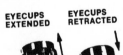

Retractable nylon eyecups for expanded view with sun or eyeglasses.

EYEPIECE RAINGUARD

All Custom and Rangemaster models come complete with eyepiece Rainguard, neck strap, and luxurious, hand-crafted carrying case.

AN EXCELLENT EXAMPLE OF OPAQUED-OUT BACKGROUNDS ON PHOTOGRAPHS. THIS ENABLES THE PHOTOGRAPHER TO SHOOT THE PRODUCTS WITHOUT WORRYING ABOUT DISTRACTING SHADOWS BEING CAST ON THE BACKGROUND. NOTE HOW THE PRODUCTS POP-OUT. THIS IS ESPECIALLY IMPORTANT WHEN THE PRODUCTS ARE APPEARING IN CATALOGS, SUCH AS THIS EXAMPLE.

PARTS CATALOGS ALWAYS USE THIS TECHNIQUE!

A GOOD EXAMPLE OF DIFFUSED LIGHTING USING A WHITE BACK-DROP. THE LIGHTS ARE BOUNCED OFF A WHITE CARD OR UMBRELLA.

YOU'VE SEEN THESE TYPES OF ADS IN PHOTO MAGAZINES AND PROBABLY WONDERED HOW THEY WERE DONE...WELL, HERE'S *ONE WAY!*

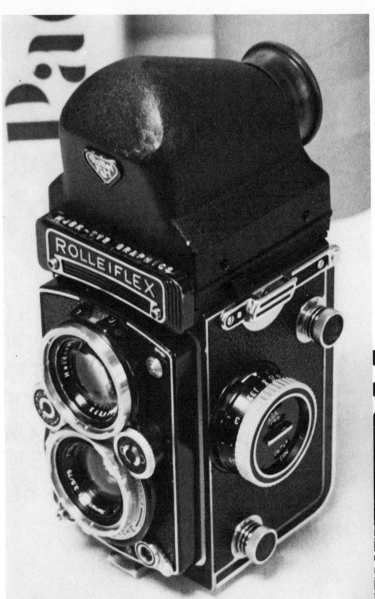

AN ORDINARY SHOT OF A CAMERA, OR SOME OTHER PRODUCT IS PRINTED IN THE USUAL WAY. THE BACKGROUND IS IGNORED BECAUSE IT'S EASY TO TAKE OUT AFTER THE PRINT IS MADE INTO A HIGH CONTRAST. A SMALL JAR OF SHOWCARD WHITE, PRO WHITE OR ANY OTHER KIND WILL DO THE JOB.

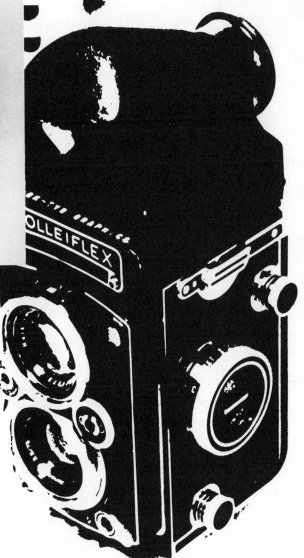

THE REGULAR PHOTOGRAPH IS THEN SHOT WITH THE KODALITH HIGH CONTRAST FILM, AND THEN PRINTED. THIS ACTUAL SIZE PRINT WAS MADE IN HIGH CONTRAST TO SHOW YOU THAT IT NEEDS AN ARTIST TO TOUCH-UP THE PRINT. *NEXT PAGE WE'LL MAKE IT SMALLER.*

HERE'S A SMALLER PRINT OF THE ROLLEIFLEX, WHICH LOOKS BETTER REDUCED! *MUCH EASIER THAN DRAWING IT!*

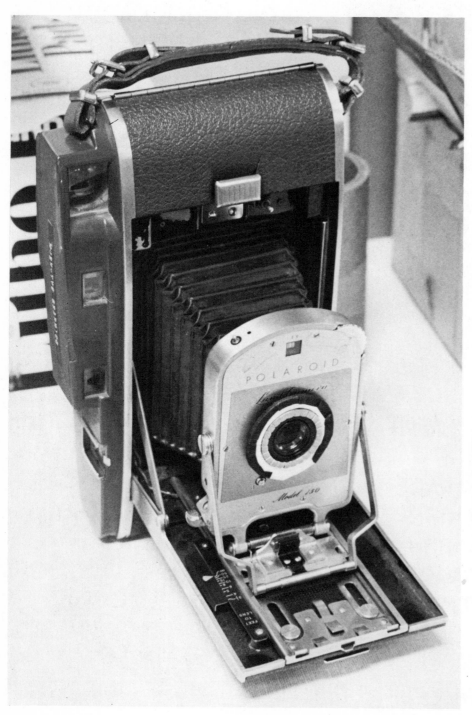

THIS OLD BUT STILL WORKING POLAROID DIDN'T COME OUT TOO WELL BECAUSE OF TOO MUCH SHADOW AND WOULD HAVE TO BE TOUCHED-UP BY AN ARTIST! *TRY SOME!*

PHOTOS FOR PARTS CATALOGS ARE AMONG THE BIGGEST OPP-
ORTUNITIES FOR BEGINNERS BECAUSE OF THE EASY SET-UP!
THERE ARE HUNDREDS OF SMALL MACHINE COMPANIES ALONE,
WHO PUT OUT PARTS CATALOGS. TRY STOPPING IN SOMETIME
AND TALKING TO THE BOSS - YOU MIGHT BE SURPRISED! THIS
PARTICULAR ONE IS FROM A COMPANY THAT REBUILDS TRANS-
MISSIONS FOR TRUCKS. THEY ARE SIMPLY SHOT AGAINST A
WHITE BACKGROUND, WITH AT LEAST THREE LIGHTS. A LOT OF
DETAIL MUST BE SEEN. SHADOWS CAN BE PAINTED OUT IF
NECESSARY — SOMETIMES THEY'RE NOT. USUALLY, THE PHOTO-
GRAPHER USES A 2¼ NEGATIVE OR LARGER AND CONTACT
PRINTS THEM! BLOW-UPS ARE UNUSUAL— BUT IT DOES HAPPEN!

THERE ARE OTHER METHODS TO DROPPING-OUT, OR OPAQUING BACKGROUNDS OUT OF PHOTOS FOR CATALOGS. THE ONES I HAVE MENTIONED, SUCH AS CUTTING-OUT AROUND THE PHOTOS OR PAINTING-OUT AROUND THE PHOTOS ARE THE MOST COMMON WAYS IN ART STUDIOS. CUTTING-OUT BEING THE MOST COMMON METHOD.

OTHER FORMS ARE USED IN PRINT SHOPS, SUCH AS RUBYLITH AND THE KOD-ALITH MASK....I SUGGEST IF YOU REALLY WANT TO GET INVOLVED IN THESE PROCESSES YOU TAKE A COURSE IN PRINTING.

AFTER THE PHOTOS ARE TURNED OVER TO THE ART DIRECTOR, OR CLIENT, THE JOB OF THE PHOTOGRAPHER IS OVER. THE RETOUCHING OR DROP-OUT IS DONE BY SOMEONE ELSE.
ANY SYSTEM WORKS...TAKE YOUR PICK!

REMEMBER—THERE ARE ARTISTS OUT THERE WHO ARE TALENTED AND ORIGINAL AND CONVINCED THAT ART CAN DO A BETTER JOB THAN PHOTOGRAPHY!

CLIENTS ARE PEOPLE LIKE EVERYONE ELSE AND WANT THE BEST THEY CAN GET FOR THE LOWEST COST. BUT IT'S THE ART DIRECTOR WHO DECIDES IN FAVOR OF ART WORK OR IN FAVOR OF PHOTOGRAPHY. STUDY PUBLICATIONS AND SEE HOW PHOTOS REPRODUCE ON DIFFERENT STOCKS—AFTER ALL IT'S YOUR PROFESSION. *SOME ADVICE: TAKE SOME ART COURSES TO IMPROVE YOUR SKILL.*

PRODUCT PHOTOGRAPHY WILL DEMAND MORE FROM A PHOTOGRAPHER THAN ANY OTHER FIELD IN THE PROFESSION. IT WILL ASK FOR HIS IMAGINATION, HIS TECHNICAL SKILL, AND MOST OF ALL......HIS ORIGINALITY. ACTUALLY, IN THE TRUE SENSE OF THE WORD, THE PRODUCT PHOTOGRAPHER IS REALLY A COMMERCIAL PHOTOGRAPHER. EVERY JOB IS DIFFERENT AND CHALLENGING.....ONE DAY HE MAY SHOOT BUILDINGS, THE NEXT, A SUBMARINE SANDWICH WITH A BOTTLE OF BEER, AND MAYBE THE NEXT DAY SOME TOYS! OF COURSE THIS DOESN'T HAPPEN EVERY DAY, BUT THE COMMERCIAL PHOTOGRAPHER HAS TO BE READY. *AND OF COURSE HE LOVES PHOTOGRAPHY WITH A PASSION...THAT'S WHAT MAKES IT ALL POSSIBLE.*
THE MOST IMPORTANT THING IS TO EXPERIMENT AND BE ORIGINAL!!

41

PRODUCT SHOTS CAN BE SHOT UNDER ONE OR A COMBINATION OF **THREE** BASIC TYPES OF ILLUMINATION! DO YOU KNOW THEM?

THE SUN! THE MOON! AND ELECTRIC LIGHTS!

WHAT ARE THOSE THREE BASIC TYPES OF LIGHTING?

THE SUN AND THE MOON ARE THE ONLY NATURAL SOURCES OF LIGHT THAT ARE USED BY PHOTOGRAPHERS!

OF COURSE THE MOON REALLY ISN'T BRIGHT ENOUGH FOR NORMAL PHOTOGRAPHIC PURPOSES, AND THEREFORE NOT VERY PRACTICAL.... EXCEPT FOR SPECIAL EFFECTS.

THE SUN IS THE BEST NATURAL LIGHT SOURCE FOR YOUR PHOTOS!

NOW LET'S TALK ABOUT THAT ARTIFICIAL STUFF!

TUNGSTEN FILAMENT

ORDINARY DOMESTIC LIGHT BULBS IN POWERS UP TO 150 WATTS, WITH SCREW BASES.

HIGH POWER BULBS WITH SCREW CAPS THAT ARE TOO LARGE FOR HOME FITTINGS!

PROJECTOR AND SPOTLIGHT BULBS!

QUARTZ-IODINE LAMP, WHICH GIVES CONSTANT INTENSITY FOR ENTIRE LIFE OF BULB!

ARC

SPOTLIGHTS, FLOOD LIGHTS, AND LIGHTING FOR MOTION PICTURE STUDIOS... WHERE IT PROVIDES NEAR DAYLIGHT COLOR TEMPERATURE.

DIFFERENT TYPES OF ARC FOR SPECIAL PROJECTORS AND SCIENTIFIC AND OPTICAL INSTRUMENTS!

VAPOUR DISCHARGE

VAPOUR LAMPS, UP TO 6 FEET LONG, ARE USED FOR PRINTING ON BLUE-SENSITIVE EMULSIONS, SUCH AS BLOCK PRINTING. ALSO DOCUMENT PRINTING!

ALSO PROJECTION LAMPS, SPOTLIGHTS, FILM STUDIO LIGHTING, AND STREET LAMPS. BLUE-VIOLET LIGHT!

FLUORESCENT

FROM THE VAPOUR DISCHARGE PRINCIPLE. MOSTLY IN TUBE FORM FOR OFFICES, HOMES, SCHOOLS, ETC. ETC.

FLASH DISCHARGE

ELECTRONIC FLASH UNITS.

BETTER WATCH OUT THERE, MR. MUSE, THIS COULD TURN INTO A BORING TEXTBOOK!

HEY, DUMMY, YOU FORGOT FLASH BULBS !!

A FLASH BULB'S LIGHT IS GENERATED BY THE RAPID COMBUSTION OF CERTAIN METALS IN OXYGEN! THE BULB IS FIRED WITH ELECTRICITY ONLY ONCE AND THEN THROWN AWAY!

THAT'S WHY THEY ARE CALLED: "EXPENDABLE FLASH."

WHEN YOU PHOTOGRAPH PRODUCTS FOR CLIENTS.....OR
ART DIRECTORS, YOU MUST UNDERSTAND IT HAS TO LOOK
MORE APPEALING IN THE PICTURE THAN IN REAL LIFE! IF
IT'S A RADIO OR TAPE RECORDER, OR A CAMERA, OR THINGS
OF THAT NATURE, EVERY KNOB, DIAL, BUTTON AND SWITCH
HAS TO BE SHARP.

ESPECIALLY THE PRODUCT'S TRADE NAME!

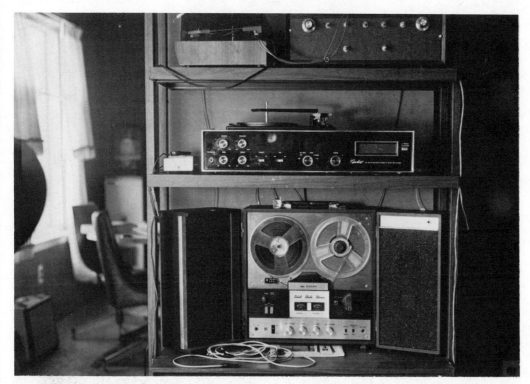

NOTICE ALL THE
CLUTTER IN THIS
PHOTO.
PRODUCTS HAVE
TO BE SET-UP
AND PLANNED
TO LOOK LIKE
BEAUTIFUL
THINGS THAT
PEOPLE WANT
TO BUY.
THE ONLY THING
THAT CAN BE
SAID ABOUT THIS...
"IT'S A PICTURE."

THIS SHOT WAS HAND-HELD FOR 1/30 SEC. AT f 2.8 ON TRI-X PAN FILM.......

THIS IS AN EXAMPLE OF HOW NOT TO PHOTOGRAPH A TAPE
RECORDER. TRUE, IT LOOKS LIKE A TAPE RECORDER.....
BUT AS YOU CAN SEE, IT'S NOT ENOUGH. YOU WANT TO
KNOW WHAT THIS PHOTOGRAPH IS? *IT'S A SNAPSHOT!*
IF YOU OWNED A COMPANY THAT MANUFACTURED TAPE
RECORDERS, WOULD YOU WANT THIS PHOTOGRAPH TO
REPRESENT YOUR PRODUCT?...IF YOU DID, YOU JUST
WOULDN'T BE IN BUSINESS VERY LONG.
CHECK THE NEXT PAGE AND SEE AN IMPROVEMENT!

WITH A TRIPOD AND A BIT OF IMAGINATION... AND PLUS-X FILM, WE COME UP WITH THIS SHOT.

NOTICE HOW THE CONTRAST OF THE ROCKS AND THE PLANTS ENHANCE THE TAPE RECORDER. PLUS...THE OUT-SIDE LIGHTING.

LOOKING DOWN ON THE PRODUCT IS VERY EFFECTIVE FOR SHOOTING PRODUCTS....AND EVEN-LIGHTING...LIKE OUT-SIDE. TAKE CARE TO MAKE THE BACKGROUNDS SIMPLE.

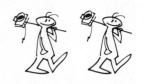

WHAT MAKES THIS PRODUCT SHOT SO FULL OF GRADATION AND TONE SEPARATION?...THAT'S SIMPLE: *A BIG NEGATIVE !*

IT'S ALWAYS A GOOD IDEA IN THE BEGINNING TO TAKE A PICTURE OF YOUR PRODUCT OUTSIDE IN THE SHADE....OR ON AN OVER-CAST DAY. THE SHADE WON'T GIVE ANY BLACK SHADOWS LIKE THE SUN........AND YOU CAN MOVE YOUR PRODUCT AROUND TO DIFFERENT LOCATIONS WITHOUT HAVING TO WORRY.

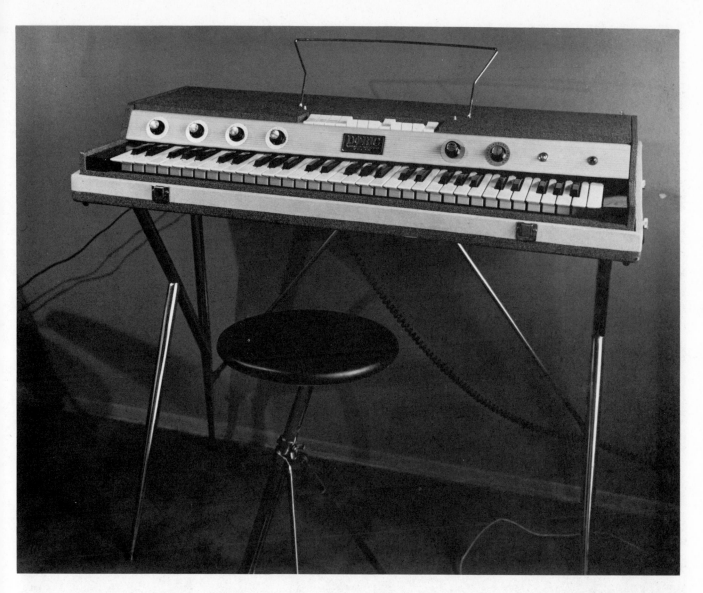

THIS PHOTO OF AN ELECTRIC ORGAN IS JUST A STOCK SHOT THAT SIMPLY SHOWS HOW IT LOOKS, AND THE COMPARATIVE SIZE OF THE INSTRUMENT.....IN OTHER WORDS, IT'S NOT AN UNUSUAL PHOTOGRAPH! IT WOULD BE ACCEPTABLE HOWEVER FOR A CATALOG SHOT, WHERE OTHER MUSICAL INSTRUMENTS ARE ALSO SHOWN.

I WOULDN'T RECOMMEND THIS FOR A STUDENT PORTFOLIO BECAUSE IT IS THE KIND OF A SHOT THAT ANYONE COULD TAKE!
UNLESS, OF COURSE YOU WANT TO SHOOT PICTURES FOR CATALOGS!

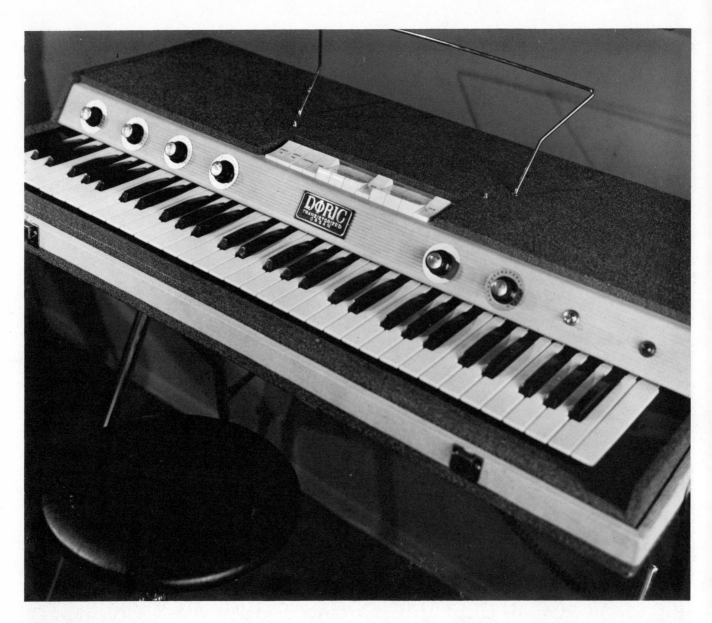

NOW I'M NOT SAYING THIS IS THE GREATEST PICTURE OF AN ELECTRIC ORGAN EVER MADE....BUT WHAT I AM SAYING IS IT'S A HECK OF A LOT MORE ORIGINAL THAN THE STRAIGHT AHEAD JOB.

HOW MUCH MORE DRAMATIC PICTURES CAN BECOME BY SHOOTING CLOSE, OR FROM A DIFFERENT ANGLE!!

TAKEN WITH A BRONICA • AVAILABLE LIGHT • f22 FOR 1 SECOND.

HERE'S ANOTHER INSTANCE WHERE A CONTRASTY PAPER MADE ALL THE DIFFERENCE. IN THIS CASE I UNDER-EXPOSED THE NEGATIVE BY TWO STOPS AND PRINTED ON A NORMAL PAPER. THE RESULT, AS YOU CAN SEE, IS A MUDDY PRINT THAT HAS BLACK AND ALL GRAYS BUT NO WHITES. *THE FIRST THING THAT SUFFERS IS <u>DETAIL</u> !*

THERE IS LITTLE THAT CAN BE DONE FOR AN UNDER-EXPOSED NEGATIVE. IF THE EXPOSURE HASN'T BEEN ENOUGH TO RECORD DETAIL IN THE SHADOWS, MORE PROCESSING WILL NOT ADD IT..... IN ANY CASE, THE PRINT WILL NOT TURN-OUT BETTER BY LONGER DEVELOPING!

THE ONLY HOPE, AS IN THIS EXAMPLE, IS A NO. 5 PAPER...BUT YOU WILL PAY A PRICE...THE PRICE IS EXTREME CONTRAST ALONG WITH *GRAIN!* IT DOESN'T SHOW IN THIS PRINT BECAUSE IT'S ONLY A 7½ X 7½ PRINT SHOT WITH A 2¼ NEGATIVE.

USE HIGH CONTRAST PAPER ONLY FOR SPECIAL EFFECTS... *OR IF YOU'RE DESPERATE!*

THIS IS NOT TOO GOOD OF A WAY TO SHOOT BINOCULARS, EVEN THOUGH IT LOOKS DRAMATIC.........

A PRODUCT SHOT LIKE THIS WOULD BE OK IF IT WERE PLANNED TO BE USED IN THE ACTUAL SIZE HERE! IT'S HARD TO SEE IN THIS SMALL PRINT, BUT HALF OF THE BINOCULAR IS OUT OF FOCUS!

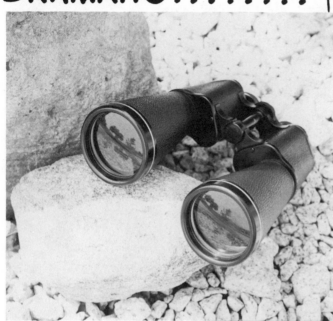

AS THE PRINT GETS LARGER, SHARPNESS BEGINS TO DROP-OFF ABOUT HALF-WAY BACK!

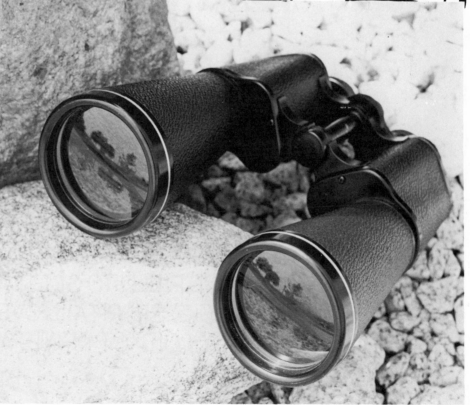

DRAMATIC BUT OUT OF FOCUS.....

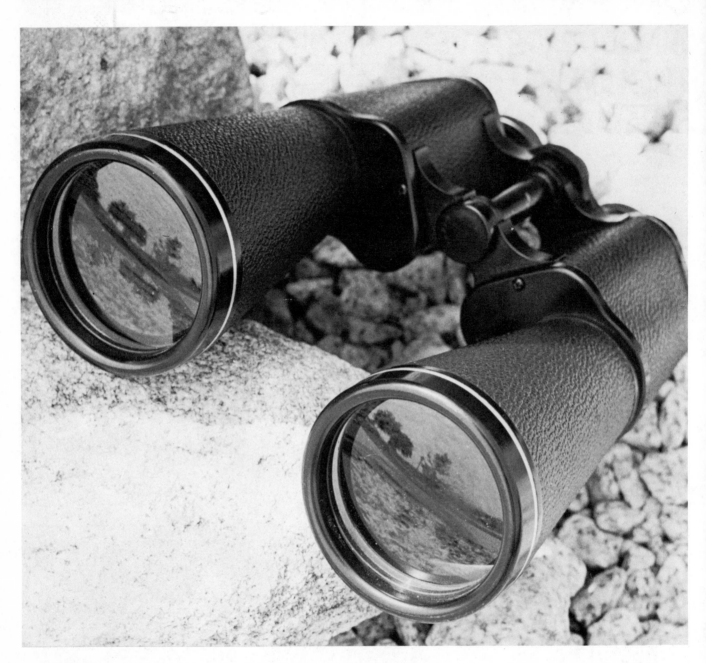

IN THIS 11X14 PRINT YOU CAN PLAINLY SEE THAT HALF OF THIS PICTURE **IS OUT OF FOCUS.** IT'S SIMPLE... AT f8 THERE JUST WASN'T ENOUGH DEPTH OF FIELD TO GET IT ALL SHARP. IN THE 3¼ x 3½ PRINT IT LOOKS SHARP ALL OVER BECAUSE IT'S A LITTLE PRINT. THAT'S WHY CONTACT PRINTS ALWAYS LOOK SHARP.

USE SMALL LENS OPENINGS...

PRODUCTS WITH A 35mm CAMERA....

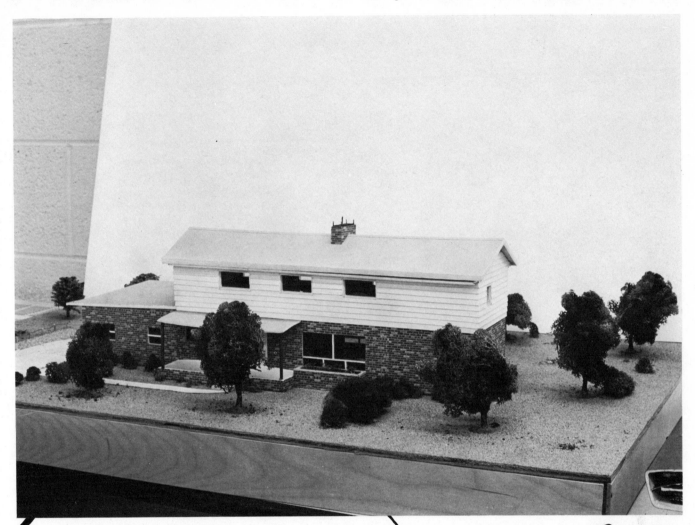

USING PLUS-X FILM AND A 35mm CAMERA, I SHOT THIS MODEL HOUSE!! OF COURSE THE CAMERA WAS ON A TRIPOD AND WAS SHOT AT f 16 FOR 1/15 SECOND! ALL THESE GO FOR MAKING A GOOD PRINT!

HERE'S THE 8X10 BLOW-UP FROM 35mm

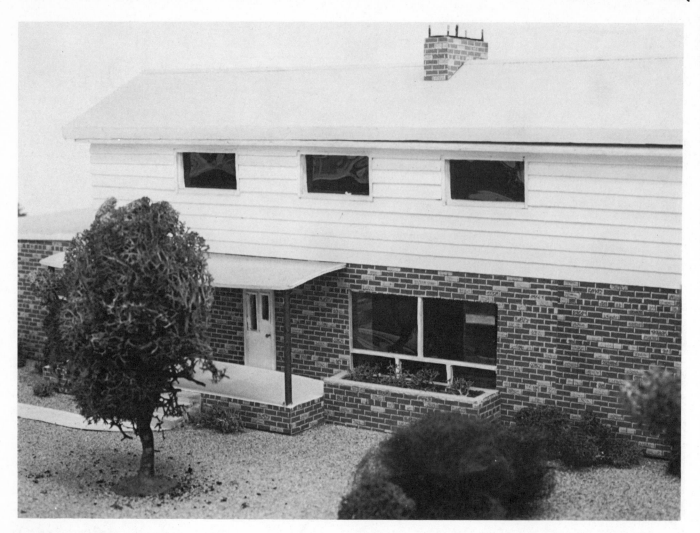

WITH CAREFUL EXPOSURE AND DEVELOPING, PLUS AN
AMOUNT OF SKILL IN PRINTING, YOU COULD GET BY
WITH USING A 35mm FOR PRODUCT PHOTOGRAPHY.
MY ADVICE WOULD BE TO STAY AWAY FROM 11X14'S!!
IT'S NOT THAT THE 35mm CAMERAS ARE *LESS SHARP*
THAN THE BIG ONES, BUT THAT IN BLOWING THEM UP
THEY LOSE TONALITY AND GRADATION... IN OTHER
WORDS THE PIECES OF GRAIN THAT MAKE THE PICTURE
GET FARTHER APART DURING ENLARGEMENT.........

A PICTURE HAS TO BE LIGHTED CORRECTLY, ABUNDANTLY, AND IN A NATURAL WAY, SO THAT IT DOESN'T LOOK PHONEY. THE PICTURE MUST ALSO HAVE **SNAP**... DARK OR VERY BLACK SHADOWS ARE TO BE AVOIDED LIKE THE PLAGUE. EVEN *TOO* DARK A SHADOW BEING CAST BY THE PRODUCT ITSELF IS A DISASTER.

THE PICTURE NEEDS ANOTHER LIGHT TO FILL-IN.

HERE'S AN EXAMPLE OF A CAMERA SHOT TAKEN BY A STUDENT WHO WASN'T PAYING TOO MUCH ATTENTION TO THE LIGHTING. NOTICE THE VERY BLACK SHADOWS ON THE CAMERA. THE DETAIL IS LOST AND THE PICTURE HAS NO **SNAP!**

LET'S TAKE THE THING OUTSIDE IN THE SHADE AND SHOOT IT... NOW, ISN'T THAT BETTER? LOOK AT ALL THE DETAIL... LOOK HOW IT **SNAPS!** WHEN YOU'RE OUTSIDE IN THE SHADE YOU CAN POSITION YOUR PRODUCT ANYWHERE YOU PLEASE WITHOUT DARK SHADOWS.

LOOK...NO EXPENSIVE LIGHTING EQUIPMENT.....

HERE'S ANOTHER STUDENT EXAMPLE

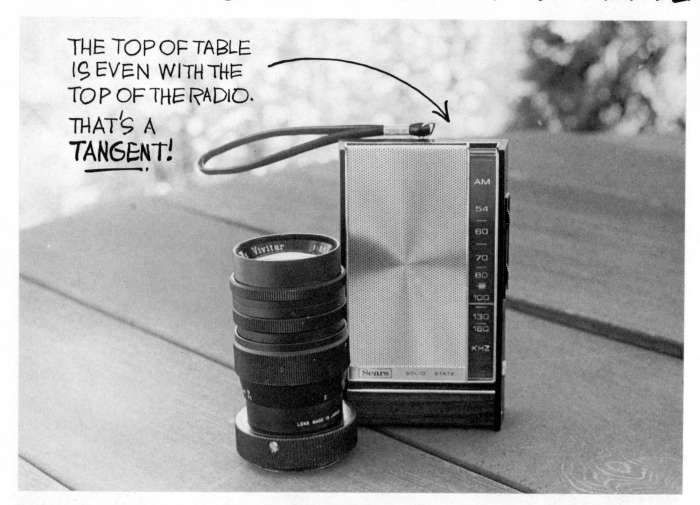

THE TOP OF TABLE IS EVEN WITH THE TOP OF THE RADIO. THAT'S A TANGENT!

THIS SHOT WAS TAKEN WITH A 50mm CAMERA LENS OUTSIDE ON A PICNIC TABLE. I SUPPOSE THE 135mm TELEPHOTO LENS WAS PUT IN THE PICTURE TO SHOW THE COMPARATIVE SIZE OF THE RADIO..... NOT TOO GOOD AN IDEA BECAUSE THE TWO TOGETHER HAVE NO CONNECTION, AND THEREFORE MAKE NO SENSE. BETTER A BOWL OF CHIPS OR A BOTTLE OF POP. IN ANY EVENT, THERE IS A TANGENT THAT REALLY BOTHERS THE EYE AND SORT OF DIVIDES THE PHOTO IN HALF.

REMEMBER....

GOOD COMPOSITION IS THE TOOL THAT THE PHOTOGRAPHER USES TO EXPRESS HIMSELF!

AVOID BIG BLOW-UPS

THIS SHOT OF A 4X5 CAMERA WAS TAKEN FROM 5 FEET AND BLOWN-UP TO 8X10. A MEDIUM DISTANCE AVOIDS DISTORTION. A BIG IMAGE SIZE ALSO AVOIDS TOO MUCH GRAIN. THE SHOT IS SHARP... ALSO CAUSED BY A LARGE IMAGE ON NEGATIVE.

HERE'S THE SAME SHOT BUT AT A DISTANCE OF TWENTY FEET AND BLOWN-UP TO MATCH THE IMAGE SIZE OF THE PRINT ON THE LEFT. NOTICE GRAIN AND LOSS OF SHARPNESS. ALSO THE FLAT LOOK, CAUSED BY THE DISTANCE...LIKE A TELEPHOTO.

 ...AND NOW...ANOTHER PROBLEM....

BE SURE NOT TO GET TOO CLOSE TO YOUR PRODUCT WITH A NORMAL OR WIDE ANGLE

ANY CHANGE OR ALTERATION IN THE SHAPE OF THE PRODUCT IN SCALE OR PERSPECTIVE AT ANY STAGE OF THE PHOTOGRAPHIC PROCESS IS CALLED **"DISTORTION!"**

THE DISTORTION IN THIS CASE WAS CAUSED BY THE PHOTOGRAPHER BEING TOO CLOSE WITH HIS 20mm WIDE ANGLE LENS.

IN A TRUE SENSE, THIS IS NOT DISTORTION, BUT AN EXAGGERATION OF THE RELATIVE PROPORTIONS IN A TRUE PERSPECTIVE CAUSED BY THE CAMERA BEING TOO CLOSE TO THE OBJECT

TRY SOME UNUSUAL SHOTS

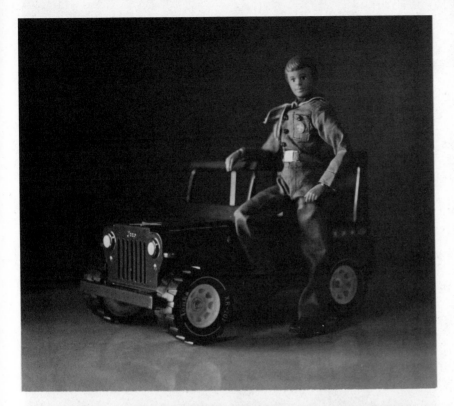

THIS IS AN INTERESTING SET-UP FOR A TOY JEEP AND A BOY SCOUT DOLL! THE MAIN PROBLEM IS THERE IS NOT ENOUGH LIGHT ON THE SUBJECT AND THE LENS WAS WIDE OPEN AT f2.8!
THE DEPTH OF FIELD IS TOO SHALLOW AND THE PRINT IS TOO DARK. THE BACKGROUND DOES NOT FIT THE SUBJECT. NOT TOO MUCH THOUGHT HERE.

LET'S TAKE THE JEEP AND DOLL OUTSIDE IN MORE NATURAL SURROUNDINGS THAT LEND A BETTER ATMOSPHERE TO THE WHOLE COMPOSITION. NOTICE THAT THE SMALL TREE IN THE BACK OF THE TOYS LOOKS LIKE A BIG ONE? NOTICE ALSO THAT THE WHOLE JEEP IS SHARP. NOW CHECK THE NEXT TWO PAGES FOR THE 8X10 BLOW-UP, AND HOW REALISTIC THE WHOLE PICTURE LOOKS.

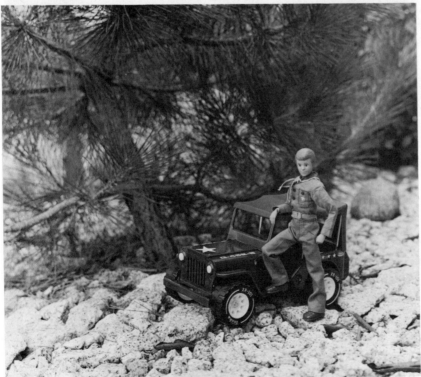

NOTICE HOW CRISP AND CLEAR IT LOOKS WITH ENOUGH LIGHT?

NOW.. NOTICE ... WHEN THE PRODUCT DOES NOT HAVE THE RIGHT AMOUNT OF LIGHT, YOU CAN'T STOP YOUR LENS DOWN FAR ENOUGH TO GET SUFFICIENT DEPTH OF FIELD. AS A RESULT, ALL THE PRODUCT IS NOT IN FOCUS. THE LITTLE PRINT DID NOT SHOW THIS LOSS OF DEPTH OF FIELD AS MUCH AS THIS BLOW-UP. BESIDES, *WHERE ARE YOU GOING TO FOCUS?*

HOWEVER, A DESK TOP IS NOT THE BEST KIND OF BACKGROUND FOR THIS PRODUCT.

DON'T JUST SET THINGS DOWN AND SHOOT THEM.

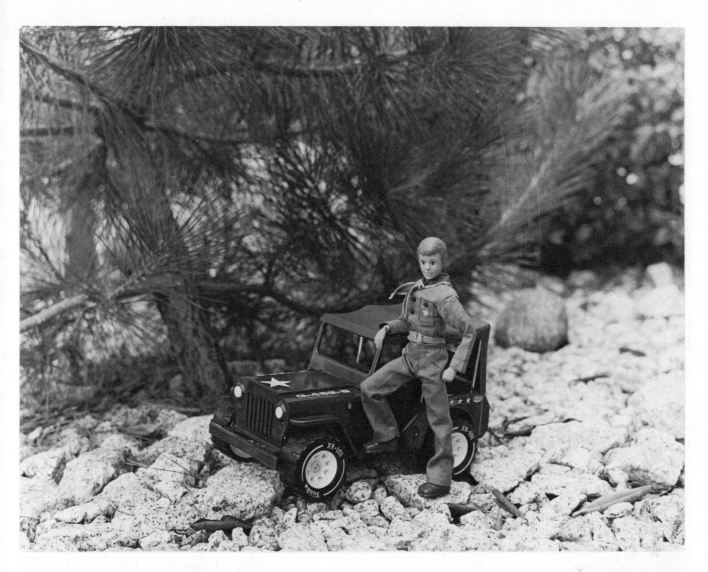

SINCE YOUR BACKGROUND CONTRIBUTES TO THE MEANING OF THE PICTURE, YOU DON'T HAVE TO BLOW-UP THE TOYS AS LARGE BECAUSE YOU WANT ALOT OF THE BACKGROUND TO SHOW... AS YOU CAN SEE, BOTH TOYS ARE IN FOCUS, AND THE TREES AND SOME OF THE ROCKS ARE OUT OF FOCUS BECAUSE THEY ARE FARTHER BACK. AS A RESULT, IT MAKES THE SMALL TREES LOOK LIKE BIG ONES... AND GIVES A REAL DEPTH TO THE PRODUCT SHOT. THIS SHOT WAS WITH A TRIPOD... *A TOOL JUST AS IMPORTANT AS A CAMERA.*

A LITTLE IMAGINATION IS MORE IMPORTANT THAN AN EXPENSIVE CAMERA WITH A BIG LENS AND FANCY EQUIPMENT.

USE TRIPOD FOR PRODUCT SHOTS!

DON'T BE STUPID AND TRY TO HAND-HOLD YOUR CAMERA FOR PRODUCT SHOTS... IT'S DISASTER! I DON'T CARE HOW STEADY YOU ARE! DON'T YOU WANT THE SHARPEST PICTURES YOU CAN GET? DO YOU WANT TO SHOW BAD, OUT-OF-FOCUS AND BLURRY PHOTOGRAPHS? THIS SHOT WAS HANDHELD FOR ONE FIFTEENTH TO GET DEPTH OF FIELD.

THE SAME SHOT ON A TRIPOD FOR 1/15 OF A SECOND. AFTER ALL, YOU SHOULD BE ABLE TO READ ANY WRITING ON THE PRODUCT CLEARLY!

REMEMBER... IF YOU'RE *NOT INTERESTED* IN GETTING SHARP PICTURES THEN GET INTO ANOTHER PROFESSION. *ESPECIALLY WHEN DOING PRODUCTS.....*

PRACTICE SHOOTING TOYS FOR AWHILE!

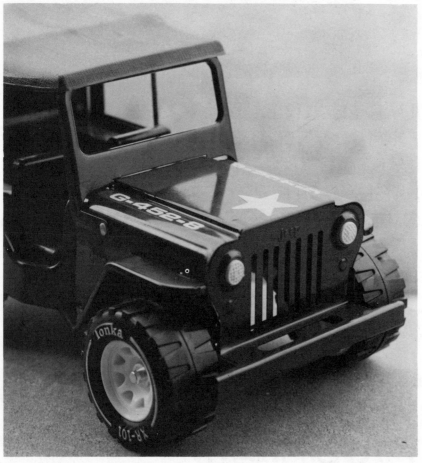

LOOK WHAT GRADED PAPERS DO!

KODABROMIDE NO. 2 AGFA NO. 6

IN THIS SHOT THE NEGATIVE WAS UNDER-EXPOSED ON PURPOSE TO ILLUSTRATE THE MUDDY PRINT FROM A NORMAL PAPER.

NOW HERES THE SAME NEGATIVE ... ONLY THIS TIME ON A HARD AND CONTRASTY PRINTING PAPER. *EMERGENCY ONLY !*

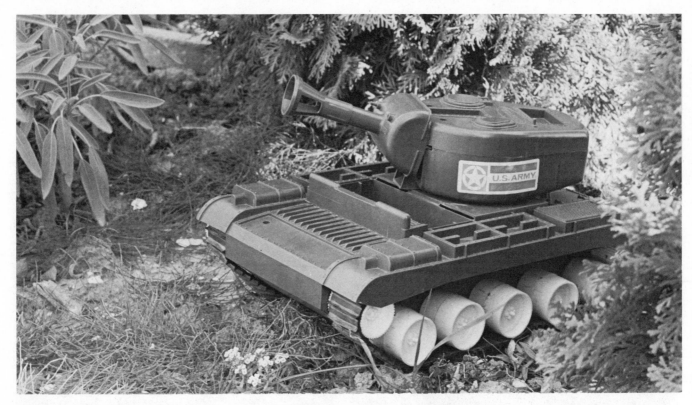

THIS IS A NO.2 PAPER...CONSIDERED A NORMAL GRADE. THIS PRINT IS ON THE SOFT AND MUSHY SIDE WITH NO BLACKS, AND GRAYS INSTEAD OF WHITE.

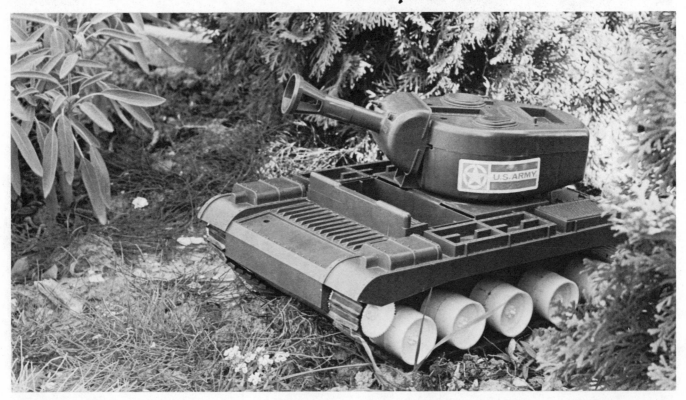

THIS IS A NO.3 PAPER, WHICH GIVES A LITTLE MORE CONTRAST. THERE ISN'T ANY DOUBT THAT THIS PRINT LOOKS BETTER BECAUSE THE WHITES ARE WHITER.

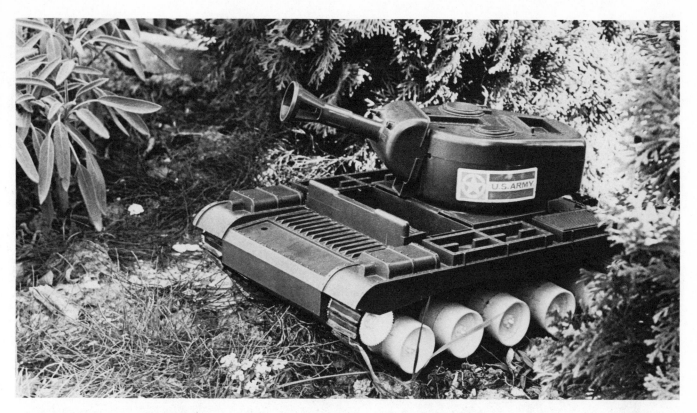

A NUMBER 4 PAPER BECOMES DRAMATIC, AND THE PRINT I WOULD CHOOSE! THE WHITES ARE CRISP AND THE BLACKS ARE JET! *PERFECT FOR THIS TOY...*

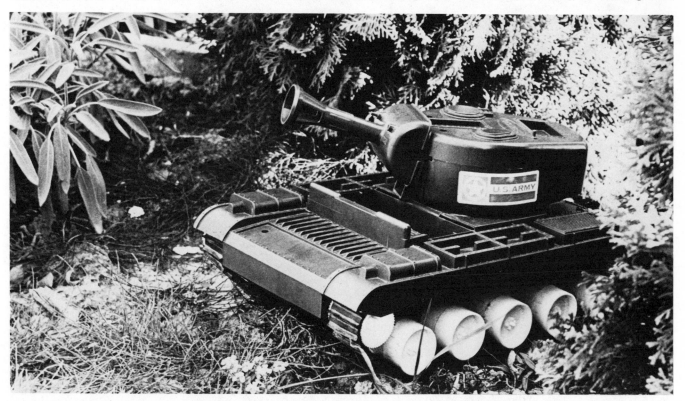

A NUMBER 5 PAPER GOES TOO FAR...THAT'S WHY I DIDN'T USE A GRADE 6! LOSS OF SHADOW DETAIL, GRAIN, AND NO DETAIL IN WHITES. *BAD CHOICE.*

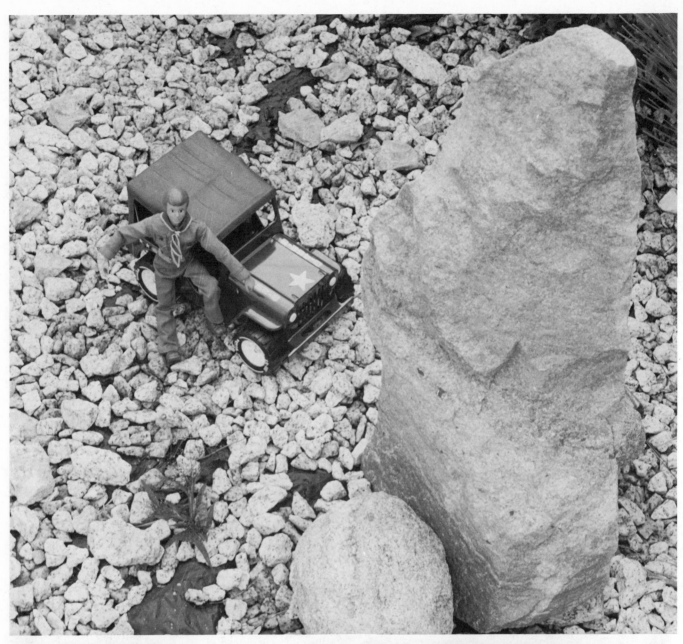

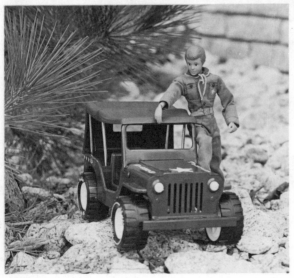

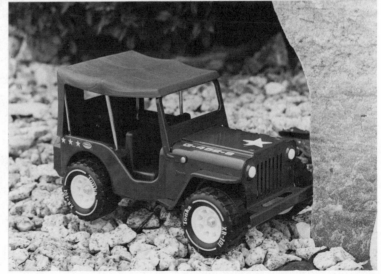

SOME MORE INTERESTING SHOTS WITH TOYS.....

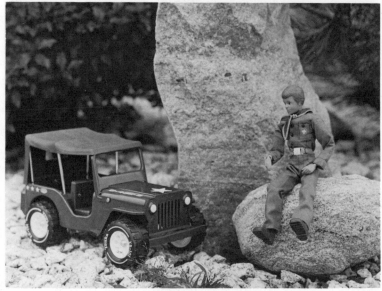

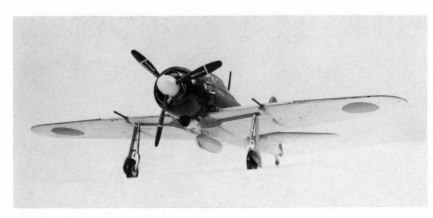

WORLD WAR II JAPANESE ZERO MODEL IS SHOT AGAINST A WHITE BACKDROP.
NOT A GOOD VIEW BECAUSE IT CREATES DISTORTION. BESIDES, THE VIEW IS TOO LOW. IN BLOW-UP, THE TAIL SECTION WAS OUT OF FOCUS.

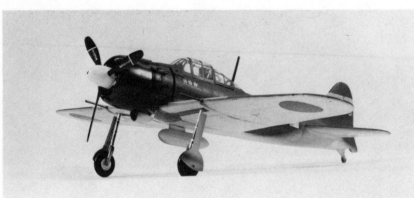

NOT BAD. HOWEVER, THE CAMERA IS STILL TOO LOW AND THE COCKPIT HAS NOT BEEN OPENED TO SEE THE PILOT. I REALLY LIKE THIS SHOT, AND WOULD HAVE CHOSEN IT FOR AN 8X10... *UNTIL I TRIED AGAIN.*

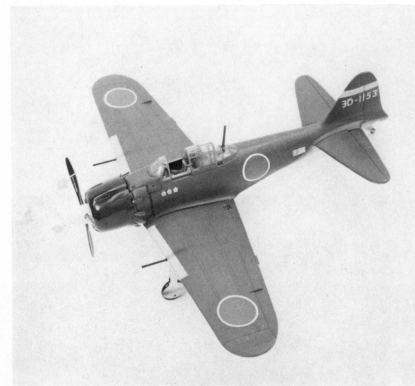

NOW I GOT WHAT I WAS LOOKING FOR IN THIS SHOT. FIRST OF ALL, THE WHOLE AIRPLANE IS IN FOCUS...SECOND, WE CAN NOW SEE THE PILOT...AND THIRD, THE BACKGROUND IS CLEAN.

NOTICE THAT THE PRINT, COMPARED WITH THE FIRST TWO IS ON THE LIGHT SIDE.

THE NEXT PAGE IS AN 8X10 PRINT OF THE BOTTOM PICTURE.

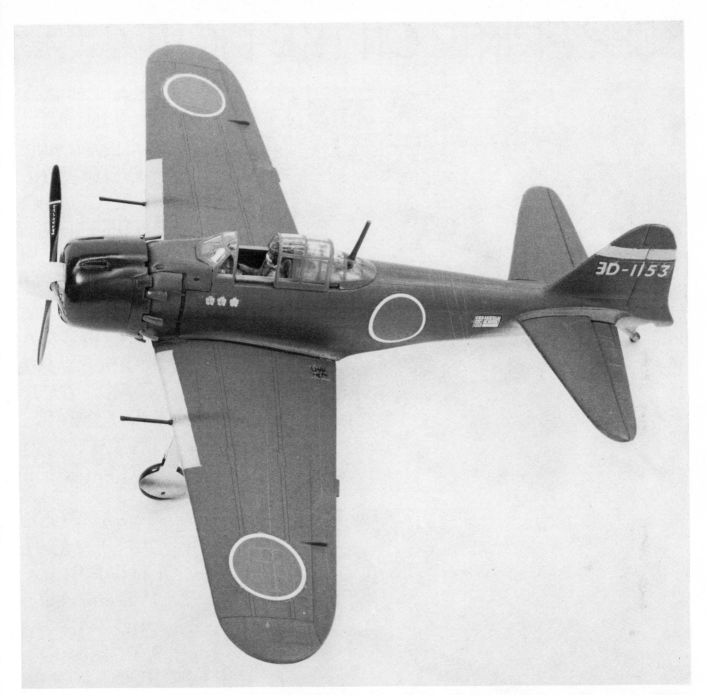

THIS 8X10 COMES OUT LOOKING LIKE THE LIFE-SIZE PLANE!

PHOTO MISSION

KEEP PRINTS ON THE LIGHT SIDE!

IF YOU HAVE A NORMAL NEGATIVE, ONE THAT HAS A NORMAL DENSITY AND THE CORRECT DEVELOPMENT, AND YOU GIVE TOO MUCH EXPOSURE IN THE ENLARGER, YOU WILL GET A DARK AND MUDDY PRINT...*LIKE THIS ONE!*...A DARK PRINT HAS NO WHITES AND HAS NO *SNAP.!*...IN OTHER WORDS IT DOESN'T *POP-OUT* AT YOU. THESE PRINTS ARE DIFFICULT FOR NEWSPAPERS TO REPRODUCE.

NOTICE THE SAME ONE PRINTED ON THE *LIGHT SIDE?* YOU CAN SEE MORE DETAIL, WHITER WHITES, AND MANY MORE GRAYS! THIS IS WHAT PROFESSIONALS CALL A *CLEAN PRINT!* THEY LOOK SHARPER. IT TAKES PRACTICE IN THE DARKROOM UNDER THE SAFELIGHTS TO GET THOSE LIGHT PRINTS..YOU HAVE TO PRACTICE UNTIL YOUR EYES ARE USED TO SEEING ON THE LIGHTSIDE.

...AND WHEN YOU'RE FINISHED SHOOTING YOUR TOYS, GIVE THEM TO THE TEEN-AGERS SO THEY CAN PLAY WITH THEM!

DAVID MIKE ARDITH

WRONG

RIGHT

TOO CLOSE. ALWAYS SHOW THE TOTAL PRODUCT...NOT JUST A PART OF IT.

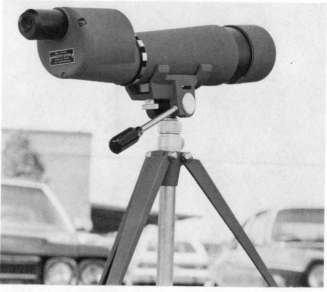

MUCH BETTER WITH NO DISTORTION... NOTICE THE WHOLE SCOPE IS SHARP.

VERY DRAMATIC WITH A 20mm LENS, BUT NOT ENOUGH OF CAMERA IS SEEN.

NOW I CAN SEE LENS AND ALOT MORE FEATURES. *MAKES YOU WANT IT!*

TAKE CARE SHOOTING PRODUCTS WITH A WIDE ANGLE LENS....PROPORTIONS ARE DECEPTIVE.

WRONG

RIGHT

SEE NEXT PAGE
FOR THE 8X10...

CASE IS IN THE WAY AND DARK AREAS ARE IN NEED OF MORE LIGHT.. CAN'T READ IT.

MUCH BETTER. CAN READ EVERYTHING NOW. DISTRACTION AT TOP IS CUT OFF....

NOT ENOUGH LIGHT. CAMERA IS TOO LOW OF AN ANGLE. CAN'T READ ANYTHING.

TOP VIEW IS BETTER... MORE LIGHT COMING FROM THE TOP AND SIDE.....

KEEP GOING THERE'S MORE

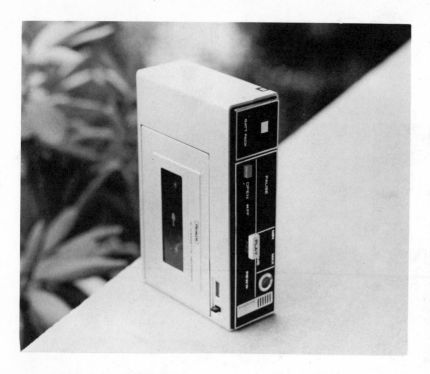

HERE WE TAKE THE TAPE
RECORDER OUT INTO THE
SHADE TO AVOID ANY
BLACK SHADOWS THAT
COULD HIDE THE DETAIL.
THIS FIRST TRY ISN'T TOO
BAD, BUT THE NAME IS
SORT OF WASHED-OUT
AND THE CONTROL SIDE IS
A LITTLE TOO BLACK.
NOTICE THE OUT-OF-FOCUS
PLANTS IN BACKGROUND
AND THE ABSENCE OF ANY
BLACK SHADOWS?

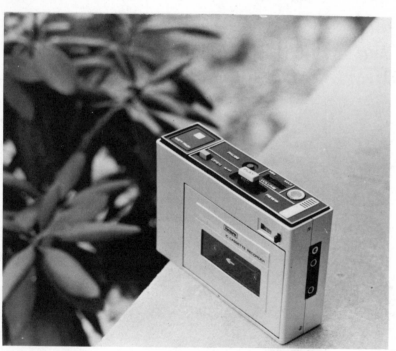

FOR AN IMPROVEMENT, WE
LAY THE RECORDER ON IT'S
SIDE, MAKING THE NAME
EASIER TO READ. SINCE
THE LIGHT IS COMING IN
FROM THE SKY, THE BLACK
FROM THE CONTROL SIDE
IS OPENED-UP... MAKING
THE RECORDER LOOK MORE
EXPENSIVE BY GIVING IT
DEPTH.
THE INCH HANGOVER OFF
THE LEDGE LENDS THE
INTEREST TO THE SHOT.

HERE'S THE BIG NEGATIVE BLOWN-UP! 8X10

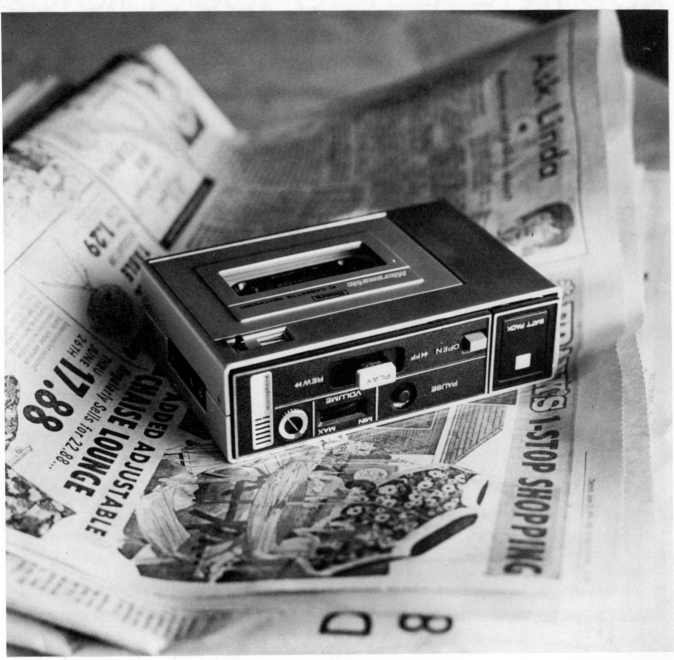

ADD INTEREST TO YOUR PHOTOS

HERE ARE TWO LITTLE MULES CARVED FROM AGATE. THE BIGGEST
ONE IS ONLY 3 INCHES HIGH, AND THE SMALL ONE TWO INCHES HIGH.
TO GET A BIG IMAGE I HAD TO GET IN CLOSE, BUT IN DOING SO THE
DEPTH OF FIELD WAS SHALLOW. PUTTING THE CAMERA ON A TRIPOD
AND SHOOTING AT f22 FOR ONE HALF SECOND, I GOT THIS SHOT......

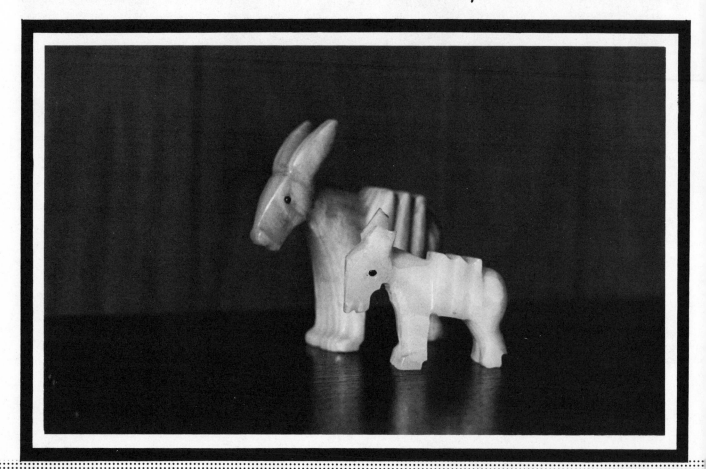

BUT THE SHOT HAS
NO INTEREST!
LET'S LOOK AT
THE NEXT PAGE!

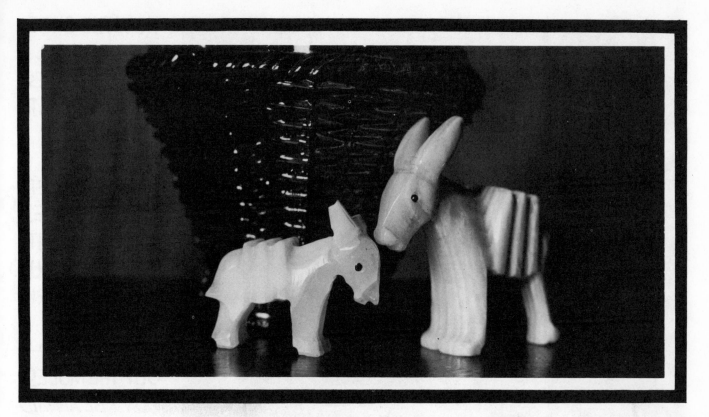

OF COURSE, PUTTING A VASE BEHIND THE MULES IS GOING TO ADD INTEREST, BUT THE PICTURE LACKS IMAGINATION. I THINK MAYBE THE IMAGE SIZE IS TOO **LARGE** FOR SOMETHING ONLY 3 INCHES HIGH... IF WE PULL THE CAMERA BACK WE'LL HAVE MORE TO WORK WITH!

NOW WE'RE ON THE RIGHT TRACK... MAKE THEM BOTH DOING SOMETHING.... HAVE THEM *OCCUPIED!*
ANIMALS ARE CURIOUS AND WOULD DO THIS SORT OF THING. OF COURSE NOT FROM A TV SET.
NOTICE IN THIS SHOT HOW THE MULES TAKE ON A NEW CHARACTER?
NEXT PAGE WE'LL DO BETTER!

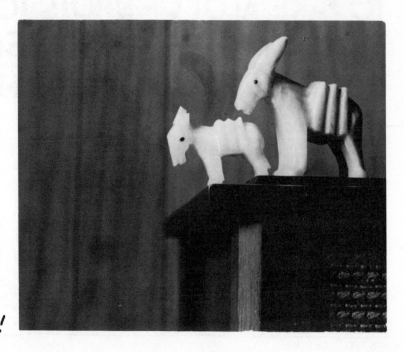

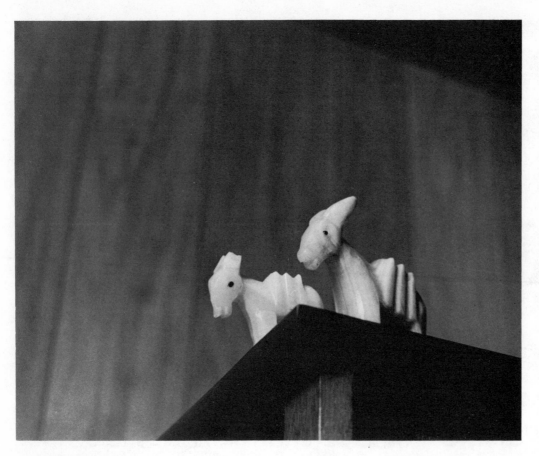

NOW THE SHOT IS FUNNIER.... NOTICE THAT BY LOOKING UP AT THE MULES MAKES THEM LOOK SMALLER AND TERRIFIED AT THE HEIGHT. THE BACKGROUND WAS KEPT DARK BECAUSE IT HELPED POP-OUT THE MULES. *DON'T BE AFRAID TO USE HUMOR!*

LOOK THROUGH YOUR LENS FOR YOUR SHOTS...... THE LENS WILL FRAME THE SUBJECT AND GIVE YOU ALOT OF NEW IDEAS! ANOTHER THING IS TO TAKE ALOT OF SHOTS TO COVER YOURSELF. I SHOT TWO ROLLS OF 35mm FILM BEFORE I GOT EXACTLY WHAT I WANTED...*40 SHOTS...*

YOU SHOULD SEE THE OTHER CAR!

KEN MUSE

PRODUCT PHOTOGRAPHY
AMONG STUDENTS HAS
TWO HANG-UPS.......
*BACKGROUNDS AND
LIGHTING!*
IT IS STILL A MYSTERY TO
ME WHY STUDENTS WILL
NOT BRACKET EXPOSURE.
THIS SHOT OF A SPOTTING
SCOPE UNDER POOR LIGHT-
ING CONDITIONS IS A GOOD
EXAMPLE. THE BACKGROUND
ISN'T TOO BAD, BUT THERE
ARE DARK SHADOWS THAT
DESTROY THE DETAILS.

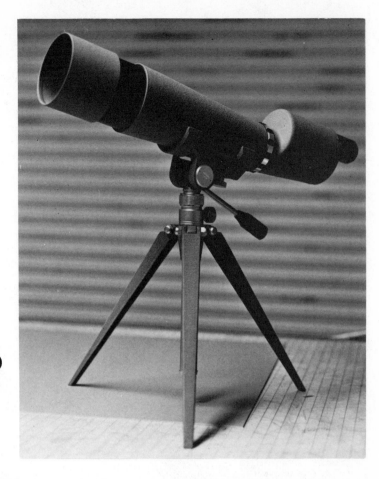

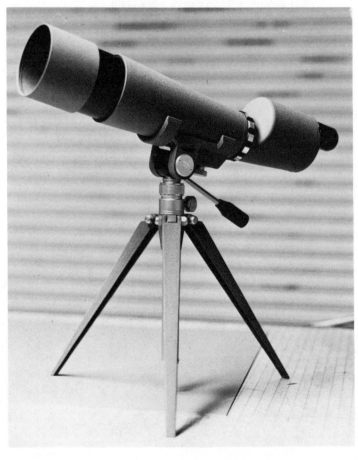

ALL YOU HAVE TO DO IS
USE THE NEXT SLOWER
SHUTTER SPEED AND THE
SPOTTING SCOPE POPS
RIGHT OUT AT YOU. WHEN
YOU BRACKET YOU ALLOW
FOR ANY ERROR IN YOUR
METER OR AN ERROR IN
YOUR SHUTTER SPEED.
I DON'T UNDERSTAND THE
BIG DEAL OF NOT TAKING
ANOTHER SHOT?
YOU HAVE TO TAKE THIS
PROFESSION SERIOUSLY!

HERE'S THE SAME SCOPE TAKEN OUT-OF-DOORS AND IN THE SHADE ON A SUNNY DAY, USING PLUS-X FILM AND A BRONICA AT ƒ5.6 AND SHOOTING FROM FIVE FEET. THE BACKGROUND IS TOTALLY OUT OF FOCUS.... CAUSING THE SCOPE TO "POP" OUT OF THE PICTURE. THIS SELECTIVE FOCUS TECHNIQUE IS VERY EFFECTIVE IN ALOT OF CASES WHEN SHOOTING PRODUCTS.
ALWAYS USE THE SLOWEST FILM WHEN YOU HAVE A CHOICE.... *AND A TRIPOD!*

THIS SHOT WAS TAKEN AT THE SAME DISTANCE, BLOWN-UP A LITTLE BIGGER TO SHOW MORE DETAIL AND A MUCH MORE FLATTERING ANGLE. SINCE I KNEW THAT ALL THE BACKGROUND WOULD WASH OUT BECAUSE OF THE OVER-EXPOSURE, I COUNTED ON THE DARKER SCOPE CREAT-ING A CONTRAST WITH THE BACKGROUND.
YOUR PRODUCT SHOTS HAVE TO HAVE CONTRAST WITH THE BACKGROUNDS...STUDY THE PRODUCT SHOTS IN YOUR CATALOGS AND TAKE NOTICE.

DON'T BLOW 'EM UP TOO BIG.... EVEN WITH PLUS-X YOU'LL GET GRAIN, AND CLIENTS DON'T LIKE GRAIN... *SEE NEXT PAGES....*

IN THE NEXT FEW PAGES ARE A SERIES OF BLOW-UPS OF A PRODUCT, USING PLUS-X 120 FILM AND A BRONICA 2¼ CAMERA!

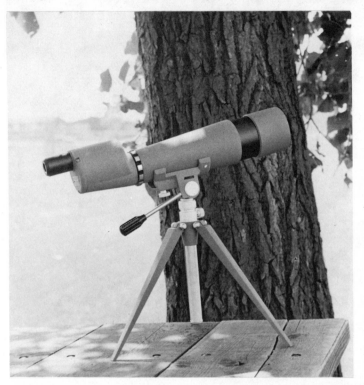

THIS SCOPE WAS SHOT AT A DISTANCE OF SIX FEET WITH THE CAMERA ON A TRIPOD. THE SHUTTER SPEED WAS 1/250 AND THE APERTURE WAS f5.6. THE DEVELOPER WAS D-76. THE TREE WAS USED FOR THE BACKGROUND BECAUSE IT WAS DARKER AND GAVE THE SCOPE MORE CONTRAST. THIS WAY THE SCOPE STANDS OUT CLEAR AND SHARP.

REMEMBER.....THE PROBLEM IN BIG BLOW-UPS IS GRAIN AND NOT SHARPNESS!

THE MIDDLE TONES SUFFER THE MOST IN BIG BLOW-UPS, BECAUSE OF GRAIN. THE GRAIN IS FROM THE FILM AND NOT THE ENLARGING PAPER.

HERE'S AN 8X10 BLOW-UP....

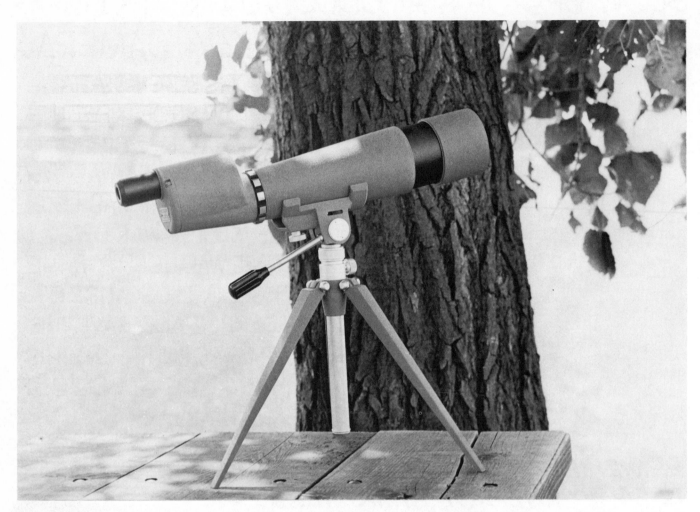

THIS 8X10 BLOW-UP IS THE BIGGEST I WOULD WANT TO GO AND RETAIN THE QUALITY THAT WOULD APPEAL TO THE BUYING PUBLIC. THE GRAIN IS NOT VISIBLE IN THIS PRINT. NOTICE AS THE IMAGE GETS LARGER, THE TREE BEGINS TO STAND OUT MORE AND CREATES MORE CONTRAST AGAINST THE SCOPE.

HERE'S AN 11 X 14 BLOW-UP........

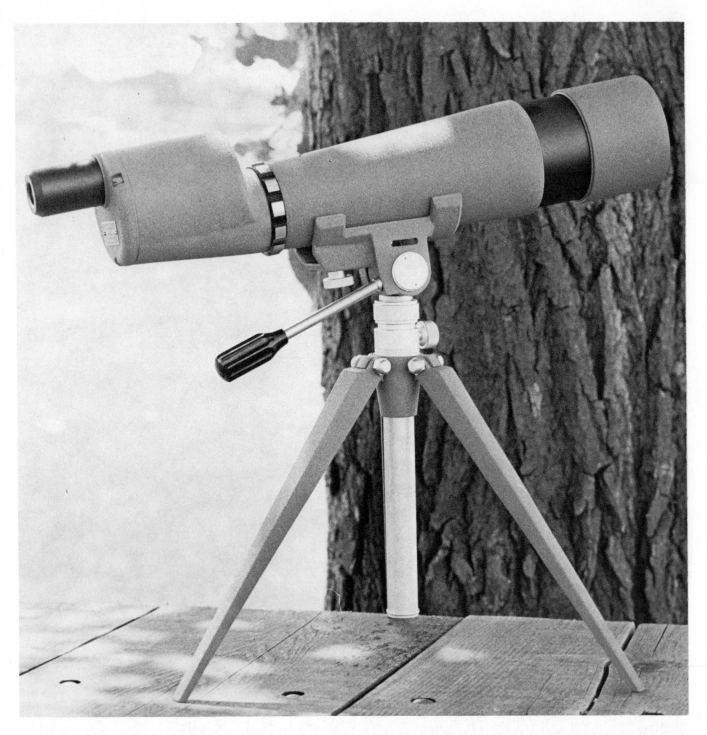

EVEN THOUGH THE SCOPE HAS A CRACKLE FINISH, THE GRAIN IS BEGINNING TO SHOW. YOU CAN SEE IT ON THE EYEPIECE. NOW THE SHARPNESS IS ALSO BEGINNING TO BREAK DOWN. IT JUST IS NOT WISE TO BLOW-UP YOUR PRODUCT SHOTS THIS BIG.

AND HERE'S THE 16X20 BLOW-UP!

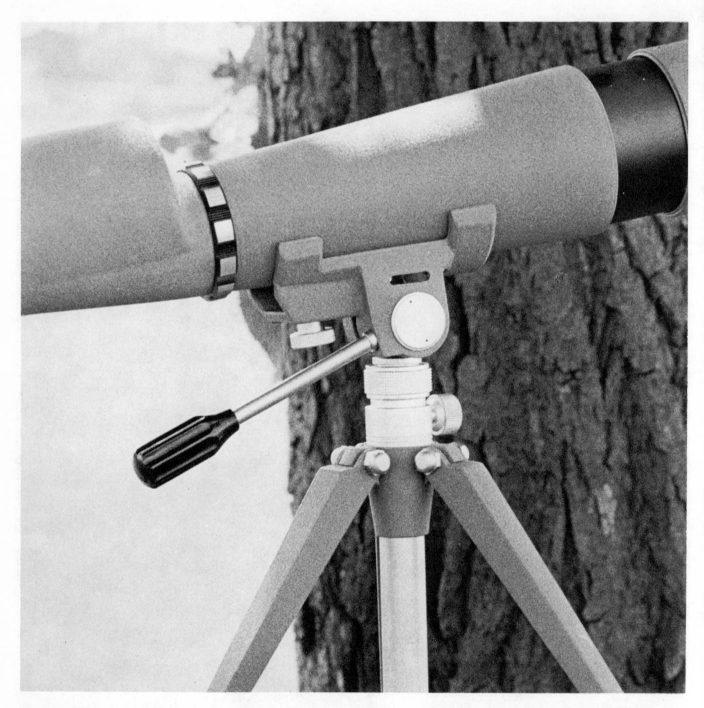

THIS BIG BLOW-UP WOULD NEVER SELL TO A CLIENT BECAUSE IT HAS TOO MUCH GRAIN AND SHARPNESS IS NOT TOO CRISP. IF THIS HAD BEEN A 4X5 OR 8X10 NEGATIVE IT WOULD HAVE BEEN A WORK OF BEAUTY!

KEEP YOUR PRINTS TO 8X10....

WHAT WENT WRONG?

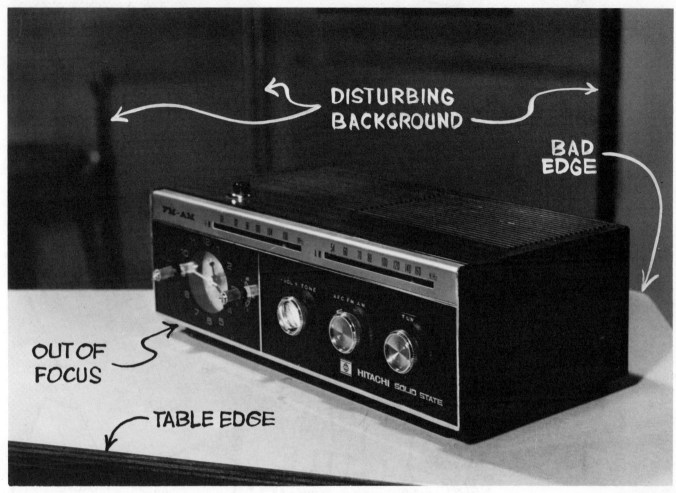

THERE IS DISTURBING BACKGROUND IN THIS PICTURE, BESIDES BEING OUT OF FOCUS IN PARTS. JUST PLACING A PRODUCT DOWN ANY OLD PLACE AND SHOOTING IT WITHOUT PLANNING IS FOOLISH!

NOTICE THAT HALF OF THE RADIO IS OUT OF FOCUS BEGINNING AT THE VOLUME-TONE KNOB! **SMALL f-STOP WAS NEEDED....**

REMEMBER SOME OF THE RULES:

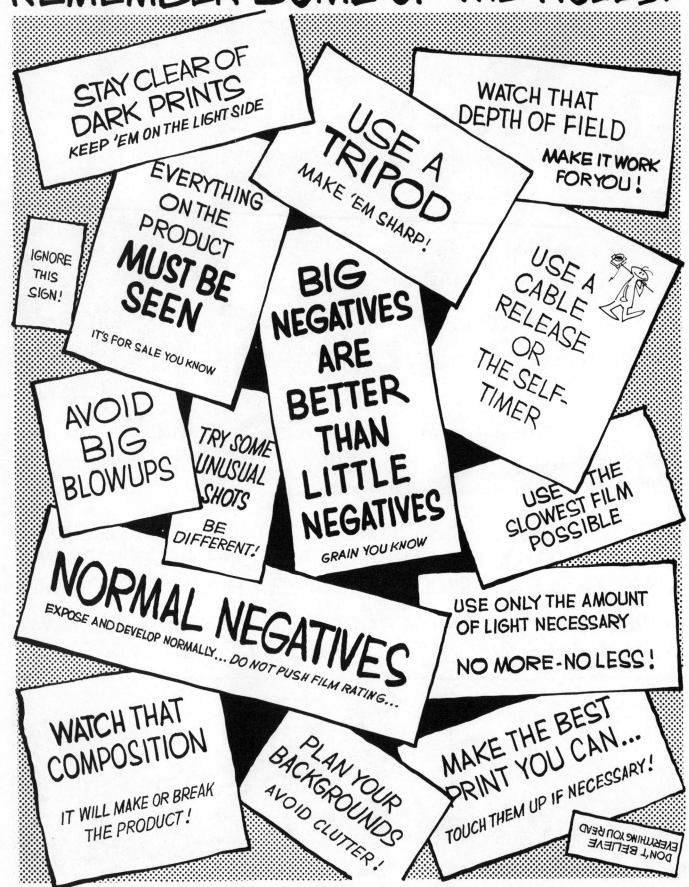

SMALL OBJECTS

SHOW HANDS. THAT'S A GOOD RULE, BUT NOT ALL THE TIME. HANDS SHOW THE COMPARATIVE SIZE OF THE PRODUCT, WHICH IN MANY CASES IS NECESSARY.

A BIG NEGATIVE IS ESSENTIAL BECAUSE OF DEPTH OF FIELD AND PRINT SIZE...PLUS GRAIN AND DEFINITION. REMEMBER...THE CLOSER YOU GET TO THE OBJECT FOR A BIGGER IMAGE ON THE NEGATIVE...THE LESS DEPTH OF FIELD YOU HAVE.

IF YOU PULL BACK TOO FAR FOR MORE DEPTH OF FIELD, THE MORE GRAIN YOU GET IN THE BIG BLOW-UPS. THIS IS A REAL PROBLEM, ESPECIALLY WITH 35mm.

AND REMEMBER, BIG BLOW-UPS HAVE GRAIN....AND CLIENTS DON'T LIKE GRAIN.

BOXES, CARTONS, CANS, PACKAGES, ETC., ETC.

SINCE THEY MUST BE IDENTIFIED WHEN PURCHASED BE SURE TO SHOW THREE SIDES...TOP AND BOTH SIDES... *AND SHARP!*

KEEP YOUR BACKGROUNDS SIMPLE.

BE SURE ALL THE LETTERING IS READABLE.

GIVE GOOD EVEN OVER-ALL ILLUMINATION.

ARCHITECTURE
EXTERIORS
PROPER PROPORTIONS ARE VERY IMPORTANT. STRAIGHT SHOTS ARE USUALLY WANTED. EXTREME WIDE-ANGLE LENSES ARE USED FOR NARROW STREET AND BIG BUILDINGS. DON'T FORGET, THE MOST IMPORTANT THING IS GOOD PERSPECTIVE.

INTERIORS
INSIDES OF ROOMS NEED TO LOOK LARGER, AND THE BEST WAY IS FROM A HIGH POSITION. YOU'LL NEED A HIGH TRIPOD.

CLOTHES

THE STYLE, OF COURSE, IS THE IMPORTANT THING..... ALONG WITH TEXTURE, SO USE A PLAIN BACKGROUND AND SHOW ALOT OF DETAIL.

THE BEST WAY TO SHOW TEXTURE AND DETAIL IS TO USE SIDE-LIGHTING. NOTICE HOW THE CRATERS OF THE MOON STAND OUT WHEN THE LIGHT IS COMING FROM THE SIDE? SAME AS CLOTHING!

NOW TURN TO THE SIDE!

MACHINES

MACHINES ARE DYNAMIC AND THE PHOTOGRAPH HAS TO CAPTURE THAT FEELING.

BE CAREFUL OF YOUR BACKGROUNDS AND USE ALOT OF LIGHT AND AVOID LARGE SHADOW AREAS. YOU'LL HAVE TO BE CAREFUL ABOUT GLARE FROM SHINY PARTS.

AND REMEMBER, IF THE PICTURE IS GOING TO BE PRINTED IN A CATALOG, YOU'LL HAVE TO SHOW ALL THE DETAIL ON THE MACHINE.

IF THE PICTURE IS GOING IN AN AD FOR A MAGAZINE, THEN IT MUST BE DRAMATIC. YOU'LL HAVE TO USE SPECIAL LIGHTING AND DO ALOT OF EXPERIMENTING.

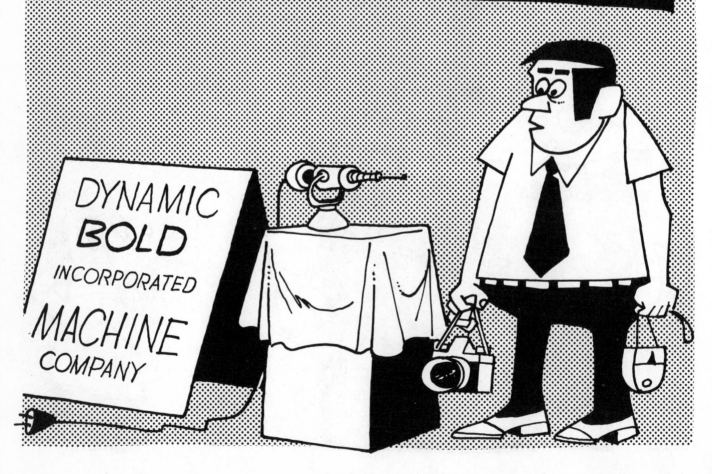

DYNAMIC
BOLD
INCORPORATED

MACHINE
COMPANY

GLASSWARE

.YOU HAVE TO BE REALLY CAREFUL WHEN LIGHTING BECAUSE OF ALL THE REFLECTIONS. TOO MANY REFLECTIONS **WILL CREATE CONFUSION!**

YOU WILL USUALLY DO BEST WITH DARKER OR BLACK BACK-GROUNDS, ALTHOUGH SOME VERY INTERESTING SHOTS CAN BE MADE WITH WHITE BACKGROUNDS.

IT'S PRETTY OBVIOUS THAT BACKGROUNDS SHOULD BE SIMPLE.

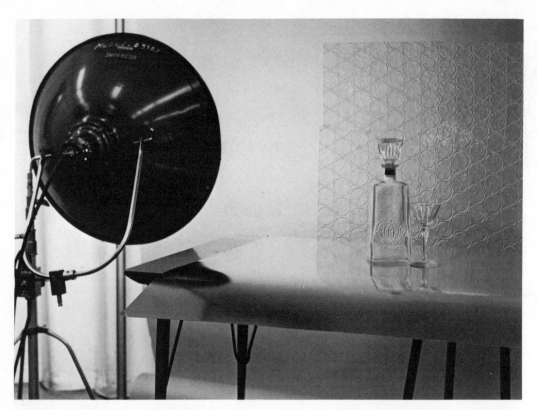

HERE IS THE DIFFUSED LIGHTING SET-UP... THE LIGHT, WITH A DIFFUSION FILTER, IS AIMED AGAINST THE PAPER BACKDROP AND BOUNCED THROUGH THE PIECE OF PLASTIC.

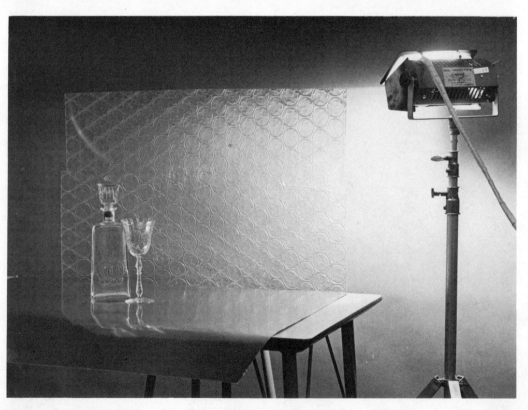

AND THIS IS THE QUARTZ DIRECT LIGHT. THIS TYPE OF LIGHT IS VERY BRIGHT, AND CREATES A HIGH CONTRAST SITUATION AND IS IDEAL FOR THIS SORT OF DIRECT LIGHTING.

THE MOST IMPORTANT THING IN SHOOTING ALL GLASSWARE IS *METERING!* I HAVE NEVER MET A PROFESSIONAL WHO DIDN'T *BRACKET!*

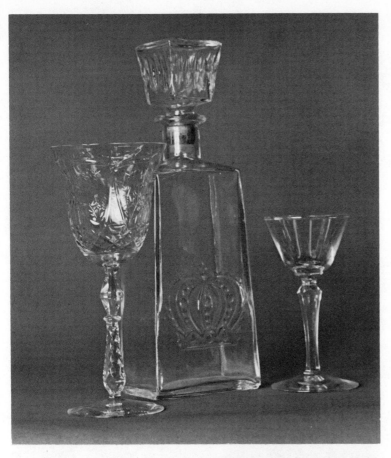

HERE IS AN EXAMPLE OF WHAT HAPPENS IF THE LIGHT IS POINTED DIRECTLY AT GLASS! THE FIRST THING YOU WILL NOTICE IS THAT THE BOTTLE AND GLASSES BECOME UNINTERESTING AND WITHOUT FORM. ALSO IT PRODUCES AN UN-STEADY GLASS OUTLINE.

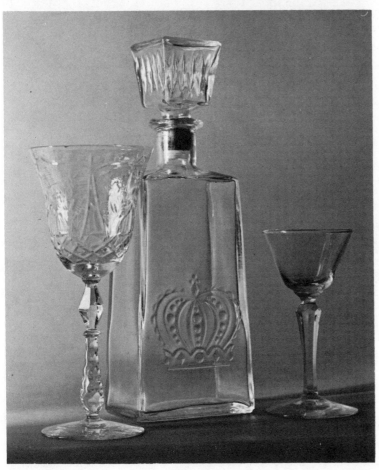

AND WHAT A DIFFERENCE USING A DIFFUSED LIGHT. BOTH OF THESE SHOTS ARE WITH ONLY ONE LIGHT. NOTICE THE EMBLEM ON THE BOTTLE IS NOW VERY CLEAR. THE WHOLE PICTURE HAS FORM. THE DIFFUSED LIGHT WAS BOUNCED OFF OF THE BACKGROUND IN BACK OF THE GLASS.

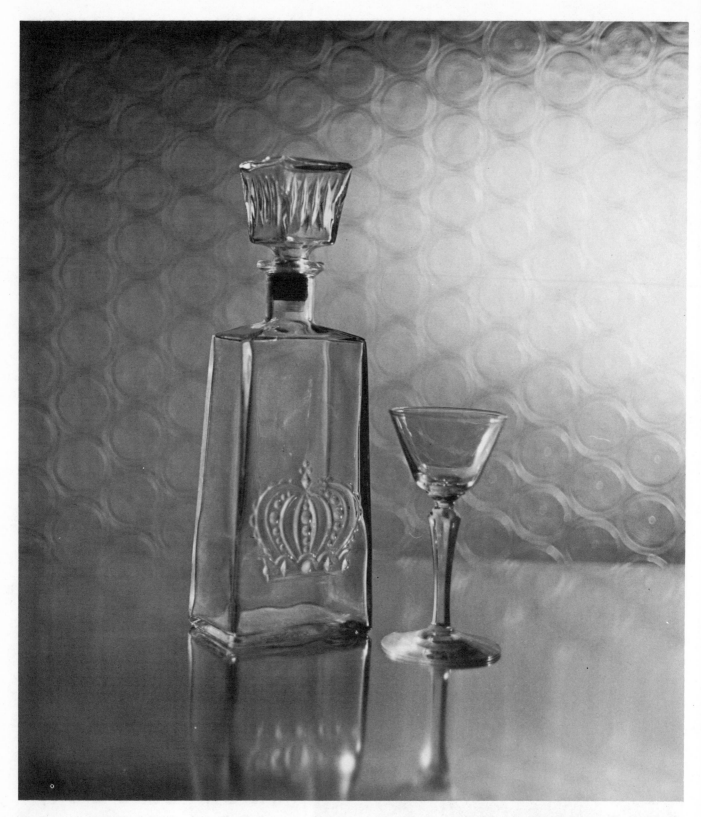

THE METER IS READ THROUGH THE BOTTLE TO THE BACKGROUND AND THEN OPENED UP TO ONE MORE STOP....OR YOU'RE IN TROUBLE!

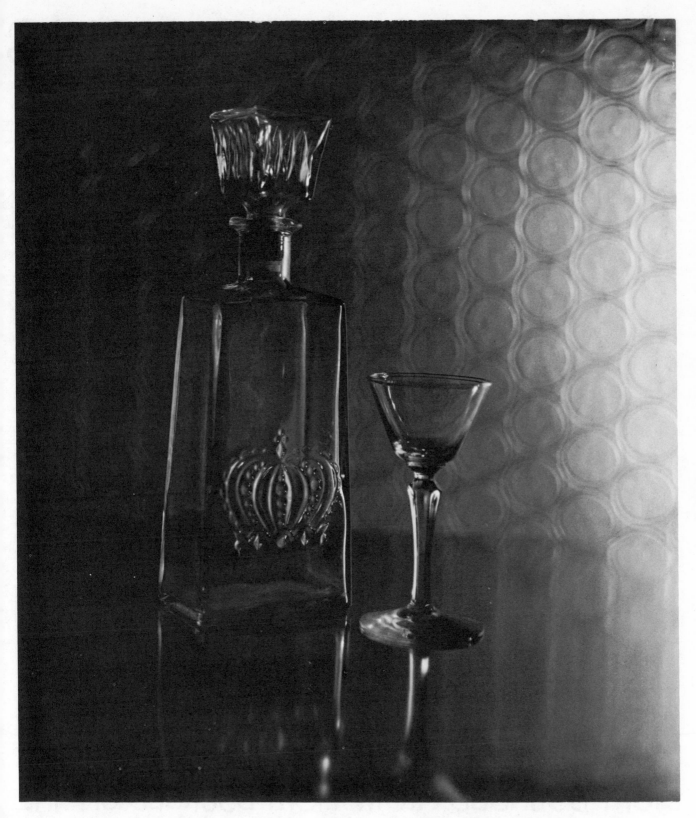

OK, SO YOU DIDN'T BELIEVE ME WHEN I
SAID TO OPEN UP ONE MORE STOP WHEN
SHOOTING GLASS OBJECTS! HERE I DIDN'T!

HOW ABOUT BOUNCING DIRECT LIGHT?

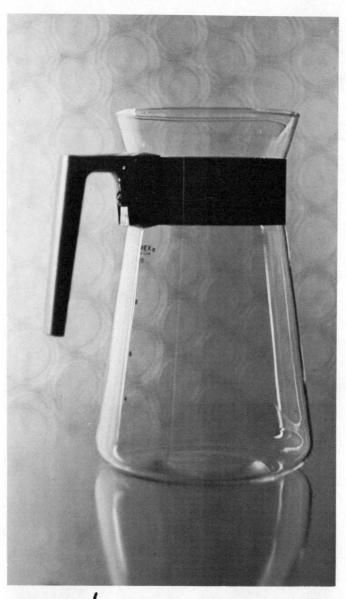

HERE'S ONE DIFFUSED LIGHT BOUNCED FROM THE BACKGROUND AND ONTO THE COFFEE POT! *NOTE THE SOFT LOOK?*

AND HERE'S ONE DIRECT LIGHT BOUNCED OFF THE BACKGROUND ONTO THE COFFEE POT! THESE TWO TECHNIQUES ARE GOOD!

HERE'S A SET-UP FOR SHOOTING GLASSWARE WE USE FOR OUR STUDENTS AT COLLEGE. A SHEET OF PLASTIC HELD UP WITH C-CLAMPS AND TWO ART EASELS. IT WORKS GREAT AND IS EASY TO ROLL UP WHEN THE STUDENTS ARE FINISHED.

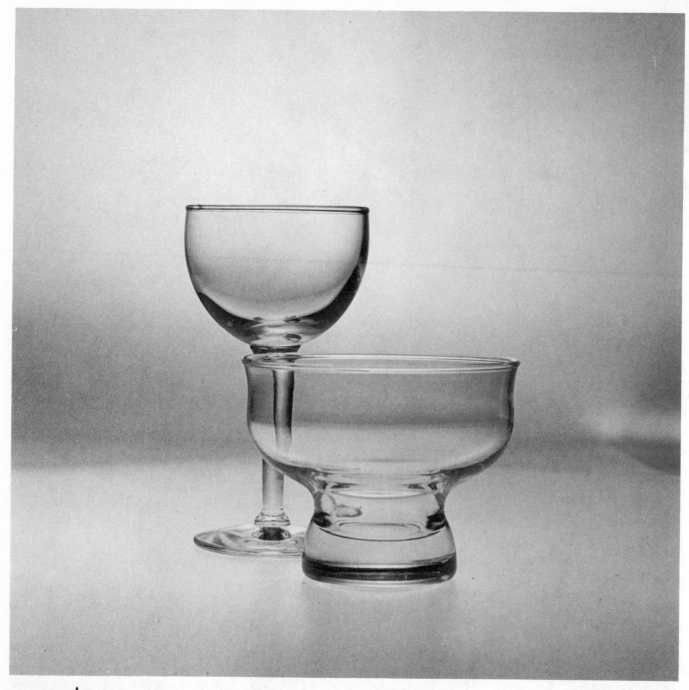

HERE'S A GLASSWARE SET-UP PHOTOGRAPHED WITH OUR
PLASTIC SHEET ON THE PRECEDING PAGE. AS YOU CAN
SEE, REAL CRYSTAL IS BEAUTIFUL. EXTREME CARE
MUST BE TAKEN WHEN FOCUSING, AND ALL ASA ON
FILM SHOULD BE HALVED. TRI-X SHOT AT AN E.I. OF
200, PLUS-X AT 60, AND PANATOMIC-X AT E.I. OF 15.

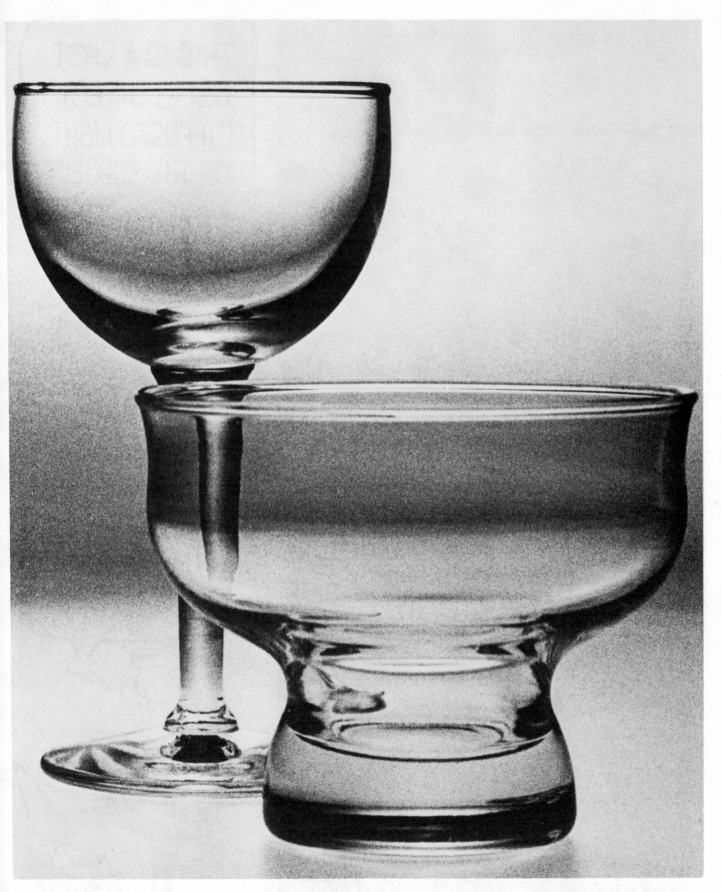

THE SAME SHOT ENLARGED TO 16X20 – AGFA 6 PAPER.

THIS IS A SHOT USING DIRECT DIFFUSED LIGHT ON THE SUBJECT

AND THIS SHOT IS THE DIFFUSED BOUNCE LIGHT!

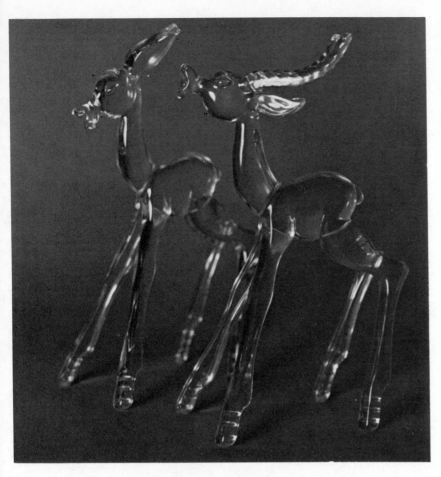

HERE IS DIRECT LIGHT BOUNCED FROM BACKGROUND

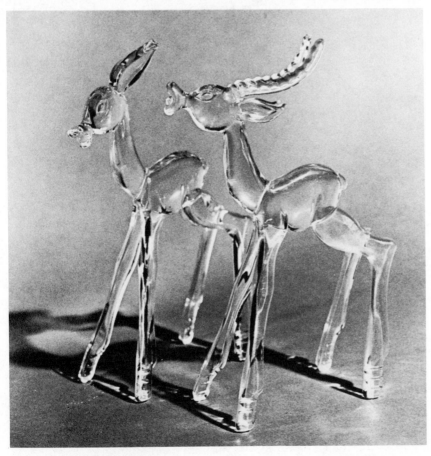

AND THIS IS A NO.6 PAPER!

JEWELRY

THE BIG PROBLEM HERE IS CALLED HALATION. IN OTHER WORDS, THE SPARKLE FROM THE JEWELRY CAN FOG FILM.

THIS WILL BE ONE OF THE MOST DIFFICULT PRODUCT SHOTS TO TAKE. YOU HAVE TO FOOL AROUND TO GET JUST ENOUGH BUT NOT TOO MUCH SPARKLE.

PLAIN BACKGROUND.

THIS TIME WE'LL TRY A **WRIST WATCH**.......

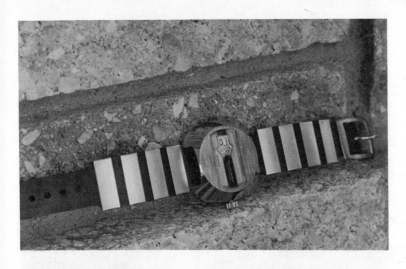

FIRST WE SHOT IT AGAINST A LEDGE ON A HOME. AS YOU CAN SEE, IT'S A LITTLE BUSY....THE WATCH BAND STANDS OUT THE BEST, BUT THE WATCH ITSELF DOESN'T DO MUCH.... IT WAS A GOOD TRY. IN COLOR IT REALLY WOULD HAVE WORKED, AS THE WATCH IS GOLD, BRICKS **GRAY!**

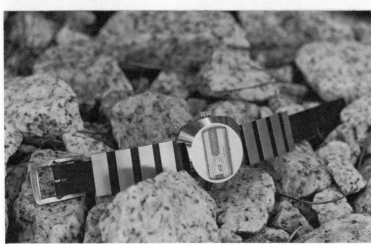

THIS IS A LITTLE BETTER BE-CAUSE **THE WATCH STANDS-OUT** MORE AGAINST THE BROKEN ROCKS... IN OTHER WORDS THERE IS MUCH MORE SEPARATION BETWEEN THE TWO.
SEE HOW IT POPS-OUT AT YOU. *THIS IS A 2¼ X 2¼ NEGATIVE.*

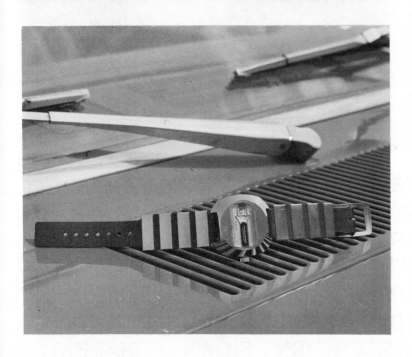

ON TOP OF A CAR IS ALSO VERY INTERESTING. I THINK THIS DOES MORE FOR THE WATCH THAN THE OTHER TWO SHOTS, SIMPLY BECAUSE THE BACKGROUND **LENDS** ITSELF MORE TO THE SUBJECT, AND THE GRILL BELOW THE WATCH MAKES A GOOD COMPOSITION. YOU SHOULD TRY ALL KINDS OF SITUATIONS WITH YOUR PRODUCTS. *BE ORIGINAL!*

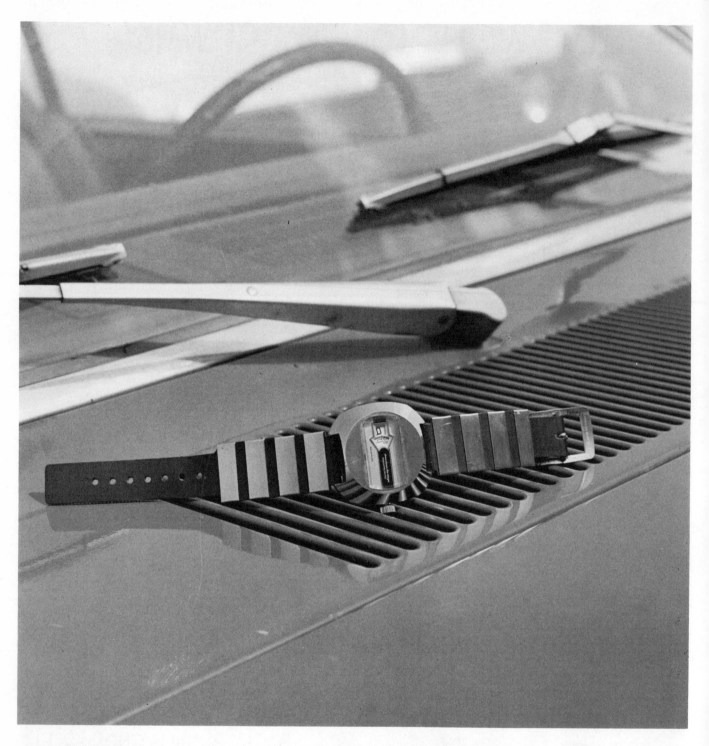

HERE'S THE 8X10 SHOT OF THE WATCH SITTING ON THE HOOD VENT OF AN AUTOMOBILE. NOTICE THE REFLECTION OF THE VENTS IN THE WATCH, AND HOW THAT ADDS FORM TO ITS SHAPE. ACTUALLY I HAD NO IDEA IT WOULD BE SO INTERESTING WHEN I SHOT IT. ALL THESE ARE THE SITUATIONS THAT HAPPEN WHEN YOU TRY UNUSUAL SETTINGS FOR YOUR PRODUCT SHOTS. I USED TRI-X FILM, BUT THE GRAIN DOES NOT SHOW BECAUSE THE 2¼ NEGATIVE ISN'T BLOWN-UP THAT BIG...

HERE'S AN INTERESTING SHOT FOR THE WATCH, AND THIS IS THE WAY IT WAS SET-UP. GLASS USED THIS WAY CAN HAVE SOME INTERESTING POSSIBILITIES FOR SMALL PRODUCTS SUCH AS RINGS, STICK PINS, EAR RINGS, PENS, ETC., ETC......YOU CAN ALSO TRY MANY KINDS OF BACKGROUNDS....YOU CAN EVEN STAND THE GLASS UP AND TAPE THE OBJECTS ON TO IT. *EVEN SCREEN DOORS WILL WORK!*

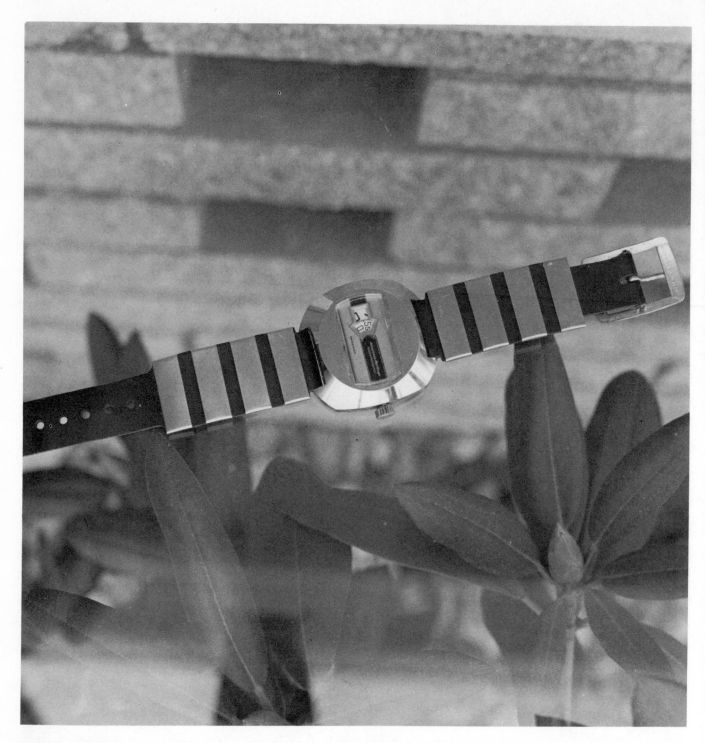

HERE'S THE 8X10 SHOT. SHOOTING UP CLOSE AT
f5.6 AND 1/250 OF A SECOND GAVE A SHALLOW
DEPTH OF FIELD...THROWING THE BACKGROUND
OUT OF FOCUS. IN COLOR IT WOULD BE A REALLY
FANTASTIC SHOT. *TRY IT...YOU'LL LIKE IT!!*

ONE LIGHT IS SOMETIMES VERY DRAMATIC FOR PRODUCT SHOTS

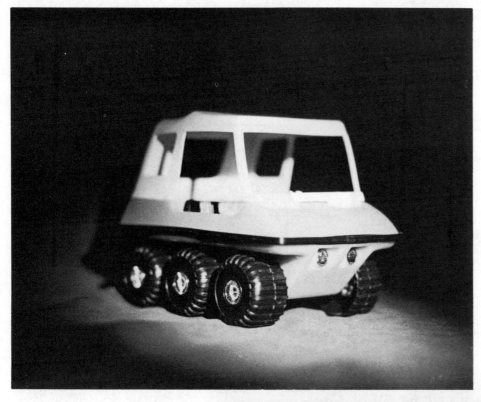

NOTICE HOW STARK AND DRAMATIC THIS TOY SHOT BECOMES BY THE USE OF ONE LIGHT SHINING DOWN FROM ABOVE. SOME PARTS ARE OVEREXPOSED AND WASHED-OUT, BUT IT DOESN'T BOTHER THE VIEWER BECAUSE IT CREATES A MOOD THAT SEEMS MORE REAL THAN A MORE ELABORATE SET-UP.

NOW, WITH MORE OF A PROFILE, THE CAR LOOKS EVEN BETTER.

YOU SEE, EVERYONE KNOWS IT'S A TOY, AND EVERYONE ALSO KNOWS HOW TOYS ARE BUILT.

TRYING TO MAKE THIS LITTLE CAR LOOK TOO MUCH LIKE A REAL CAR WOULD BE SILLY.

IT'S FALLACY FOR A PHOTOGRAPHER TO HAVE TOO MANY LIGHTS AROUND. THIS ONLY CREATES CONFUSION. IF YOU STUDY PRODUCT PHOTOGRAPHS, YOU WILL FIND, EXCEPT THOSE DELIBERATELY DRAMATIZED, THAT ONLY TWO LIGHTS WERE USED. ALL OTHER FLOODS AND SPOTS WERE USED TO OPEN UP SHADOWS OR SEPARATE TONES.

HERE ARE THE FACTS!

PHOTOGRAPHY IS HARD WORK......

DON'T THINK BECAUSE YOU HAVE AN EXPENSIVE CAMERA, A BATTERY OF LENSES, AUTOMATIC THIS AND THAT, AND A LAB TO DO YOUR DEVELOPING AND PRINTING THAT YOUR PROBLEMS ARE OVER.

IT'S MUCH MORE THAN AIMING AN AUTOMATIC CAMERA, PRESSING THE BUTTON AND YOUR PRINT IS DELIVERED. YOU MAY GO THROUGH A DOZEN ROLLS OF FILM, SPEND HOURS... AND EVEN DAYS OF SET-UPS, AND STILL NOT GET IT!

THE CAMERA ONLY *TAKES* PICTURES!

THE INDIVIDUAL PERSONALITY *MAKES* THEM!

MY PRIDE AND JOY!

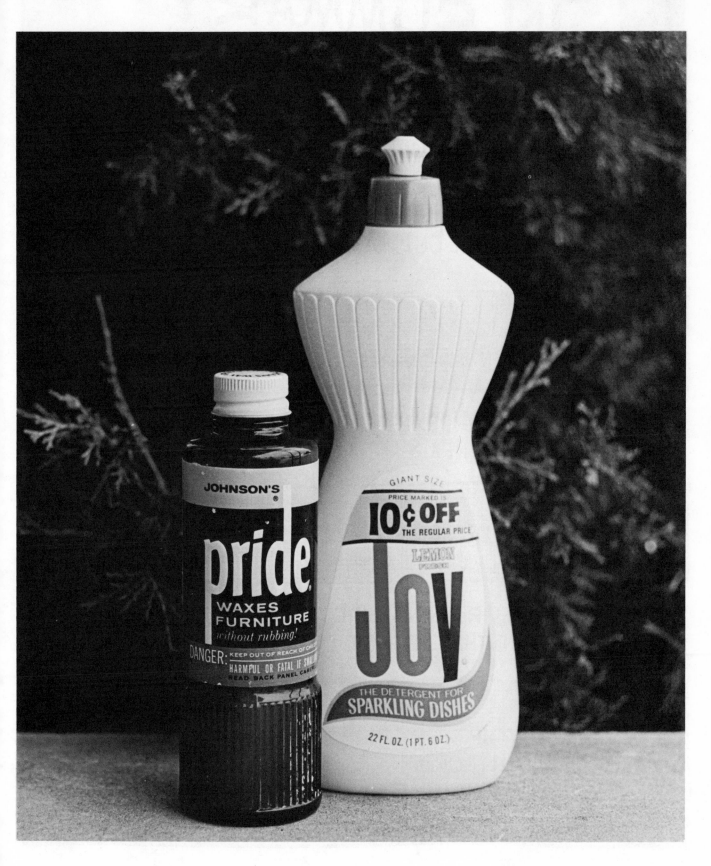

IN SUMMARY

DON'T PLACE THE OBJECT DEAD CENTER WITHOUT A REASON.

KEEP AWAY FROM THE OUTSIDE EDGES OF THE PICTURE AREA.

ARRANGE THE LIGHT AND SHADE SO THAT THE CONTRASTY PART OF THE PICTURE FALLS ON THE POINT OF INTEREST.

THE CLOSER TO THE CENTER OF THE PAPER THE LESS IT ATTRACTS THE EYE. NEARER THE EDGES...MORE ATTRACTION.

THE STRONGEST PULL ARE LINES INTERSECTING AT RIGHT ANGLES.

PARALLEL LINES RUNNING DIRECTLY ACROSS THE PICTURE WILL FORCE THE EYE RIGHT OFF THE PAPER.

DON'T CLUTTER-UP THE PICTURE AND FORCE THE EYE TO SEE MORE THAN IT ORDINARILY DOES. WIDE ANGLE LENSES ARE UNREAL. THE EYE HAS AN ANGLE OF ABOUT 50 DEGREES.

IF AN OBJECT DOESN'T LOOK INTERESTING FROM HEAD-ON TRY SHOOTING FROM VARIOUS ANGLES. EVEN ON TOP.

EVERYTHING IN THE PICTURE MUST BE IN HARMONY. PUTTING A TELEPHOTO LENS NEAR A RADIO IS RIDICULOUS. REALLY.

DO AWAY WITH ALL UNNECESSARY BACKGROUND CLUTTER.

THE MAIN OBJECT SHOULD BE BIGGER, MORE CONTRASTY, OR IN THE MAIN POSITION ON THE PAPER. OR ALL OF THEM.

DON'T LET AN UNINTERRUPTED LINE CUT THE PICTURE IN HALF.

THE PICTURE AREA SHOULD HAVE MASSES OF LIGHT AND DARK THAT ARE UNEQUAL. DON'T TRY TO BALANCE THEM.

GIVE LOTS OF SPACE AROUND YOUR PEOPLE SHOTS.

THE EYE WILL FOLLOW LIGHT. IT WILL TEND TO SEE THE DARKER AREAS FIRST. *WHITE ON BLACK ATTRACTS.*

KEEP THE SKYLINE AWAY FROM THE PICTURE CENTER.

GREAT MOMENTS IN PHOTOGRAPHY

THE FIRST PAY CHECK

introduction to FASHION

I'D LIKE TO TOUCH FOR A MOMENT ON FASHION!

FASHION PHOTOGRAPHY IS GROWING AT SUCH A RAPID RATE THAT IT'S DIFFICULT TO KEEP UP WITH THE QUALIFICATIONS THAT ARE REQUIRED!

SINCE WE ARE ESSENTIALLY SELLING A PRODUCT, WE FIND OURSELVES BACK WITH THE ART DIRECTOR WHO IS WORKING THROUGH CLIENTS AND AN AGENCY. OF ALL THE TYPES OF PHOTOGRAPHERS, THESE ARE A DIFFERENT BREED. MOST OF THEM, INCLUDING WOMEN, ARE IN THEIR LATE TWENTIES AND IN CONTACT WITH YOUNG PEOPLE — THEY KNOW HOW THEY THINK WHEN IT COMES TO CLOTHES, AND HOW THE YOUNG PEOPLE WANT TO **DRESS!**
THE FASHION PHOTOGRAPHER HAS TO UNDERSTAND CLOTHING TEXTURES AND BE ABLE TO CREATE MOODS THAT BRING THEM OUT. HE MUST KNOW HIS COMPOSITION AND UNDERSTAND HIS LIGHTING — AND EACH PICTURE HE TAKES HAS TO HAVE A NEW QUALITY ABOUT IT — SOMETHING THAT GIVES IT ORIGINALITY.
BEING A PHOTO TECHNICIAN IS THE **LEAST** IMPORTANT PART OF THE JOB. THE MOST IMPORTANT PART OF THE JOB IS TO FLATTER THE MODEL AND FLATTER THE CLOTHING. THE MODELS ARE YOUNGER AND SEXIER, BOTH MEN AND WOMEN, AND ARE GETTING HARDER TO COME-BY. UNLIKE THE HARD PRODUCT LINES, FASHION CAN BE COVERED WELL BY THE SMALL CAMERAS, SUCH AS THE 2¼ AND 35mm TYPES. THE SMALL CAMERAS ALLOW THE MODELS TO BE MORE NATURAL AND MOVE ABOUT MORE GRACEFULLY. THERE ARE STILL MANY FASHION PHOTOGRAPHERS USING 4X5 AND LARGER VIEW CAMERAS FOR THE PURPOSE OF SHOWING FINE DETAIL — OR FOR THE CLOTHING ACCESSORIES, OR EVEN FOR MORE ELABORATE SET-UPS IN THE STUDIO. FOR SMALL CAMERAS, TRIPODS ARE NEVER USED AND FILL-IN FLASH IS VERY COMMON. EVERYTHING THE PHOTOGRAPHER AND THE MODEL DO IS FOR CREATING MOOD! LET'S FACE IT — THESE FASHION PHOTOGRAPHS ARE NOT HAND-OUTS. THEY ARE FOR REPRODUCTION IN

PUBLICATIONS - AND EACH PICTURE HIGHLIGHTS SOME TEXTURE, OR A LINE, OR PATTERN IN A GARMENT.

AND REMEMBER -

THE TYPE OF STOCK TO BE USED IN PRINTING WILL DETERMINE THE WAY THE PICTURE IS TO BE SHOT AND PRINTED.

MOST FASHION MAGAZINES ARE PRINTED ON "COATED" PAPER, WHICH MEANS YOU CAN SHOOT FOR A LONG TONAL SCALE AND RETAIN UP TO 85% OF THE ORIGINAL PRINT QUALITY - OF COURSE THERE IS STILL SOME DETAIL THAT WILL BE LOST IN REPRODUCTION. IN THE CASE OF NEWSPAPERS, WHICH ARE A SPECIAL CONCERN BECAUSE THEY FLATTEN-OUT THE TONES, MORE SEPARATION IS NECESSARY AND DEFINITE BLACKS MUST BE PRESENT. ONE OTHER IMPORTANT THING TO REMEMBER IS THAT FLESH SHOULD BE SLIGHTLY OVER-EXPOSED.

LEMME TELL `YA A GOOD PLACE FOR INFORMATION ON FASHION!

A GOOD SOURCE OF *SHORT* AND RIGHT TO THE POINT COMPREHENSIVE INFORMATION ON FASHION PHOTOGRAPHY CAN BE FOUND IN THE *ENCYCLOPEDIA OF PHOTOGRAPHY* - PUBLISHED BY THE GREYSTONE PRESS - VOLUME 8, PAGES 1411 TO 1430!

THE TRULY GREAT FASHION PHOTOGRAPHER IS MORE AWARE OF HOW THINGS LOOK - AND NOT HOW HE WANTS THEM TO LOOK!

HEY, MAN, TAKE A PICTURE OF ME!

ABOVE ALL, KEEP YOUR LIGHTING SIMPLE AND STUDY THE PHOTOS OF OTHER FASHION PHOTOGRAPHERS IN FASHION MAGAZINES TO SEE HOW THEY WORK - TRY TO FIGURE IT OUT! WE ALL LEARN BY DOING - NOT BY READING BOOKS ON FANCY LIGHTING AND VERY EXPENSIVE EQUIPMENT.

I'VE SEEN SCORES OF BAD PHOTOS TAKEN WITH EXPENSIVE CAMERAS!

HOW DID FASHION ADS BEGIN?

IN THE 19th CENTURY, DURING THAT ERA OF THE *DAGUERREOTYPE, PRINTS COULD NOT BE MADE OR REPRODUCED IN NEWSPAPERS......NOT ONLY THAT...THE DAGUERREOTYPE PRODUCED AN IMAGE THAT WAS **REVERSED!** SO IN THOSE DAYS THE ONLY THING LEFT WAS THE WOODCUT FOR FASHION ADS. THE WOODCUTS WERE LINE DRAWINGS CARVED IN WOOD. COLOR COULD ALSO BE ADDED!

THE PHOTOGRAPHER IN FASHION ADS IS RESTRICTED TO BRINGING OUT CERTAIN THINGS IN THE PHOTOS, SUCH AS A COLLAR, THE HANG OF SLACKS, HOW THE GARMENT FITS, THE FABRIC, ETC, ... AND HE MUST CONFORM TO THE ART DIRECTOR'S AD LAYOUT!

✱ A DAGUERREOTYPE IS A WHITISH SILVER IMAGE ON A POLISHED SILVER PLATE.

WHERE YOU SHOOT THE PICTURE IS IMPORTANT!

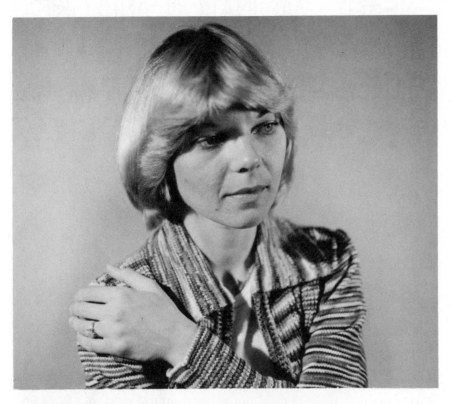

A TYPICAL PICTURE OF A SWEATER FASHION SET-UP IN A STUDIO. EILEEN, A STUDENT IN THIS SHOT HAS A GOOD FACE FOR FASHION. THE HAND WAS ADDED TO ADD INTEREST AND CONTRAST. THE PICTURE COULD EASILY BE IMPROVED.

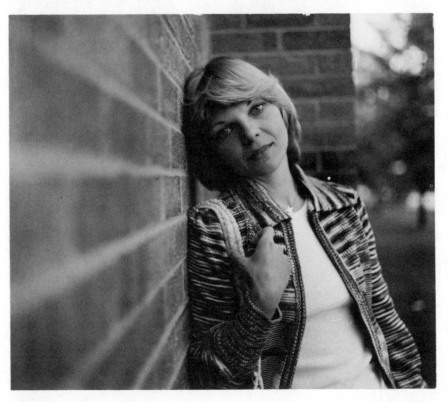

TAKE THE MODEL OUTSIDE ON AN OVERCAST DAY OR IN THE SHADE. TO DRAW ATTENTION EVEN MORE I PUT HER NEAR A BUILDING AND PUT THE CAMERA NEAR ALSO. NOTICE HOW THE OUT-OF-FOCUS BRICKS DRAW THE EYE TOWARD HER.

IN A SENSE, THE FASHION PHOTOGRAPHER MUST MAKE EVEN A BURLAP SACK DRESS DELIGHTFUL TO WOMEN SO THEY WILL ALL WANT TO RUSH OUT AND BUY ONE. TO DO THIS MEANS ENERGY, IMAGINATION, AND GREAT TECHNICAL PROFICIENCY. BESIDES ALL THIS AN INTUITIVE FEELING FOR FASHION. IN OTHER WORDS, YOU MUST KNOW HOW MEN AND WOMEN WANT TO DRESS.

SIMPLE THINGS ARE THE MOST IMPORTANT IN FASHION. A BEAUTIFUL GIRL IN A LOVELY DRESS.... BUT JUST SITTING..?

LOOK AT THE DIFFERENCE CREATED BY A LITTLE MOVEMENT IN HER POSITION. IT EVEN MAKES THE DRESS COME ALIVE.

ON THIS YOU CAN DEPEND:

PHOTOGRAPHIC TECHNICIANS LACKING IN IMAGINATION DO NOT ENJOY LONG CAREERS IN FASHION. MOST OF ALL THE FASHION PHOTOGRAPHERS COME INTO THE FIELD FROM ART AND DESIGN SCHOOLS. A FEW FROM DARKROOMS & STUDIOS! REMEMBER→ *FASHION DOES NOT NEED PEOPLE WHO ARE HARD TO GET ALONG WITH. THIS WHOLE FIELD IS THE RESULT OF TEAM WORK FROM ART DIRECTORS, DESIGNERS, AND MODELS. AND IT WILL ALWAYS BE!*

THIS IS A DEAD FASHION SHOT, AND VERY UNCREATIVE. JUST STAND HER AGAINST SOMETHING AND SHOOT.... THERE IS NO THOUGHT HERE. *DRESS LOOKS DULL.*

BETTER SHE COME IN THE STUDIO WITH A PLAIN BACKGROUND TO MAKE THE DRESS APPEAR SIMPLE, BUT WITH GOOD TASTE! *STUDY THE POSES IN FASHION MAGS!*

FASHION BACKGROUNDS

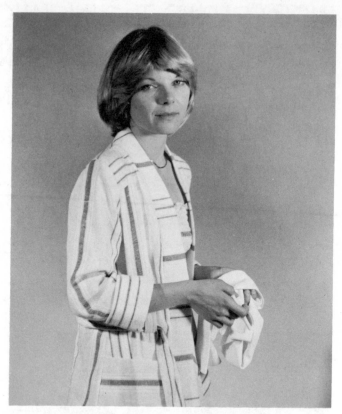

BUSY BACKGROUND PLAIN BACKGROUND

PLAIN BACKGROUNDS DO A LOT WHEN YOU WANT
TO ACCENT THE CUT OF THE MATERIAL. ALSO..
THE PLAIN BACKGROUNDS ARE FOR MODELS
WHO PROJECT WELL. FOR THOSE WHOSE PER-
SONALITIES DO NOT, THE BUSY OR OUT-OF-
FOCUS BACKGROUNDS ARE NEEDED. IT'S UP TO
YOU AS THE PHOTOGRAPHER TO DECIDE!
USE THIS RULE→ WHEN THE FABRIC DESIGN IS
IMPORTANT THE SIMPLE BACKGROUND WILL
BE THE BEST!

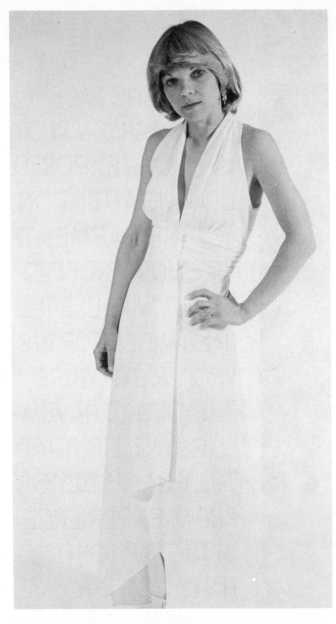

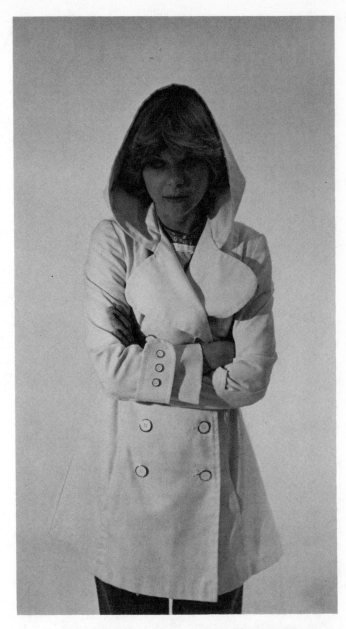

USE HIGH KEY LIGHTING FOR CLOTHES THAT ARE LIGHT-TONED, SUCH AS RAIN COATS, SUMMER DRESSES, DAYTIME WEAR, WEDDING GOWNS, ETC., ETC., LIKE THIS!

IF YOU IGNORE THIS IMPORTANT RULE YOU WILL GET SOMETHING LIKE THIS. TOO MUCH CONTRAST WILL KILL THE FINE LOOK OF LIGHT-TONED CLOTHING!

THE FASHION PHOTOGRAPHER IS HIGHLY PAID, PROBABLY THE BEST OF ANY PHOTO FIELD. A LOT OF TRAVELING, LOOKING FOR NEW BACK-GROUNDS, AND RECOGNITION FOR HIS OR HER WORK IN THE FORM OF A CREDIT LINE ALONG SIDE OF THE PRINTED PHOTOGRAPH!

METER READINGS

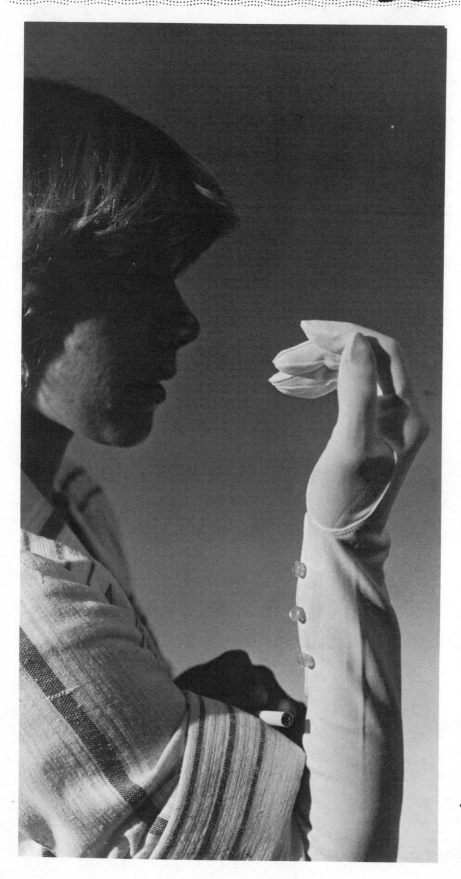

NOTICE THE FACE IN THIS FASHION SHOT IS UNDEREXPOSED, DRAWING ATTENTION TO THE GARMENT! LIKE MOST PROFESSIONALS WHO USE THE HAND METER FOR THE PROPER EXPOSURE, THEY ALSO HAVE A "LIGHT SENSE" THAT THEY CAN RELY ON FROM EXPERIENCE IN THE FASHION FIELD. IT'S CALLED "PERSONAL JUDGEMENT."

SOMETIMES THE EFFECT FAR OUTWEIGHS THE LOSS OF SHADOW DETAIL... IN THIS CASE, THE FACE HAS LOST THE DETAIL, BUT THE PICTURE IS WORTH IT.

...... AND EXPERIMENT........

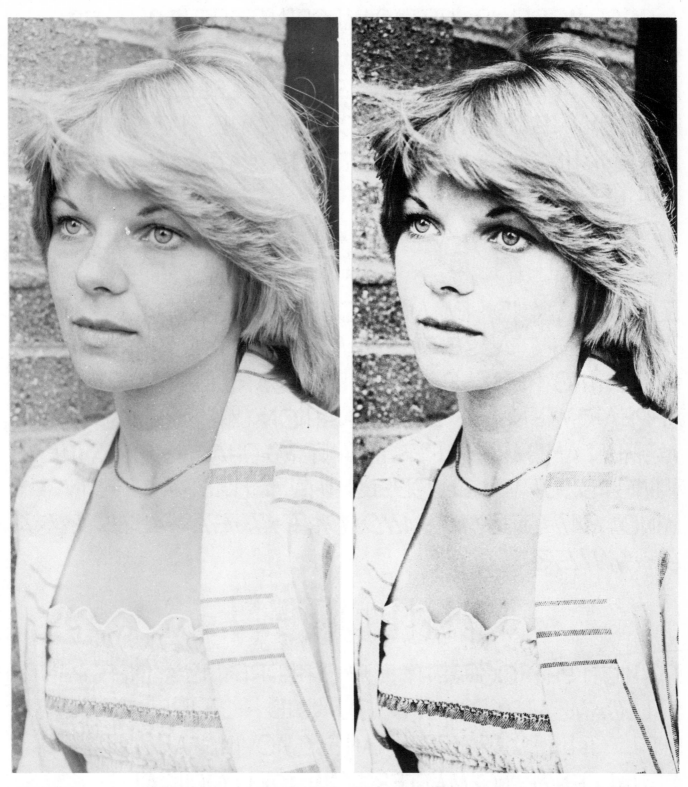

FIRST... A STRAIGHT SHOT ON THEN THE SAME NEGATIVE
PLUS-X FILM AND PRINTED. PRINTED ON AN AGFA 6 PAPER.

THE MODEL

A GOOD MODEL IS JUST AS IMPORTANT AS THE CLOTHES SHE IS WEARING. SHE CAN MAKE OR BREAK YOUR PICTURE. AS A GENERAL RULE, THE MODELS ARE SELECTED BEFOREHAND BY THE MAGAZINE, OR CLIENT. THE PHOTOGRAPHER HAS NOTHING TO SAY ABOUT IT. BUT THAT'S A PART OF THE BUSINESS.

TYPES OF MODELS

BOTH MALE AND FEMALE MODELS ARE USUALLY ON THE THIN SIDE BECAUSE THE CAMERA LENS HAS A WAY OF FATTENING PEOPLE......AND REGARDLESS HOW IT MAY APPEAR, MEN ARE LESS FASHION CONSCIOUS THAN WOMEN AND MORE RESISTANT TO CHANGE. ANOTHER THING ABOUT MALE MODELS THAT MUST BE KEPT IN MIND: *RATHER THAN HANDSOME, THEIR FACES MUST BE "INTERESTING!"*

CHILDREN

FASHION PHOTOGRAPHY FOR CHILDREN IS A DIFFERENT BALLGAME. TRY FOR A GOOD "KID PICTURE". SINCE THE LITTLE THINGS ARE CONSTANTLY MOVING ABOUT, IT IS A CHALLENGE NO MATTER HOW YOU LOOK AT IT.

NOTE: IT'S NOT HOW MANY LIGHTS YOU USE, BUT WHERE YOU PUT THEM.

NOTE ON COLOR FOR FASHION........

THE THREE COLORS REPRESENTED IN COLOR FILM FAITHFULLY REPRODUCE ANY COMBINATION OF COLORS, NO MATTER HOW MANY. AND IN THE FINAL PRINTING PROCESS, BLACK IS ADDED TO BRING THE FINAL PRODUCT CLOSER TO REALITY......BUT MOST COLOR PRINTS ARE FAR FROM THE TRUTH IN COLOR, BECAUSE A FINISHED COLOR PRINT CANNOT PRODUCE THE LUMINOSITY IN A COLOR TRANSPARENCY.

WHEN LIGHTING FOR COLOR FASHION SHOTS, THE LIGHTING IS MORE CAREFULLY PLANNED, EVEN MORE SO IN PORTRAITS. FOR ONE THING, PROPS IN THE BACKGROUNDS THAT LOOK GOOD IN BLACK AND WHITE CAN LOOK PHONEY IN COLOR. THE RULE: COLOR NEEDS 4 OR 5 TIMES MORE LIGHT THAN B&W.

MY ADVICE: GET A BUNCH OF FASHION MAGAZINES AND STUDY HOW THE PHOTOS WERE MADE. STUDY THE LIGHTING, THE POSES, THE BACKGROUNDS, HOW THE CLOTHES HANG. STUDY THE NEWSPAPERS TOO. NOTICE THERE ARE MORE BLACK AND WHITE SHOTS THAN COLOR. THESE MAGAZINES WILL HELP YOU CREATE!.. AND ATTEND FASHION SHOWS!

ELECTRONIC FLASH

I DON'T INTEND GOING INTO TECHNICAL JARGON ABOUT ELECTRONIC FLASH BECAUSE THERE ARE VOLUMES OF INFORMATION AVAILABLE. INSTEAD, LET'S TOUCH A BIT ON THE PRACTICAL SIDE — AND WE'LL TRY MAKING IT EASY TO UNDERSTAND.....

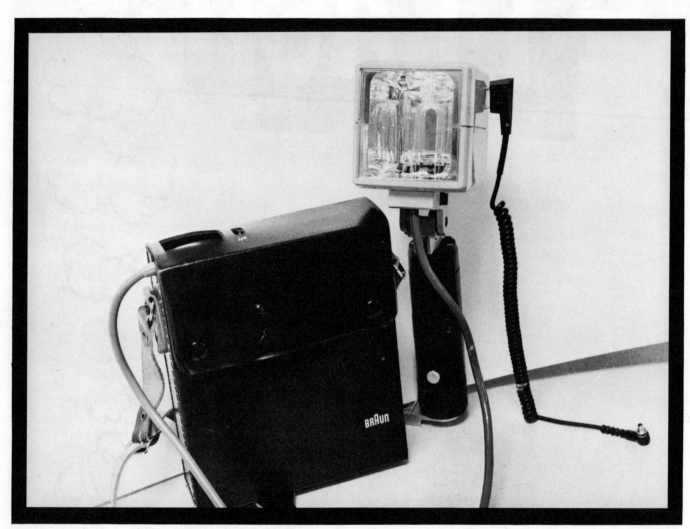

THE STANDARD PARTS TO AN ELECTRONIC UNIT, SUCH AS THE ONE ABOVE, ARE THE POWER SUPPLY, THE CAPACITOR, THE TRIGGERING CIRCUIT— AND THE FLASH TUBE. IN THIS CASE, ALSO WITH A REFLECTOR. THE POWER PACK IN THIS UNIT IS PACKED ALONG WITH THE CAPACITOR, AND THE TRIGGERING CIRCUIT AND FLASH TUBE ARE ALSO ONE UNIT. IT TAKES ANYWHERE FROM 250 TO 2000 VOLTS TO CHARGE THE CAPACITOR!

A SMALL, OR MINIATURE ELECTRONIC FLASH UNIT LIKE THIS ONE IS USED BY MORE PHOTOGRAPHERS...OR SHOULD I SAY "PEOPLE", THAN ANY OTHER SINGLE UNIT. THE PRICES RANGE AS LOW AS $9.95. THESE COMPACT UNITS CONTAIN EVERYTHING IN A SINGLE HOLDER, INCLUDING THE POWER SUPPLY, THE FLASH TUBE, AND THE CAPACITOR.

MOST INSTRUCTION MANUALS ON THESE UNITS TELL YOU TO LET THE TUBE CHARGE UP AGAIN BEFORE SHUTTING IT OFF! EXPENSIVE ONES WILL WORK OFF A WALL SOCKET AND ALSO OFF BATTERIES. THEY ARE ALSO AUTOMATIC AS WELL AS MANUALLY OPERATED. *DON'T BE WITHOUT ONE!*

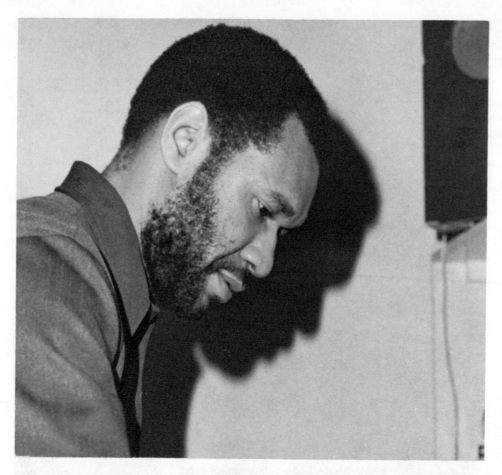

BEGINNERS TAKE FLASH PICTURES LIKE THIS, WITH BLACK SHADOWS, CAUSED BY THE BRIGHT FLASH! BEGINNERS ARE BEGINNERS BECAUSE THEY DON'T THINK BEFORE THEY TRIP THE SHUTTER! MR. WATTS IS TOO CLOSE TO THE WALL—*THAT'S WHY!*

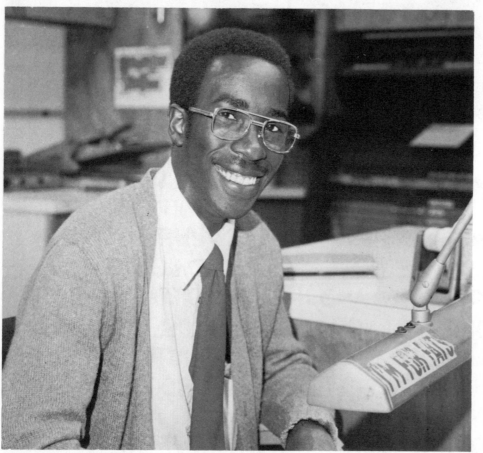

AND *PRESTO*— THE SHADOW IS GONE!

OF COURSE IT IS!

THE WALL IS TOO FAR BACK FOR DONNIE CRUTCHER TO CAST A SHADOW, MAKING FOR A PROFESSIONAL LOOK TO THE PICTURE. *TRY IT!*

THE SECRET OF FILL-IN FLASH....

PROFESSIONALS USE FILL-IN FLASH WHEN SHOOTING OUTSIDE IN SUNLIGHT TO *FILL-IN* THE SHADOWS AND SOFTEN THE CONTRAST ON THE FACE — IT IS ESPECIALLY USEFUL IN COLOR PHOTOGRAPHY BECAUSE COLOR FILM HAS A LIMITED CONTRAST RANGE.

HERE'S HOW IT'S DONE → TAKE A METER READING FOR YOUR SUBJECT FOR A PROPER EXPOSURE FIRST. (KEEPING IN MIND THAT A LIMITED NUMBER OF SHUTTER SPEEDS FOR ELECTRONIC FLASH ARE AVAILABLE ON A 35mm SLR CAMERA ... *COMPUR, OR LEAF SHUTTERS WORK AT ALL SPEEDS WITH ELECTRONIC FLASH*)

NEXT, DIVIDE THE FLASH GUIDE NUMBER FOR YOUR FILM BY THE f STOP YOU SET! THIS WILL GIVE YOU THE FLASH TO SUBJECT DISTANCE.

NOTE: PUT AUTOMATIC FLASH UNITS ON MANUAL (M).

LOOK WHAT HAPPENS

HERE'S THE DOUBLE IMAGE PRODUCED BY A FOCAL PLANE SHUTTER. THE 60th OF A SECOND SYNC SPEED FOR ELECTRONIC FLASH WAS TOO SLOW A SHUTTER SPEED FOR SUNLIGHT... IF YOU DON'T BELIEVE IT, TRY IT YOURSELF!

HERE ARE SOME GOOD EXAMPLES OF FILL-IN FLASH AT WEDDING!

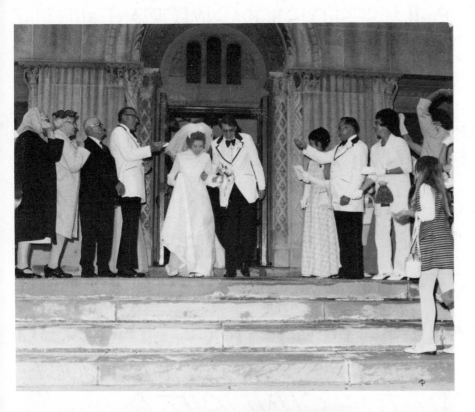

A PRO PHOTOGRAPHER FRIEND OF MINE, GEORGE JENKINS, HAS BEEN SHOOTING WEDDINGS FOR OVER 15 YEARS AND USING THE HASSELBLAD CAMERA AND ELECTRONIC FLASH. GEORGE HAS HIS OWN SYSTEM.

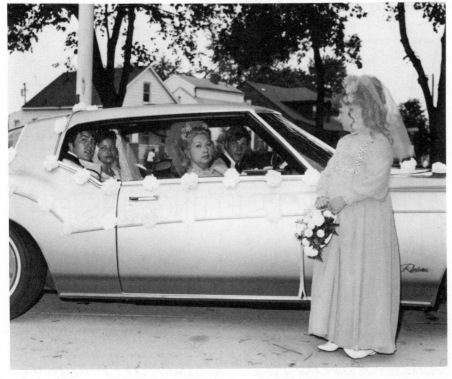

HE DOES NOT WORRY ABOUT GUIDE NUMBERS. BY JUST BACKING AWAY SO HE IS NOT TOO CLOSE AND SHOOTING AT THE OUTDOOR SETTING OF f11 at 125 FOR HIS FILM RATING, HE JUST FIRES HIS FLASH ... AND THEY ARE BEAUTIFUL

HERE'S THE SECRET OF FILL-IN-FLASH...

IT IS IMPORTANT TO UNDERSTAND THAT THE AMOUNT OF FILL-IN-FLASH DEPENDS ON HOW MUCH LIGHT IS ALREADY FALLING ON THE SUBJECT. THIS MEANS THE FILM SPEED IS NOT AS IMPORTANT, AND THAT FOR ANY GIVEN SITUATION, THE FLASH TO SUBJECT DISTANCE IS THE SAME FOR ANY FILM... *AND USE A COMPUR SHUTTER!*

FIRST RULE

SET THE LENS OPENING FOR SUNLIGHT FOR THE FILM BEING USED, BECAUSE THE FLASH MUST NOT BE STRONGER THAN THE SUN-LIGHT.....OTHERWISE THE EFFECT IS LOST. *REMEMBER→THE FLASH MUST PRODUCE LESS LIGHT THAN THE SUNLIGHT!*

WHAT TO DO.....

MOVE THE FLASH BACK TO TWICE THE DISTANCE. THIS WILL GIVE YOU A FOUR TO ONE RATIO...... DO NOT USE THE AUTOMATIC SETTING..INSTEAD, USE THE GUIDE NUMBERS.

OTHER METHODS→ USE YOUR FLASH AT HALF POWER OR PUT A WHITE HANDKERCHIEF OVER THE FLASH.
YOU COULD EVEN USE ONE OR TWO KLEENEXES OVER FLASH.

SOME ADVANTAGES OF ELECTRONIC FLASH

- IT STOPS FAST ACTION, AND THAT MEANS SHARPER PICTURES.

- A LOT OF FLASHES PER UNIT...SOME AS HIGH AS 10,000.

- OPERATING COSTS ARE LOW.

- ELECTRONIC FLASH IS NEARER TO SUNLIGHT.

- SYNCHRONIZATION IS SIMPLE.

- CONSISTENT RESULTS IF IN GOOD WORKING ORDER.

- EXCELLENT FOR PORTRAITS BECAUSE THE LIGHT IS COOL AND THE ACTION STOPPING ABILITY IS GREAT FOR CATCHING EXPRESSIONS.

CAUTION

BE CAREFUL OF HIGH VOLTAGE IN CIRCUITS OF ELECTRONIC FLASH UNITS....ESPECIALLY WHEN PERFORMING MINOR REPAIRS........ BETTER STILL, TAKE IT TO AN EXPERIENCED ELECTRONIC FLASH REPAIRMAN.

WHEN FINISHED SHOOTING, SHUT OFF YOUR UNIT AND DISCHARGE THE CONDENSERS BY FLASHING THE LAMP!

REMEMBER THIS ABOUT EXPOSURE:

BRIGHT SUNLIGHT PRODUCES TOO MUCH OF A RANGE IN BRIGHTNESS, AND THE DIFFERENCE BETWEEN THE HIGHLIGHTS AND THE SHADOWS ARE 7 TO 1, OR EVEN HIGHER ON THE BEACH AND IN SNOW SCENES. THE BRIGHTNESS SHOULD BE BROUGHT DOWN TO AT LEAST 3 TO 1 FOR SHADOW DETAIL. *ESPECIALLY TRUE IN COLOR SHOTS!*

PLUS-X, SUNLIGHT, f8 at 250 SHADOW EXPOSURE, f5.6-125

TO BE TRUTHFUL, I WOULD NOT RECOMMEND USING A FOCAL PLANE SHUTTER FOR FILL-IN-FLASH. INSTEAD, DO WHAT MOST PROFESSIONALS DO AND EXPOSE FOR THE SHADOW AREA, IN BLACK & WHITE FILM, AND LET THE HIGHLIGHTS TAKE CARE OF THEMSELVES... AND THE ABOVE RIGHT HAND SHOT PROVES THEY DID A PRETTY GOOD JOB!

OPEN FLASH...

THIS IS FUN... YOU FIRE THE ELECTRONIC FLASH IN-DEPENDENTLY WHILE YOUR CAMERA SHUTTER IS OPEN.

YOU WILL GET ALOT OF CREATIVE EFFECTS
FOR EXAMPLE – WHILE YOUR SHUTTER IS OPEN, THE FILM WILL RECORD OBJECTS LIT BY EXISTING LIGHT, AND OBJECTS LIT BY YOUR ELECTRONIC FLASH!

SO YOU'LL GET BOTH A SHARP AND BLURRED PICTURE. TO CREATE A FEELING OF MOVEMENT!
OR IF THERE IS A LARGE DARK AREA, YOUR OPEN SHUTTER CAN LIGHT-UP THE ROOM BY FIRING THE FLASH SEVERAL TIMES IN THE SAME PICTURE.
NOTE: PUT AUTOMATIC FLASH UNITS ON MANUAL (M).

IF YOU HAVE A TWO INCH LENS, SUCH AS YOUR NORMAL ON YOUR 35mm CAMERA, AND YOU ARE AT f4 – AND FOCUSED ON AN OBJECT THREE FEET AWAY (36 INCHES) FROM THE LENS – AND IF THE PERMISSIBLE CIRCLE OF CONFUSION IS ·002 INCHES?

$$u = 36; \quad F = 2; \quad n = 4; \quad c = ·002$$

$$u_1 = \frac{Fu(F+cn)}{(F^2+ucn)} = \frac{2 \times 36(2+·008}{4+·288}$$

$$= \frac{72 \times 2·008}{4·288} = \frac{144·526}{4·288} = 33·7 \text{ ins.}$$

$$u_2 = \frac{Fu(F-cn)}{(F^2-ucn)} = \frac{2 \times 36(2-·008)}{4-·288}$$

$$= \frac{72 \times 1·992}{3·712} = \frac{143·424}{3·712} = 38.6 \text{ ins.}$$

DON'T BE ALARMED.... I JUST ADDED THIS FOR THOSE PEOPLE WHO DIG THE MATH!

HONEST, I WON'T DO IT AGAIN!

GREAT MOMENTS IN PHOTOGRAPHY!

PRICING YOUR FIRST CAMERA

144

GETTING FED UP

WITH THE MESS IN YOUR DARKROOM?

GETTING TIRED OF CHEMICAL STAINS ON YOUR FLOOR - YOUR WALL - AND ON YOU?

HAD IT UP TO HERE WITH MIXING CHEMICALS OR GETTING READY TO PRINT AND DISCOVER YOU FORGOT TO MIX THEM?

TIRED OF WASHING AND WASHING? DO YOU SPEND HOURS FEEDING THEM INTO A DRYER?

OR NOT HAVING A DRYER - OR A SMALL ONE - AND LIMITING YOUR PRINTS TO MAYBE ONLY A DOZEN! IS THIS YOU, BROTHER?

SO...WHAT'S STABILIZATION?

THAT'S SIMPLE!

THEY MAKE THIS ENLARGING PAPER WITH A CHEMICAL BUILT RIGHT IN IT, AND WHEN YOU RUN IT THROUGH A MACHINE CALLED A *STABILIZATION PROCESSOR,* IT RUNS BETWEEN ROLLERS THAT HAVE A CHEMICAL ON THEM CALLED *ACTIVATOR!*

THIS CHEMICAL "ACTIVATES" THE OTHER CHEMICAL BUILT INTO THE PAPER – AND PRODUCES A PRINT!

THE PAPER KEEPS RIGHT ON ROLLING THROUGH THE MACHINE AND THROUGH A SECOND SET OF ROLLERS THAT HAVE *STABILIZER* ON THEM.
THIS CHEMICAL "STABILIZES" THE PRINT SO IT WON'T FADE AWAY WHEN THE LIGHTS GO ON– OR WHEN YOU SHINE A FLASHLIGHT ON IT. *THE PRINT COMES OUT DAMP!*

LET'S START AT THE BEGINNING AND ASSUME THAT YOU'VE HAD IT "UP TO HERE" WITH TRAY DEVELOPING!

THE FIRST THING YOU WOULD DO IS SCRAPE UP ENOUGH OF THAT OLE GREEN STUFF TO GET YOURSELF A "PROCESSOR" – *BECAUSE* – WITHOUT A PROCESSOR YOU "AIN'T GOIN' NO WHERE!" I SUPPOSE YOU COULD POUR THE ACTIVATOR IN A TRAY AND DEVELOP THE STABILIZATION PAPER THAT WAY – BUT THEN YOU'D BE RIGHT BACK WHERE YOU STARTED FROM – *TRAY DEVELOPING!*

YOU COULD START WITH AN INEXPENSIVE UNIT FROM 'SPIRATONE' IN NEW YORK FOR SOMEWHERE UNDER $150 – AT THIS WRITING!

THEIR ADDRESS IS: 130 WEST 31st STREET.

NEXT YOU'LL NEED THE TWO CHEMICALS CALLED "ACTIVATOR" AND "STABILIZER". THEY ARE MANUFACTURED BY DIFFERENT COMPANIES BUT ARE STILL ACTIVATOR AND STABILIZER, AND WILL WORK WITH ANY STABILIZATION PAPER YOU WANT TO USE!

I BOUGHT A BUNCH OF DIFFERENT BRANDS OF CHEMICALS AND USED EVERY BRAND OF STABILIZATION PAPER I COULD LAY MY HANDS ON – WITH ALL OF THEM GIVING GOOD RESULTS!

BUT REMEMBER – YOU'LL GET THE BEST QUALITY PRINTS BY USING THE BRAND NAME PAPER WITH THE BRAND NAME CHEMICALS!

NORMAL NEGATIVES ARE THE GREATEST!

THE GREATEST!

THAT'S RIGHT— ESPECIALLY FOR STABILIZATION!!

THE REASON BEING THAT THE PAPER GOES THROUGH THE PROCESSOR AT THE SAME RATE OF SPEED ALL THE TIME FOR EACH PRINT— YOU CAN'T SPEED THEM UP OR SLOW THEM DOWN TO GIVE YOUR PRINT A LONGER TIME IN THE ACTIVATOR LIKE YOU CAN DO IN THE TRAY TO COMPENSATE FOR HIGHER OR LOWER CONTRAST.

SO—THERE IS A BUILT-IN ADVANTAGE IN STABILIZATION PRINTING—*"YOU MUST SHOOT AND DEVELOP FOR A NORMAL NEGATIVE."*

SO WHAT'S SO BAD ABOUT THAT?

150

BUT WAIT.....DON'T PANIC!

IF YOU HAVE NEGATIVES THAT ARE UNDER OR OVEREXPOSED YOU CAN STILL USE PRINTING FILTERS TO GET GRADED PAPERS. ALL OF THE PAPERS THAT I'VE TRIED WORK GREAT WITH MY POLYCONTRAST FILTERS WITH THE EXCEPTION OF THOSE VERY HARD, HIGH CONTRAST PAPERS THAT ARE USED FOR COPY WORK SUCH AS KODAK "T" PAPER, AGFA TP-6 OR OTHER SIMILAR TYPES! THIS GIVES THE BEST BUILT-IN ADVANTAGE FOR STABILIZATION PRINTING – *YOU MUST EXPOSE THE ENLARGING PAPER PROPERLY BECAUSE YOU CAN'T COMPENSATE IN THE ACTIVATOR –* **REMEMBER–THE ROLLER SPEED IS CONSTANT!**

THIS BIT OF KNOWLEDGE BOILS DOWN TO THE CORRECT EXPOSURE FOR THE CORRECT DEVELOPMENT.....AND WHAT COULD BE BETTER TRAINING FOR A PHOTOGRAPHER! IF YOU PRINT BY STABILIZATION LONG ENOUGH YOU GET TO BE QUITE AN EXPERT AT JUDGING THE CORRECT EXPOSURE ALL THE TIME WITH NORMAL NEGATIVES! YOU WILL NEVER GO BACK TO TRAY DEVELOPING AGAIN – *WELL, ALMOST!*

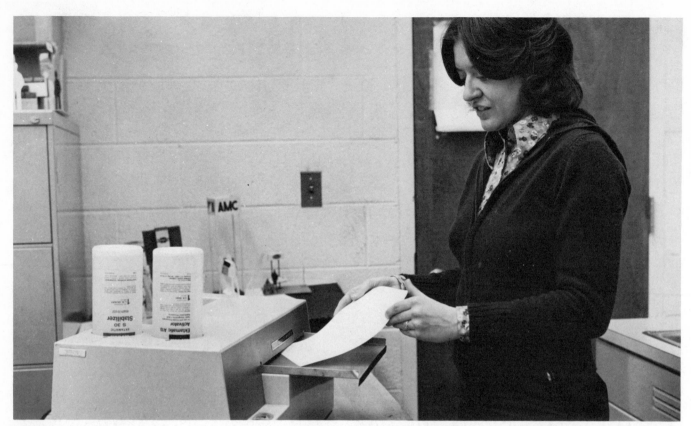

THIS IS THE KODAK "EKTAMATIC" STABILIZATION PROCESSOR. THAT'S A PRINT BEING FED-IN WITH THE *EMULSION SIDE DOWN!*

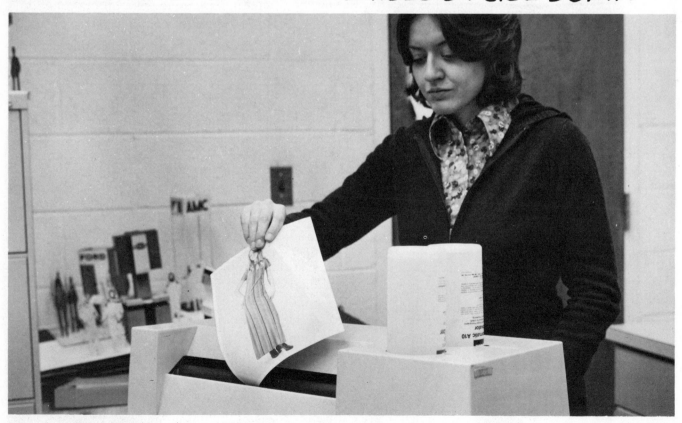

AND HERES THE PRINT COMING OUT – WITH THE ROOMLIGHT ON!

HERE'S WHAT IT LOOKS LIKE INSIDE

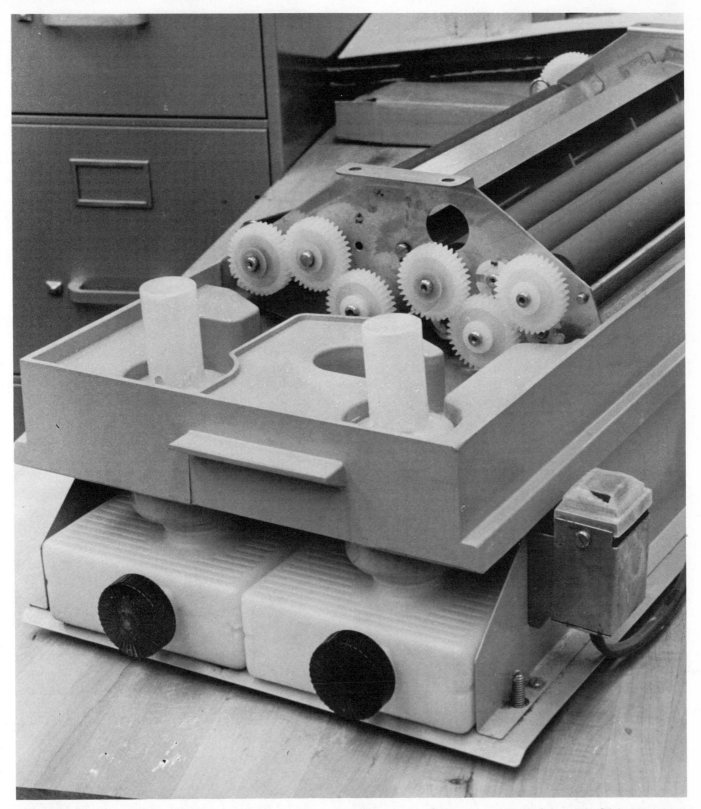

HERE'S A CLOSE-UP LOOK INSIDE OF A KODAK EKTAMATIC STABILIZATION PRINTER! *THIS IS A REAL WORKHORSE!*

NOW LET'S DISMANTLE IT!

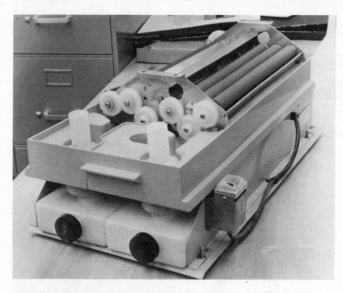

LET'S TAKE THE COVER OFF OF THE UNIT TO LOOK INSIDE. ALL UNITS ARE ALIKE IN ONE RESPECT – THEY HAVE ROLLERS.

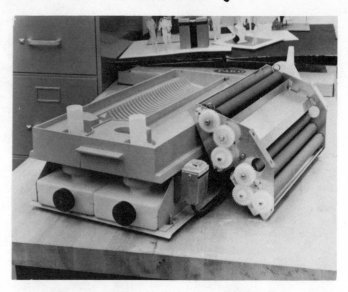

NEXT, WE TAKE OUT THE ROLLERS AND EXPOSE THE CHEMICAL TRAYS. THIS EKTAMATIC HOLDS ONE QUART OF EACH.

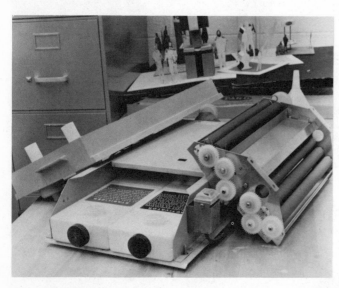

NEXT, WE TAKE OUT THE TRAYS AND EXPOSE THE CONTAINERS THAT THE OLD CHEMICALS ARE DRAINED INTO. ➙

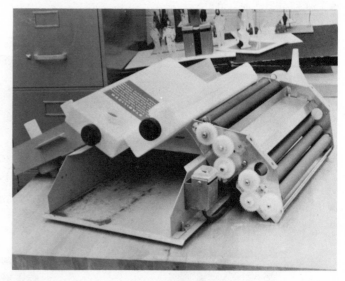

AND HERE IS THE COMPLETE BREAKDOWN! THIS MACHINE IS FOUR YEARS OLD, AND JUST GOES ON AND ON.......

SOONER OR LATER THE ROLLERS HAVE TO BE REPLACED... THEY WILL EVENTUALLY LEAVE LINES ON YOUR PRINTS! NOTHING LASTS FOREVER!

THE AGFA UNIT...

AN ARROW POINTS TO THE LITTLE HANDLE THAT GUIDES THE FILM OR PAPER THROUGH THE PROPER ROLLERS....
THIS IS A HEAVY UNIT... NOT TOO EASY TO CARRY ABOUT!

HERE'S THE AGFA UNIT... TOTALLY DISASSEMBLED!

THIS UNIT, ONE OF THE MOST EXPENSIVE OF ITS KIND FOR BLACK AND WHITE PRINTING, IS SHOWN BROKEN-DOWN ABOUT AS FAR AS POSSIBLE WITHOUT CALLING A REPAIR MAN.

THE AGFA PROCESSOR WILL ALSO DEVELOP A SPECIAL TYPE OF GRAPHIC ART FILM WHICH IS VERY SIMILAR TO OUR FAVORITE "KODALITH!"

THE ASSEMBLED AGFA UNIT READY FOR ACTION!

HERE'S THE UNIT JUST BEFORE WE PUT ON THE TOP COVER. NOTICE ALL THE ROLLERS? THE LAST TWO SETS OF ROLLERS ARE FOR FILM DEVELOPING – *NOTE THE ARROWS!*

IT TAKES ME ALMOST AN HOUR TO DISASSEMBLE THE UNIT– CLEAN IT– AND PUT IT BACK TOGETHER AGAIN! AND BELIEVE ME, I'M NOT COMPLAINING!

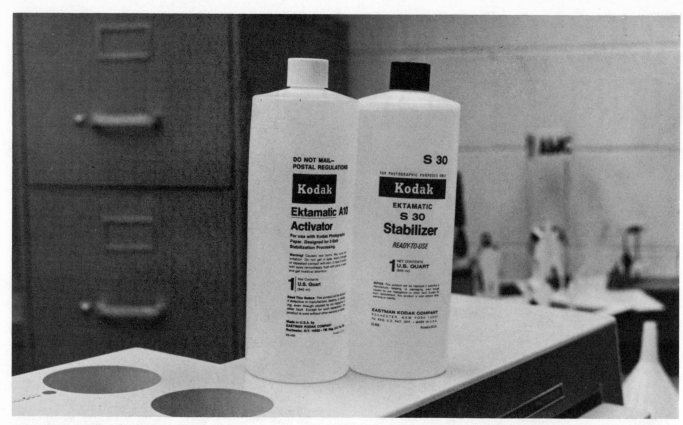

THERE ARE MANY BRANDS OF STABILIZATION CHEMICALS ON THE MARKET— HERE ARE TWO OF THEM! *THEY ARE NOT DILUTED!*

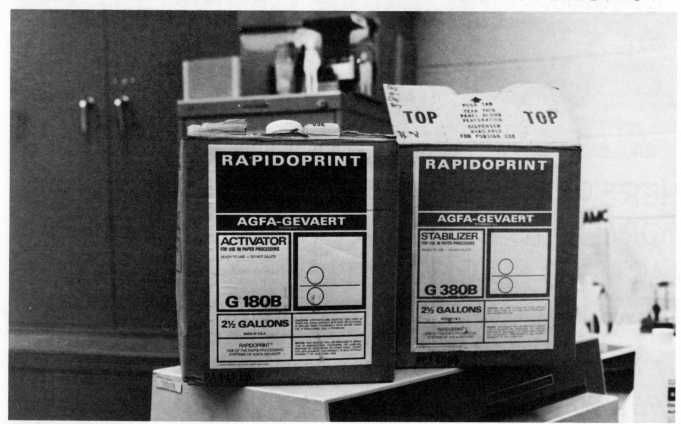

NO MATTER WHO MAKES THEM —THEY'RE ALL ADDED THE SAME WAY.

HERE'S HOW YOU ADD CHEMICALS!

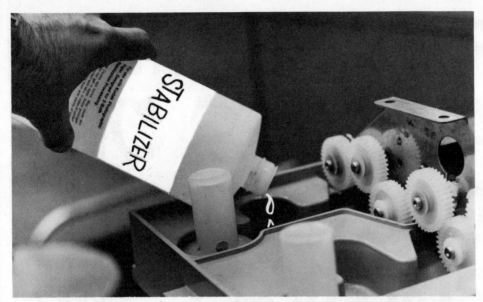

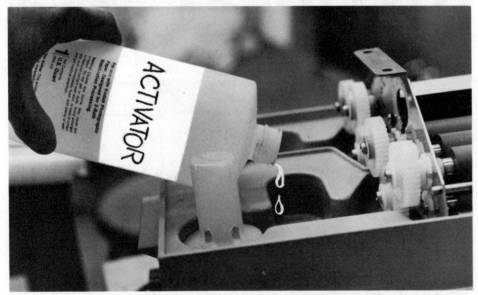

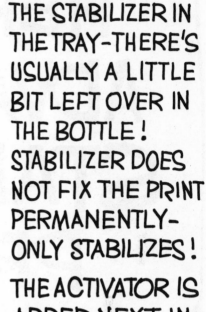

FIRST YOU POUR THE STABILIZER IN THE TRAY—THERE'S USUALLY A LITTLE BIT LEFT OVER IN THE BOTTLE! STABILIZER DOES NOT FIX THE PRINT PERMANENTLY—ONLY STABILIZES!

THE ACTIVATOR IS ADDED NEXT IN THE TRAY—CARE SHOULD BE TAKEN NOT TO SLOP THE TWO SOLUTIONS TOGETHER! THE PRINTS CAN BE FIXED IN ORDINARY FIX IF YOU WISH!

LIKE ALL EQUIPMENT IN THE DARKROOM, THE STABILIZATION PRINTER HAS TO BE TAKEN CARE OF. THE CHEMICALS SHOULD NOT SET IN THE TRAYS FOR MORE THAN 7 DAYS BECAUSE THEY BECOME GOOEY AND WILL CAUSE THE ROLLERS TO LEAVE MARKS ON YOUR PRINTS — AND OCCASIONALLY PART OF THE PICTURE WILL NOT PRINT! AFTER A WEEK THE ROLLERS SHOULD BE TAKEN OUT AND CLEANED WITH A SOFT BRUSH AND A MILD SOAP! I REALISE IT'S A LOT OF TROUBLE — BUT IT SURE AS HECK IS WORTH IT.

REMEMBER — WHEN YOU FEED THE PRINTS IN THE PROCESSOR THEY HAVE TO BE FACE DOWN, OTHERWISE THEY WILL EMERGE ON THE OTHER SIDE OF THE PROCESSOR *TOTALLY WHITE* ... AND DON'T BE SURPRISED!

NO WATER – NO PLUMBING!

NO PIPES GOING IN AND NO PIPES LEADING OUT! PICK UP THE UNIT AND SET IT ANYWHERE YOU PLEASE AND PLUG IT IN. BUT NOT WHEN ITS' FILLED.

NEED WE SAY MORE?

YOUR SOLUTION LEVEL IS KEPT CONSTANT WITH AN AUTO-LEVEL DEVICE – BOTH OF THE CHEMICALS WILL MAINTAIN THEIR PROPER LEVEL – AUTOMATICALLY!

REQUIRES NO EXPERIENCE!

ACTUALLY ANY BEGINNER TO PHOTOGRAPHY CAN PRODUCE PRINT AFTER PRINT – AND EACH ONE IS INDISTINGUISHABLE FROM ONE THAT IS TRAY PROCESSED! ONCE YOU GET THE RIGHT EXPOSURE THE PROCESSOR WILL FEED-OUT A PERFECT PRINT! I KNOW A PHOTOGRAPHER WHO HAS NEVER TRAY DEVELOPED IN HIS LIFE – AND DIDN'T REALLY KNOW HOW – AND HE IS MAKING A GOOD LIVING DOING PROMOTIONAL PHOTOGRAPHY, USING THE KODAK *EKTAMATIC PROCESSOR!*

THE ONLY PROBLEM IS I DON'T KNOW HOW TO DEVELOP FILM!

NO SET-UP NO CLEAN-UP!

ANY ROOM CAN NOW BE A DARKROOM – THAT'S NICE IF YOU LIVE IN AN APARTMENT—YES, STABILIZATION IS REALLY DRY PROCESSING! JUST THINK, NO SPLASHING UP THE WALLS – NO MESSY BOTTLES, NO CHEMICALS TO PREPARE – JUST WALK IN - PRINT - AND WALK OUT AGAIN!

SAVES TIME

AFTER YOU EXPOSE THE STABILIZATION PAPER IN YOUR ENLARGER, YOU FEED IT INTO YOUR PROCESSOR.... AND *PRESTO* - YOU HAVE A PRINT IN 10 SECONDS AND READY FOR YOUR CLIENT! *HOW ABOUT THAT?*

SAVES

JUST THINK—YOUR ENTIRE DARKROOM WILL CONSIST OF YOUR ENLARGER AND A SMALL TABLE FOR YOUR *PROCESSOR*....

SPACE

CONSISTENT PRINTS!

BECAUSE OF SPLIT SECOND CONTROL WITH THE ROLLERS, ALL PRINTS ARE UNIFORMLY PROCESSED — A FEAT DIFFICULT WITH TRAY PROCESSING!

WHICH PRINT IS STABILIZED & WHICH ONE TRAY DEVELOPED?

ANSWER IS ON THE NEXT PAGE!

10 SECONDS 10½ SECONDS 11 SECONDS

HERE IS SOMETHING YOU CAN DO WITH STABILIZATION BY JUST PUSHING 2 BUTTONS: *ONE ON THE TIMER CLOCK AND ONE ON THE PROCESSOR!* TWENTY THOUSAND PRINTS WILL ALL COME OUT *ALIKE!*

OF COURSE YOU COULD GET EXACTLY THE SAME RESULTS BY TRAY DEVELOPING – BUT YOU COULDN'T DO IT AS EASY, OR AS SWIFT AS STABILIZATION – *AND TIME IS MONEY!*

DO YOU WANT TO PROVE IT TO YOURSELF? OK! GO IN THE DARKROOM WITH *ONE* NEGATIVE AND PRINT 20 SEPARATE PRINTS WITH TEN OF THEM *ONE HALF SECOND* EXPOSURE – REMEMBER, EACH PRINT SEPARATELY BECAUSE THAT'S WHAT I'M DOING WITH STABILIZATION PRINTING!

TENTHS-OF-A-SECOND EXPOSURE DOES MAKE A BIG DIFFERENCE... *LOOK!!*

THREE SECONDS AT f8 MADE A PRINT A LITTLE ON THE *DARK* SIDE FOR GOOD NEWSPAPER REPRODUCTION.

TWO SECONDS AT f8 MADE THE PRINT A LITTLE WASHED-OUT- OR TOO MUCH ON THE LIGHT SIDE.

TWO AND FIVE-TENTHS OF A SECOND IS A PERFECT ONE FOR REPRO-DUCTION. HOW ABOUT THAT?

ANOTHER GOOD EXAMPLE OF A ONE HALF SECOND EXPOSURE IS THIS SHOT OF PHIL DICK, THE ASSISTANT PROMOTION MANAGER FOR WJBK-TV, DETROIT. *TIME: 4 SECONDS.*

THE DIFFERENCE IS SLIGHT BUT YOU CAN SEE IT. THIS ONE WOULD PRINT BETTER ON NEWSPAPER STOCK! NOTE THE SMALL TYPE ON THE BOOK IS A LOT EASIER TO READ. *TIME: 4½ SECONDS.*

TRY MAKING 50 PRINTS SOMETIME IN A TRAY AND SEE HOW LONG IT TAKES YOU!

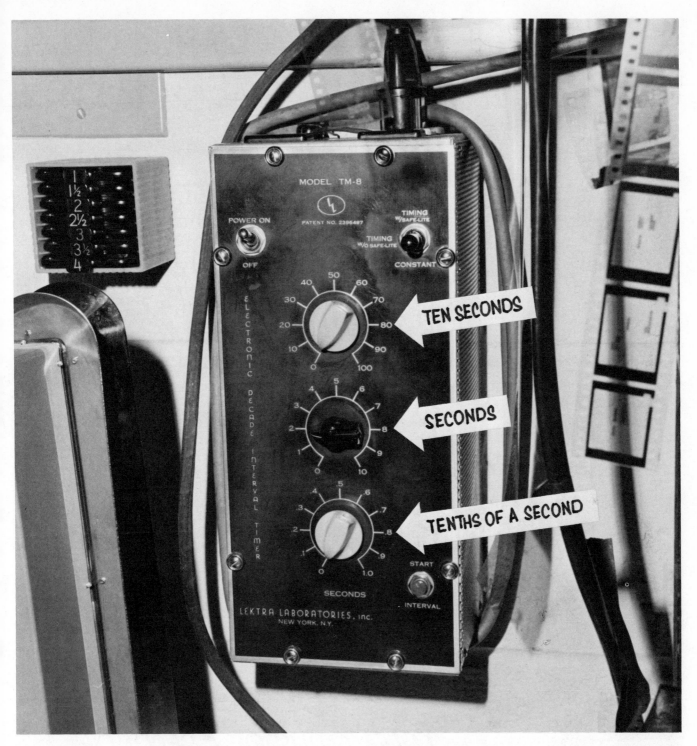

THIS MODEL TM-8 TIMER-CLOCK, FROM LEKTRA LABORATORIES, WILL ENABLE THE PHOTOGRAPHER TO EXPOSE PRINTS IN TENTHS OF A SECOND—SOMETHING VERY USEFUL—AS YOU WILL SEE ON THE SUCCEEDING PAGES. HOWEVER—WITHOUT STABILIZATION PRINTING, WHERE ALL PRINTS GET EXACTLY THE SAME DEVELOPMENT, IT WOULDN'T BE AS PRACTICAL TO USE FOR B & W !

HERE ARE THE FIRST 3 EXPOSURES WITH THE MODEL TM8 TIMER CLOCK...

TWO TENTHS OF A SECOND –
THE ONE TENTHS OF A SECOND EXPOSURE PRODUCED A WHITE PRINT – TWO TENTHS WAS THE FIRST TO SHOW A FAINT PICTURE! NOTE THE DARK AREAS SHOW UP FIRST.

THREE TENTHS OF A SECOND –
MORE DETAIL IS BEGINNING TO SHOW UP IN THE FACES AND OTHER THINGS START APPEARING – LIKE JIM'S WATCH! ALSO, THE BACKGROUND IS BEGINNING TO APPEAR IN THE SCENE.

FOUR TENTHS OF A SECOND –
THIS ONE IS FINE EXCEPT THERE ARE NO BLACKS – JUST WHITE AND GRAY. THE TOPS OF BOTH PAUL'S AND JIM'S HEAD ARE NOT VISIBLE BECAUSE OF NOT ENOUGH EXPOSURE.

5/10·OF A SECOND

6/10·STILL NO BLACKS

7/10·BEST EXPOSURE

8/10·SHADOWS DARK

9/10·GETTING MUDDY

1 SECOND·TOO DARK

1¹⁄₁₀·OF A SECOND

1 ½·SECONDS·BAD!

175

I'M SHOWING YOU ALL THESE PICTURES FOR ONE VERY GOOD REASON – NO ONE CAN TELL THE DIFFERENCE FROM TRAY OR STABILIZATION PRINTING. BESIDES, IT'S EASIER... YOU ONLY HAVE *ONE* THING TO CONTROL AND THAT'S THE EXPOSURE AT THE ENLARGER... *AND THAT'S NOT ALL BAD!*

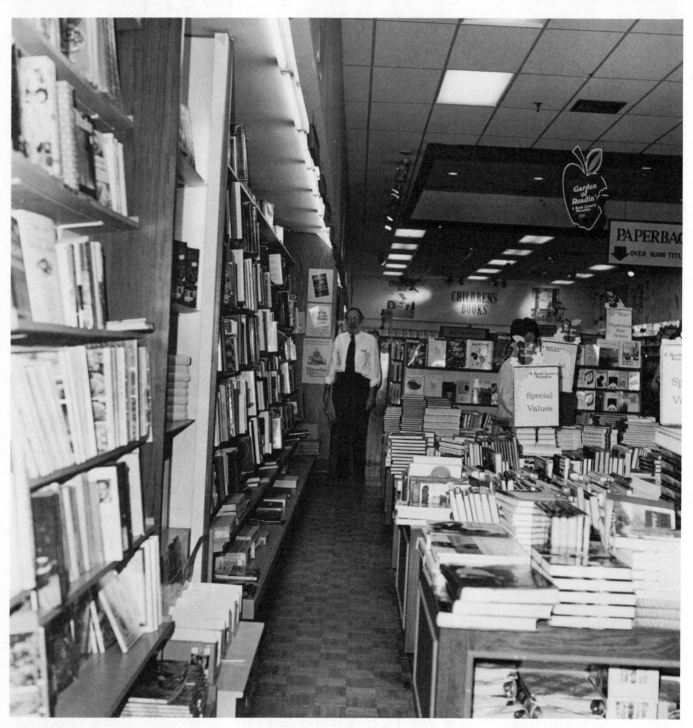

THIS IS BILL RAYBURN, MANAGER OF B. DALTON, BOOKSELLER–TROY, MICHIGAN.

I HOPE I'VE MADE THE POINT IN REGARD TO STABILIZATION AND ITS ADVANTAGES OVER DEVELOPING ORDINARY ENLARGING PAPER IN A TRAY! OF COURSE IF YOU'RE DOING PORTRAITS YOU SHOULD USE TRAY DEVELOPING TO UTILIZE ALL THE FINE TEXTURED PAPERS AVAILABLE FOR THAT PURPOSE - BUT FOR MOST OTHER JOBS, STABILIZATION PROCESSING IS THE SYSTEM TO USE. THERE IS NO OTHER WAY TO GET SUCH CONSISTENTLY BEAUTIFUL PRINTS. EVERY PHOTOGRAPH IN THIS BOOK, WITH THE EXCEPTION OF THOSE TRAY DEVELOPED FOR A SPECIFIC REASON, WERE PRINTED BY STABILIZATION - AND THEN FIXED AND WASHED LIKE TRAY PRINTS.

STABILIZATION PAPER - *TRAY DEVELOPING*
THIS IS BEVERLY PAYNE, *NEWSCASTER* · *WJBK-TV - DETROIT*

STABILIZATION PAPER - *TRAY DEVELOPING*

177

AND OF COURSE
ANOTHER GREAT
THING ABOUT THE
STABILIZATION
PAPER IS THAT IT
CAN BE DEVELOPED
IN ORDINARY
PAPER DEVELOPER.
YOU CAN'T KEEP IT
IN LONGER TO GET
MORE CONTRAST
LIKE ORDINARY
ENLARGING PAPER.
IT DEVELOPS TO
FULL TONALITY IN
45 SECONDS AND
STOPS DEVELOPING.

STABILIZATION PAPER- *TRAY* MEDALIST - *TRAY*

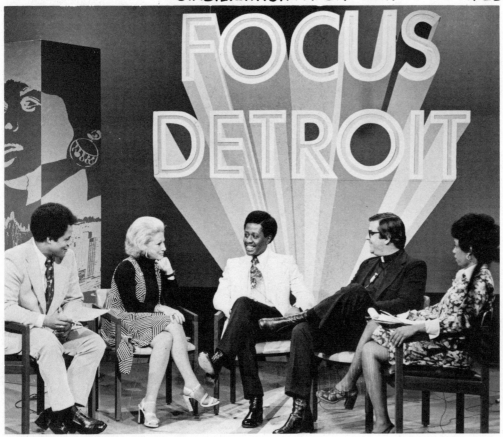

STABILIZATION - *TRAY* KODABROMIDE-TRAY

BEFORE WE GO.....

A FEW WORDS ABOUT
STABILIZATION

⭐ DON'T PUT STABILIZED PRINTS FACE-UP ON A GLOSSY DRUM WITHOUT FIXING AND WASHING FIRST—*THEY WILL STICK!*

⭐ AIR DRYING IS THE BEST! A HOT DRUM, NO MATTER HOW FAST IT TURNS, WILL TAKE THE RICH BLACKS FROM THE PRINTS!

⭐ FIX AND WASH FOR THE TOP QUALITY PRINTS THAT CLIENTS LOVE TO BUY!

BUT THE BEST THING IS THE PRINTS WON'T CURL WHEN THEY DRY! *HOW ABOUT THAT?*

SOME PARTING REMARKS ABOUT STABILIZATION PRINTING!

SPEAKING OFF-THE CUFF, I RARELY TRAY DEVELOP AS MUCH AS I USED TO — THE REASON IS, OF COURSE, THAT STABILIZATION DOES AS GOOD A JOB... AND MOST OF THE TIME, A BETTER JOB. THERE ARE TIMES THOUGH WHEN I LIKE TO WORK WITH A DIFFICULT NEGATIVE TO GET THE BEST I CAN OUT OF IT... IN THIS WAY I CAN USE BOTH EXPOSURE AND DEVELOPMENT TOGETHER! SOME THINGS CAN'T BE DONE WITH STABILIZATION, SUCH AS PRINTING UNDEREXPOSED NEGATIVES. THERE'S ANOTHER GOOD REASON TOO, FOR DEVELOPING IN A TRAY, YOU CAN USE ALL THOSE BEAUTIFUL TEXTURED PAPERS FOR PORTRAITS AND OTHER SPECIAL PICTURES YOU HAVE. I'M SURE, HOWEVER, THE FUTURE THERE WILL BE TEXTURED PAPERS FOR STABILIZATION PRINTING. IT'S A REAL DRAG, AS YOU WELL KNOW, TO SET-UP THE TRAYS AND LOOK FORWARD TO CLEANING UP THE MESS WHEN IT'S ALL OVER. STABILIZATION GIVES YOU A WAY OUT OF THAT CHORE....

WARNING!

STABILIZER

BE SURE TO EMPTY TRAY AFTER COLL-ECTING USED STABIL-IZER. POUR INTO THE DRAIN, USING PLENTY OF WATER FOR FLUSH-ING. DO NOT MIX THE ACTIVATOR AND THE STABILIZER TOGETHER, BECAUSE STRONG AMMONIA FUMES WILL RESULT!

ACTIVATOR

CAUTION: LIQUID CAUSES EYE BURNS, AND PROLONGED OR REPEATED CON-TACT WITH SKIN MAY CAUSE IRRITAT-ION IF SPLASHED IN EYES. FLUSH IMMEDIATELY WITH PLENTY OF WATER AND GET MEDICAL ATTENTION. BE SURE TO EMPTY TRAY AFTER COLL-ECTING USED ACTIVATOR. POUR INTO A DRAIN USING PLENTY OF WATER FOR FLUSHING. DO NOT MIX ACTIVATOR AND STAB-ILIZER TOGETHER BECAUSE STRONG AMMONIA FUMES WILL RESULT!

PUSHING FILM

SUPER
BOMB
PAN
FILM
ASA
18,000

WHY PUSH FILM?

WHEN THERE IS ENOUGH LIGHT TO GET A NORMAL NEGATIVE AND YOU'RE SHOOTING THREE TIMES THE FILM INDEX FOR A PORTRAIT....THEN YOU'RE STUPID, BESIDES BEING A REAL LOUSY PHOTOGRAPHER. THE PRICE YOU PAY FOR PUSHING FILM WILL BE PAID WITH EACH PRINT YOU MAKE.

PUSH FILM WHEN YOU WANT TO STOP REAL FAST ACTION, NEED A LOT OF DEPTH OF FIELD, OR YOU NEED A FAST SHUTTER SPEED WITH A LONG AND SLOW TELEPHOTO... OR YOU'RE TRAPPED WITH A SLOWER FILM AND DON'T HAVE A **CHOICE!**

WHEN THE LIGHT LEVEL IS VERY LOW AND YOUR LIGHT METER DOESN'T MOVE, AND YOU NEED SOME SORT OF PICTURE.......

PUSH THE FILM!

BUT HERE'S THE PRICE YOU PAY: *BLOCKED-UP HIGHLIGHTS, NO DETAIL IN THE SHADOWS, LOTS OF CONTRAST AND* **GRAIN!**

TRI-X 120 FILM DEVELOPED IN D-76 AT ONE PART WATER TO ONE PART DEVELOPER

NORMAL DEVELOPMENT AND NORMAL EXPOSURE. NO FLOOD LIGHTS USED, ONLY OVERHEAD FLUORESCENT LIGHTS.

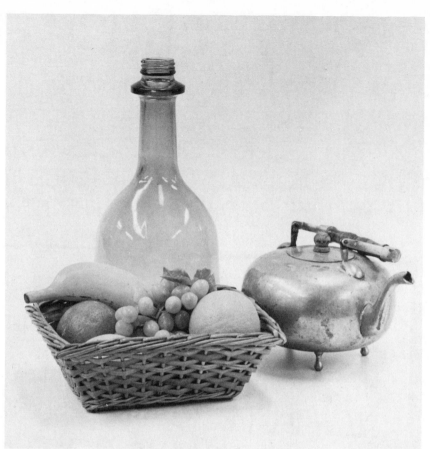

D-76 NORMAL, ASA 400 24X24 BLOW UP.

ACUFINE, E.I. 1200 70°, 8MIN. 1:1

DIAFINE, E.I. 1600 3 MIN. A, 3 MIN. B

ACUFINE, E.I. 3600 70°, 20 MIN. 1:1

NOTE: E.I. MEANS "EXPOSURE INDEX"

PLUS-X 120 FILM DEVELOPED IN D-76 AT ONE PART WATER TO ONE PART DEVELOPER

NORMAL DEVELOPMENT AND NORMAL EXPOSURE. ALL BLOW-UPS ARE 24 X 24 INCHES WITH 75mm COMPONON.

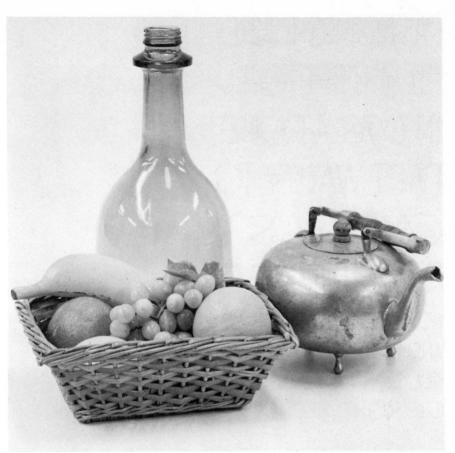

D-76 NORMAL ASA 125 ACUFINE, E.I. 320 70°, 8 MIN. AT 1:1 DIAFINE, E.I. 400 3 MIN. A, 3 MIN. B ACUFINE, E.I. 650 70°, 24 MIN. AT 1:1

PANATOMIC-X 120
FILM DEVELOPED
IN D-76 AT ONE
PART WATER TO
ONE PART
DEVELOPER

NORMAL DEVELOPMENT
AND NORMAL EXPOSURE.
ALL NORMAL SHOTS ON
THE RIGHT ARE 8X10.

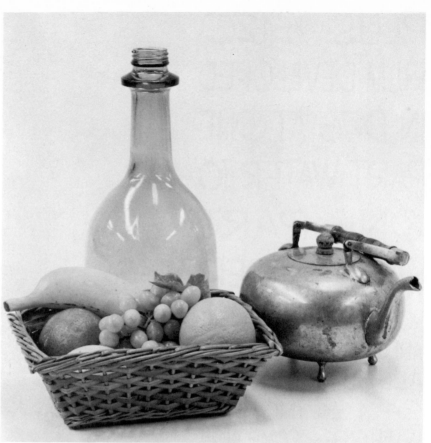

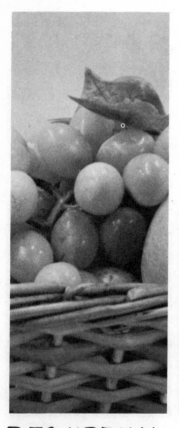 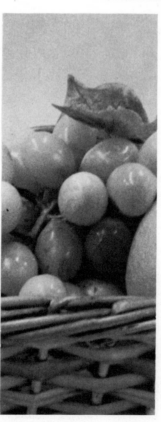 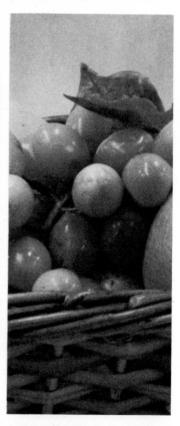

D-76 NORMAL ACUFINE, E.I. 100 DIAFINE, E.I. 160 ACUFINE, E.I. 320
ASA 32 70°, 9MIN. AT 1:1 3 MIN. A, 3 MIN. B 70, 27 MIN. AT 1:1

8X10 OF TRI-X, ASA 400 · D-76, 7 MINUTES AT 70°

8X10 OF TRI-X, EXPOSURE INDEX 800 · D-76, 11 MIN. 70°

8X10 OF TRI-X, EXPOSURE INDEX 1600·D-76,10 MIN.75°

8X10 OF TRI-X, EXPOSURE INDEX 3200·D-76,13 MIN.75°

16 X 20 PRINT *NOTICE ALL THE SOFT TONES!*

TRI-X PAN · ASA 400
D-76 AT 70° FOR 7 MINUTES

TRI-X PAN • E.I. 800
D-76 AT 70° FOR 11 MINUTES

16X20 PRINT *NOTICE THE SOFT TONES ARE GOING?*

TRI-X PAN · E.I. 1600
D-76 AT 75° FOR 10 MINUTES

16 X 20 PRINT *COMPARE THIS WITH THE ASA 400!*

TRI-X PAN · E.I. 3200
D-76 AT 75° FOR 13 MINUTES

IF YOU'D LIKE TO EXPERIMENT WITH PUSHING THE FILM SPEEDS, TRY SOME OF THESE COMBINATIONS!

	NORMAL DEVELOPMENT	TO DOUBLE FILM SPEED	TO TRIPLE FILM SPEED	TO QUADRUPLE FILM SPEED
AGFA ISOPAN ULTRA ASA 400	ATOMAL 10 min. 70°	ATOMAL 16 min. 70°	NOT ADVISABLE	NOT ADVISABLE
GAF SUPER HYPAN ASA 500	HYFINOL 7 min. 70°	HYFINOL 11 min. 70°	ACUFINE 8 min. 75°	ACUFINE 11 min. 75°
ILFORD HP-4 ASA 400	MICROPHEN 5 min. 70°	MICROPHEN 8 min. 70°	ETHOL UFG 3 min. 70°	ETHOL UFG 5 min. 70°
KODAK TRI-X ASA 400	D-76 7 min. 70°	D-76 11 min. 70°	D-76 10 min. 75° OR HC-110(A) 6½ min. 68°	D-76 13 min. 75° OR HC-110(A) 8 min. 68°

THESE DEVELOPING TIMES FOR HIGHER RATINGS ARE PERSONAL! *MAKE YOUR OWN TESTS!*

NOTE→ YOU'RE NOT SHOOTING TRI-X AT ASA 800 OR 1600... YOU'RE SHOOTING JIM SMITH OR MARY JONES 800 OR 1600! *ASA IS NORMAL RATING ONLY! ABOVE THAT IS "EXPOSURE INDEX."*

ANOTHER FINE DEVELOPER FOR HIGH FILM INDEX IS "DIAFINE." THEIR DEVELOPING CHART IS BELOW. LEAVING THE FILM IN LONGER WILL NOT PUSH INDEX ANY HIGHER!

RECOMMENDED FILMS & EXPOSURE INDICES

EXPOSURE INDEX†

MINIATURE & ROLL FILMS	
Kodak Tri-X	2400
Kodak Tri-X Professional	1600
Kodak Plus-X Pan	400
Kodak Panatomic-X	200
Kodak Verichrome Pan	500
Agfa Isopan Record	1600
Agfa ISU	800
Agfa ISS	500
Agfa IF	200
Agfa IFF	100
Ilford HP4	800
Ilford FP4	400
Ansco Super Hypan	1000

SHEET FILMS	
Kodak Royal X	3000
Kodak RS Pan	2000
Kodak Royal Pan	2000
Kodak Super XX	1000
Kodak Plus X	400
Kodak Panchro Press B	640
Kodak Portrait Pan	400
Kodak Panatomic X	200
Ansco Super Hypan	1500
Ansco Versapan	400
Dupont Cronar Press	1600
Dupont Cronar High Speed Pan	640
Dupont Arrow Pan	640
Dupont XF Pan	160
Gevaert Gevapan 36	1200
Gevaert Gevapan 33	640
Gevaert Gevachrome 32	500
Gevaert Gevapan 30	160

†Determined by sensitometric means and verified by practical applications for meters calibrated on the ASA system.

 DIAFINE

INSTRUCTIONS FOR USE

Diafine may be used within a temperature range of 70 to 85 F with a minimum time of 3 minutes in each solution. Increased developing times will have no practical effect on the results.

DEVELOPING PROCEDURE

Any type of tray or tank may be used.

Do not pre-soak films.

1. Immerse film in Solution **A** for at least 3 minutes, agitating **very gently** for the first 5 seconds and for 5 seconds at 1 minute intervals.

2. **Drain, but do not rinse.**

3. Immerse film in Solution **B** for at least 3 minutes, agitating **very gently** for the first 5 seconds and for 5 seconds at 1 minute intervals.

4. Drain and rinse in plain water for about 30 seconds. (We do not recommend the use of an acid stop bath.)

5. Fix, wash and dry in the usual manner.

Optimum results are obtained if all solutions, including the wash, are maintained at the same temperature. CARE MUST BE EXERCISED TO PREVENT ANY AMOUNT OF SOLUTION **B** FROM ENTERING SOLUTION **A**.

To maintain the original volume of the liquids, add equal amounts of fresh **A** & **B** to their respective working solutions. Since the introduction of dry film into Solution **A** decreases its volume more rapidly than that of **B**, some of the **B** will have to be discarded before adding the fresh **B** solution.

In use, the solutions will become discolored and a slight precipitate may form which will in no way affect their working properties. The precipitate may be removed, if desired, by filtering.

IT'S A BAD PRINT BECAUSE THE WHOLE THING IS OUT OF FOCUS, ESPECIALLY THE EYES. ANOTHER THING IS THERE ARE BAD WATER MARKS RUNNING THROUGH THE PICTURE, ESPECIALLY NEAR THE TOP! *ALSO A HAIR NEAR THE TOP OF PAM'S HEAD!* THIS IS A POOR QUALITY PRINT. DON'T WASTE YOUR VALUABLE TIME WITH BAD NEGATIVES.

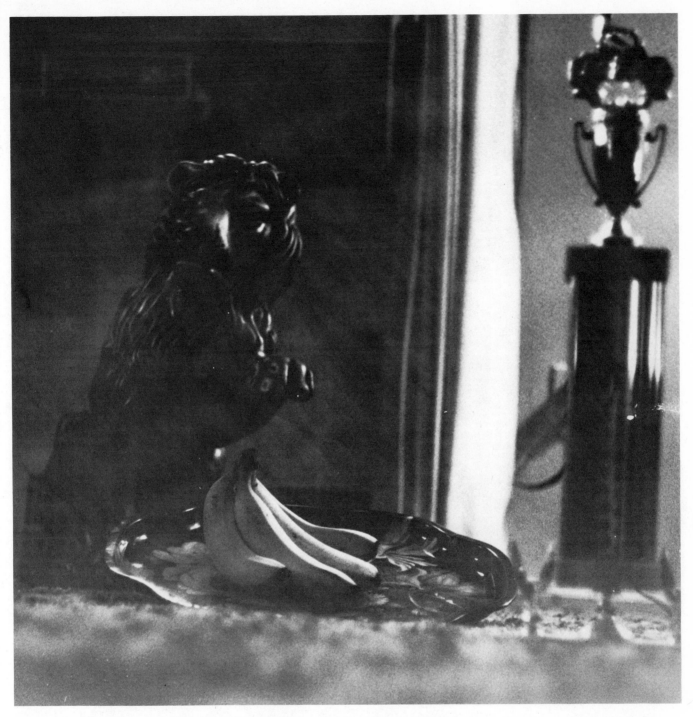

THIS IS A PIECE OF JUNK! NO DETAIL IN THE SHADOWS, NO BLACKS, AND STREAKY LINES FROM UNDERDEVELOPING IN THE PAPER DEVELOPER. THE NEGATIVE IS UNDEREXPOSED AND THAT'S WHY WE HAVE THIS EXCUSE FOR A PRINT. *THERE'S ONLY ONE THING THIS PRINT IS GOOD FOR— YOU CAN USE THE BACK TO DRAW ON!*

ANOTHER ONE TOTALLY OUT OF FOCUS. WHY WASTE YOUR MONEY BUYING EXPENSIVE CAMERAS? EXPOSURE WISE, THE SHADOW AREAS ARE BLOCKED-UP, CREATING A HIGH-CONTRAST APPEARANCE. ON THE OTHER HAND, IT HAS THE POTENTIAL OF A GOOD PICTURE — IF IT WERE EX-POSED CORRECTLY..... *AND PRINTED SHARP!!*

WHO WANTS PICTURES OF PEOPLE TOTALLY OUT OF FOCUS?
THIS IS SLOPPY CAMERA WORK. BESIDES BEING ANOTHER
POOR EXCUSE FOR PHOTOGRAPHY, IT'S A ROTTEN PRINT!
ONCE AGAIN THERE ARE NO BLACKS—ONLY GRAY AND
WHITE—ANOTHER UNDEREXPOSED NEGATIVE! ALSO
NOTICE ALL THE DUST ON THE PRINT? *THROW IT AWAY!*

BAD ANGLE, NO SHADOW DETAIL, BAD EXPOSURE,
DUST AND HAIRS —AND OUT OF FOCUS! BOY, WHAT
ELSE WOULD YOU WANT FOR A LOUSY PRINT.... IF YOU
WERE THIS PERSON, WOULD YOU WANT THIS PRINT?
SHOOTING AGAINST A BRIGHT WINDOW TAKES A LOT OF
SKILL IN EXPOSING AND PRINTING! BUY A CHEAPER CAMERA.

LOOK AT ALL THOSE HAIRS AND DUST. WHAT A MESS!
IF YOU LOOK CLOSELY YOU WILL NOTICE THAT HER FACE
IS OUT OF FOCUS — ESPECIALLY HER EYES, AND THERE IS
TOO MUCH AIR AROUND THE MODEL. THE LIGHT NEXT
TO HER IS THE ONLY THING THAT MAKES THE PICTURE
INTERESTING! *UNFIT FOR PUBLICATION. (U.F.P.)*

JUST AN OPEN FIELD... AND OF NO PARTICULAR INTEREST.
STOP AND THINK— A FIVE YEAR OLD CHILD TOOK THIS
PICTURE! I SHOWED HER HOW TO FOCUS AND SHE
POINTED THE CAMERA AND SHOT, AND THEN I DEVELOP-
ED IN ACUFINE AND PRINTED THE ROLLEIFLEX SHOT
FULL FRAME— *WHAT'S SO GREAT ABOUT THAT?*

A STOCK SHOT OF A BUNCH OF PARKED CARS BY SOME
SORT OF BROADCASTING STATION. ANYONE MIGHT HAVE
TAKEN THIS PICTURE.......JUST FOCUS AND SHOOT!
THE DEVELOPING IS JUST CHEMISTRY — NO BIG DEAL!
THIS COULD BE ANOTHER GOOD EXAMPLE OF HOW TO
WASTE FILM. *WOULD YOU PUT THIS IN YOUR PORTFOLIO?*

THIS IS THE ONLY PICTURE IN THE BUNCH THAT SERVES A PURPOSE – *IT'S A LENS TEST!* NO ONE CARES IF THE PICTURE IS UPSIDE DOWN OR RIGHT SIDE UP! IF THERE WERE SOME WRITING OF SOME KIND ON THE WALL, IT WOULD BE AN INTERESTING PICTURE. GOOD PICTURES ARE PLANNED – UNLESS YOU HAPPEN UPON A FLYING SAUCER!

BIG DEAL! ANYONE COULD HAVE SHOT THIS ONE....FOR PICTURES LIKE THIS I GIVE MORE CREDIT TO THE LENS DESIGNERS... *YOU CAN ALMOST SEE EVERY LEAF ON THE TREE!* IF YOU INTEND SHOOTING A LOT OF UN-INTERESTING PICTURES LIKE THIS ONE, THEN STAND IN LINE WITH ALL THE OTHER MORONS WITH CAMERAS!

I KNOW WHAT THIS IS — IT'S THE LAST SHOT ON THE ROLL — THE PHOTOGRAPHER TOOK IT BECAUSE HE DIDN'T WANT TO WASTE THE LAST FRAME...WELL, I'VE GOT A BIT OF NEWS FOR YOU.... *HE DID!* I SUPPOSE IF A PERSON WANTED TO PROVE THAT PEOPLE ARE USING ASHTRAYS AND NOT THE FLOOR — THIS WOULD PROVE IT!

WHAT IS A GOOD PHOTOGRAPH?

THIS IS A GOOD PHOTOGRAPH, EVEN THOUGH THERE EXISTS NO DEFINITION THAT I CAN FIND FOR ONE.
WHAT MAKES IT GOOD? IT HAS GOOD EXPOSURE, IT IS SHARP, IT RELAYS A MESSAGE... AND IT'S NOT HARD TO FIGURE OUT WHAT'S GOING ON. I AM AWARE THERE ARE OTHER PHOTOS THAT ARE GOOD BUT MAY NOT HAVE ANY OF THESE FEATURES!
BUT NOT IN COMMERCIAL PHOTOGRAPHY!

A GOOD PHOTO. NOTE THAT THE MONKEY IS JUST ABOVE THE GEOMETRIC CENTER. THE EXPOSURE IS GOOD, IT'S SHARP, AND IT'S INTERESTING.!.!.!

HERE'S A PICTURE TAKEN FOR ENJOYMENT !!
IT'S NOT A BIG DEAL BUT IT HAS A FULL SCALE
OF TONE, IT'S SHARP, YOU KNOW WHAT'S
GOING ON, AND IT IS PLEASING TO LOOK AT!
WHAT'S A BETTER MESSAGE ?

VERY GOOD USE OF SPACE IN FRONT OF WALKERS. GIVES THE FEELING THEY HAVE SOME PLACE TO GO. LOOKING DOWN ALSO PROVIDED UNUSUAL VANTAGE POINT! ON THE GROUND THIS WOULD BE A **SNAPSHOT!**

A GOOD PHOTO BECAUSE OF THE SHARPNESS AND TECHNIQUE OF SELECTIVE FOCUS. IT'S ALSO AN UNUSUAL ANGLE. HERE IS THE PHOTOGRAPHER USING IMAGINATION AND COMING UP WITH SOMETHING **NEW!**

GOOD PHOTO OF CITY SKYLINE. THE CONTRAST
AGAINST THE CHALK-WHITE SKY IS EFFECTIVE.
THE DARK BUILDINGS AND STREETS HELP
GIVE DEPTH AND HEIGHT TO THE PICTURE.!
THIS IS DETROIT, MICHIGAN, ABOUT 1956!

TRY TO IMAGINE GIVING A CLIENT A PHOTO OF HIS PRODUCT THAT IS OUT-OF FOCUS, POORLY EXPOSED, AND WITH NO IMAGINATION!

REMEMBER— THERE ARE A LOT OF PEOPLE WITH 35mm CAMERAS RUNNING AROUND TAKING PICTURES, AND FEW CAPABLE OF TURNING OUT GOOD PRINTS IN THE DARKROOM. UNLESS YOU STUDY GOOD COMMERCIAL PHOTOGRAPHS YOU WILL WANDER DOWN THE PATH OF SLOPPY PHOTOGRAPHY! *DO YOU WANT A HOBBY OR A PROFESSION?*

PRO SOURCES

IF YOU'RE SERIOUS ABOUT **PHOTOGRAPHY** AND HOW IT FITS INTO THE COMMERCIAL ART FIELD YOU'LL NEED SOME **PROFESSIONAL SOURCES!**

GENERALLY SPEAKING, CURRENT MAGAZINES WILL BE THE BEST SOURCE FOR A PHOTOGRAPHER TO STUDY HOW OTHER PROFESSIONALS ARE WORKING! *HERE HE CAN STUDY HOW OTHER PROS THINK!*

BUT THERE ARE OTHER SOURCES— *"THE ART DIRECTOR'S PROFESSIONAL PUBLICATIONS!* THESE MAGAZINES COLLECT THE BEST PHOTOGRAPHY AND ART FROM ALL OVER THE WORLD! *LET'S HAVE A LOOK....*

THIS IS THE ART DIRECTOR'S BIBLE — ALL OF THE
BEST ART AND PHOTOGRAPHY FROM ALL OVER
THE WORLD IS IN THIS YEARLY PUBLICATION. ANY
BIG ART STORE WILL HAVE A COPY FOR SALE....
HERE YOU WILL FIND THE PROFESSIONALS AT
THEIR BEST — DON'T BE WITHOUT A COPY.......

PRINT MAGAZINE • 6400 GOLDSBORO ROAD, N.W., WASHINGTON, D.C. 20034...

PUBLISHED BI-MONTHLY • $16 PER YEAR - FOREIGN POSTAGE IS $3.50 A YEAR.

ADA PUBLISHING CO., INC., 19 W. 44th STREET, N.Y. NEW YORK · 10036 · 75¢ EACH ISSUE!

PUBLISHED MONTHLY EXCEPT JULY AND AUG. - $5 YEAR - CANADA $6.50 - FOREIGN $8.50....

ADVERTISING TRADE PUBLICATIONS, INC., 19 W. 44th ST., NEW YORK, N.Y., 10036 • $1.25

PUBLISHED MONTHLY • $11 PER YEAR — ADD $5 FOR CANADA AND $10 FOR FOREIGN...

P.O. BOX 10300 • 410 SHERMAN AVENUE • PALO ALTO, CALIFORNIA • 94303 — 3 DOLLARS.

PUBLISHED BIMONTHY • RATES: U.S. AND CANADA, ONE YEAR $18 – FOREIGN, $22

COULD YOU TELL A STORY IN FIVE PICTURES WITHOUT USING CAPTIONS?

THE SECRET HERE IS TO OVERSHOOT YOUR STORY AND THEN SELECT THE FIVE BEST PICTURES THAT TELL THE STORY THE QUICKEST......

EILEEN ELOCK

COULD YOU TAKE PICTURES WITH BROAD SOCIAL SIGNIFICANCE?

IN THIS ASSIGNMENT YOU SHOULD FIND THINGS WITH YOUR CAMERA THAT EVERYONE CAN RELATE TO! A PHOTOGRAPH WITH A MESSAGE WE ALL UNDERSTAND.

GOOD SUBJECTS ARE:
POLLUTION
DRUGS
SMOKING
ALCOHOLISM
ACCIDENTS
OLD FOLKS
HOSPITALS
GAMBLING
SLUMS
CRIME

JOHN GEORGE

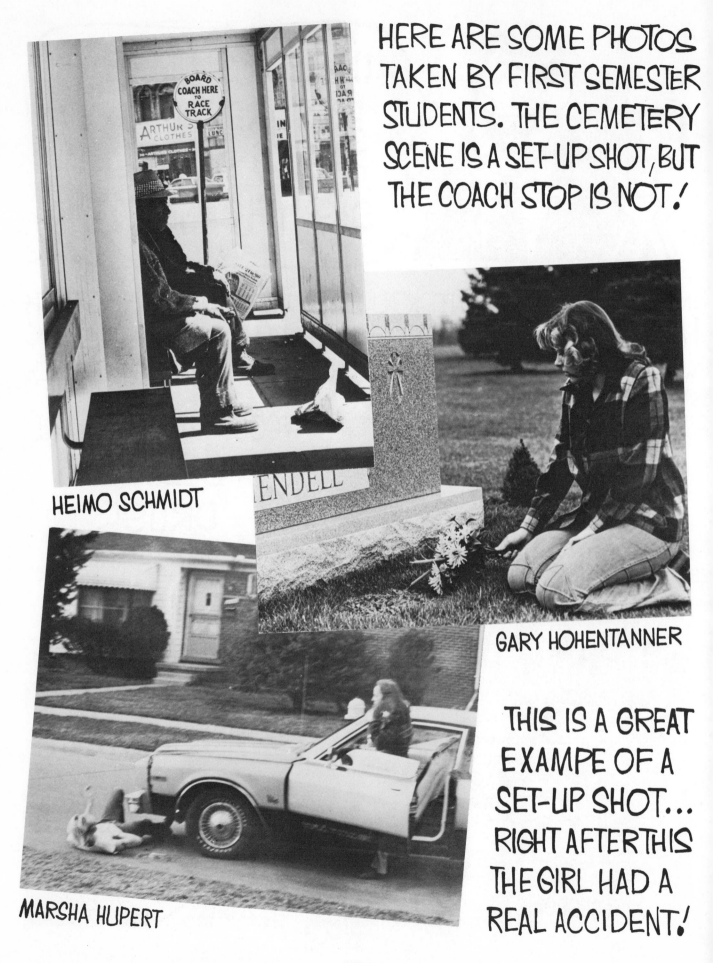

HERE ARE SOME PHOTOS TAKEN BY FIRST SEMESTER STUDENTS. THE CEMETERY SCENE IS A SET-UP SHOT, BUT THE COACH STOP IS NOT!

HEIMO SCHMIDT

GARY HOHENTANNER

MARSHA HUPERT

THIS IS A GREAT EXAMPE OF A SET-UP SHOT... RIGHT AFTER THIS THE GIRL HAD A REAL ACCIDENT!

THIS IS AN EXCELLENT ASSIGNMENT BECAUSE IT WILL FORCE YOU TO BE FRIENDLY AND MEET PEOPLE..... AFTER ALL, PEOPLE ARE WHAT IT'S ALL ABOUT! IT'S PEOPLE THAT OWN COMPANIES, WRITE OUT CHECKS, BUY YOUR PHOTOGRAPHS, AND PRINT MAGAZINES & BOOKS! REMEMBER→ NO FAIR USING YOUR RELATIVES AND FRIENDS!

ASK THE PERSON IF IT IS OK IF YOU TAKE THEIR PICTURE, THEN SEND THEM AN 8X10 OF THEMSELVES.

233

NEXT—TRY A SET-UP SHOT.... FOLLOWING A THEME!

FOR EXAMPLE:

THIS IS A THEME SHOT BECAUSE THE ELEMENTS BELONG TOGETHER!! EVERYTHING IN THIS PICTURE IS MUSICAL!

LOOK AROUND YOU AND NOTICE THE THINGS THAT GO TOGETHER! FOR EXAMPLE, A TENNIS RACKET, BALL, AND A SWEATSHIRT. *GET IT?*

THIS IS NOT A THEME SHOT BECAUSE THE BOWL OF FRUIT IS NOT MUSICAL. ANOTHER BAD EXAMPLE WOULD BE A TELEPHOTO LENS NEXT TO A TRANSISTOR RADIO, OR A BOTTLE OF AFTER SHAVING LOTION SITTING NEXT TO A TELEPHONE. *LOOK AROUND...OR SET SOMETHING UP!*

NOTICE IN THIS SHOT, BASED ON A SET-UP THEME, SELECTIVE FOCUS ON THE MICROPHONE IS VERY DRAMATIC.....ANY OTHER APPROACH WOULD BE CLUTTER!

THIS TIME USING A GUITAR WITH THE BACKGROUND OUT OF FOCUS, WE AGAIN AVOID CLUTTER BUT ALL THESE ELEMENTS GO TOGETHER—TRY ONE !

the JOB

THE ONLY THING BETWEEN YOU AND YOUR FIRST JOB IS YOUR *PORTFOLIO.......* AND DON'T YOU FORGET IT!

BE SUSPICIOUS WHEN THEY ASK FOR YOUR DEGREE INSTEAD OF YOUR PORTFOLIO. YOU WOULDN'T WANT TO WORK WHERE YOUR ABILITY AND ORIGINALITY WOULDN'T BE APPRECIATED WOULD YOU? LET ME RESTATE THAT DEGREES ARE ONLY CREDENTIALS, BUT A PORTFOLIO IS THE PROOF OF YOUR ABILITY! *A QUESTION➔ WOULD YOU REFUSE TO LISTEN TO A RECORD UNTIL YOU WERE SURE ALL THE MUSICIANS HAD A DEGREE IN MUSIC? I HOPE NOT.*

NO DOUBT YOU'VE HEARD THIS REMARK A GOOD MANY TIMES: IF TWO PHOTOGRAPHERS HAVE EQUAL ABILITY BUT ONE HAS A DEGREE, THEN THE ONE WITH THE DEGREE WILL GET THE JOB. HAVE YOU EVER MET TWO PEOPLE WITH EQUAL ABILITY?

HOWEVER, IF THE TWO ARE CLOSE IN ABILITY, OTHER FACTORS COME INTO PLAY, AND THERE ARE MANY: HOW DOES THE PERSON DRESS, AND IS HE OR SHE AN OUTGOING PERSONALITY. AND MOST IMPORTANT OF ALL → *WHAT IS THE PERSON'S ATTITUDE!* I'VE BEEN AN ART DIRECTOR IN MANY AGENCIES, AND I HAVE NEVER ASKED AN ARTIST OR PHOTOGRAPHER IF THEY HAD A DEGREE, ONLY A *PORTFOLIO!*

WE ALL KNOW WHAT THE PROBLEM IS DON'T WE? PEOPLE WANT TO BE MUSICIANS, ARTISTS, WRITERS, PHOTOGRAPHERS, ETC, ETC, .. BUT NOT BADLY ENOUGH! NO ONE WANTS TO PRACTICE! THEY JUST WANT TO BE SOMEONE *AND THAT'S ALL!*

HERE'S YOUR SURPRISE!

THE BEST JOBS AREN'T IN THE WANT ADS, THEY'RE IN THE **PHONE BOOK!** THEY'RE LISTED UNDER "ADVERTISING AGENCIES!" THAT'S WHERE YOU TAKE YOUR PORTFOLIO AND SHOW YOUR WORK TO THE ART DIRECTOR. THE AGENCY HAS ALL THE CLIENTS AND THE ART DIRECTOR BUYS FOR THEM! DON'T JUST WALK IN—PHONE FOR AN APPOINTMENT.

HERE'S A SAMPLE ADVERTISING AGENCY PAGE!

ANOTHER CATEGORY IN THE PHONE BOOK IS THE "PHOTOGRAPHERS-COMMERCIAL" SECTION.... HERE'S WHAT YOU'LL FIND:

PHOTO FINISHERS · PHOTO IDENTIFICATION AERIAL PHOTOGRAPHY · CUSTOM LABS COMMERCIAL PHOTOGRAPHERS · PORTRAIT STUDIOS · WEDDING PHOTOGRAPHERS · SCHOOL BOOK PHOTOGRAPHY · AND PHOTO RETOUCHING!

THERE'S A CAREER OUT THERE....

SCIENTIFIC PHOTOGRAPHY
ATOMIC SECRETS, CRIMINAL DETECTION, RESEARCH, HOSPITAL AND OPERATIONS, IMPROVING METALS, HIGH SPEED PHOTOGRAPHY, ETC., ETC.

THEATRE PHOTOGRAPHY
TV, MOTION PICTURES, STAGE PRODUCTIONS, PUBLICITY SHOTS, DISPLAY, CONCERTS, ETC., ETC.... YOU'LL BE BUSY ALL THE TIME.

CHILD PHOTOGRAPHY
ONCE YOU BECOME GOOD AND SPECIALIZE IN CHILDREN, YOU'LL HAVE MORE WORK THAN YOU CAN HANDLE...AND YOUR OWN HOURS.

FASHION PHOTOGRAPHY
MAGAZINES, CLOTHING MANUFACTURERS, AGENCIES, EXCLUSIVE STORES, ETC., ETC., AND A LOT OF TRAVELING AND PHOTO CREDIT.

INDUSTRIAL PHOTOGRAPHY
LOCATION SHOOTING, LIGHTING TECHNIQUES, AND INVOLVEMENT WITH LARGE COMPANIES. AUTOMOTIVE, AIRCRAFT AND HEAVY EQUIPMENT.

ADVERTISING PHOTOGRAPHY
RETAIL DEALERS, MANUFACTURERS, ART DIRECTORS, AND AN ENDLESS VARIETY OF CLIENTS AND PRODUCTS. *BIG NEGATIVES.*

WEDDING PHOTOGRAPHY

YOU'LL NEVER REST ON WEEKENDS. ELECTRONIC FLASH USED MOSTLY. MAJORITY OF COLOR PRINTS ALONG WITH CANDID SHOTS.

LAB TECHNICIAN

COMMERCIAL DEVELOPING & PRINTING, BOTH COLOR & BLACK & WHITE. ALSO SOPHISTICATED LAB EQUIPMENT. GOOD TECHNICIANS IN DEMAND.

PORTRAITURE

HIGHLY SATISFYING CAREER. EVERYONE IS PROSPECTIVE CUSTOMER. LIGHTING TECHNIQUES AND INTERESTING PEOPLE. *BIG NEGATIVES.*

PRESS PHOTOGRAPHY

MOSTLY 35mm CAMERAS USED BY NEWSPAPERS, MAGAZINES, AND TRADE PUBLICATIONS, SMALL NEWSPAPERS NEED PHOTOGRAPHERS TOO.

TRAVEL PHOTOGRAPHY

HUNTING, FISHING, CAMPING, VACATIONS, ETC., ETC., LOTS OF PUBLICATIONS NEED PHOTOGRAPHERS. LOTS OF TRAVEL. EXPENSE ACCOUNT.

FIRST, YOU MUST KNOW WHAT PHOTO FIELD YOU LIKE, AND DO WELL IN, AND THEN WORK TOWARD A GOOD PORTFOLIO, TO PROVE YOU CAN DO IT! NEXT, GET IN CONTACT WITH THE COMPANY OR PERSON RESPONSIBLE FOR HIRING PHOTOGRAPHERS. THEN MAKE AN APPOINTMENT...DON'T JUST SIT AROUND AND BLAME OTHER PEOPLE OR SOCIETY FOR YOUR MISFORTUNE! IF YOU'RE GOOD YOU'LL GET THE JOB. THERE'S ALWAYS ROOM FOR A GOOD TALENT ON TOP! *UNLESS, OF COURSE, A RELATIVE OWNS THE BUSINESS!*

ARE YOU PREPARED TO SHOW YOUR PHOTOGRAPHS TO PROFESSIONALS?

THAT'S EXACTLY WHAT YOU'RE DOING WHEN YOU TAKE YOUR PORTFOLIO TO AGENCIES OR COMPANIES. YOU WILL BE ENTERING A WORLD OF PHOTOGRAPHIC COMPETITION WHERE DEGREES MEAN NOTHING AND TALENT AND CREATIVITY MEAN EVERYTHING!

OPEN UP YOUR PORTFOLIO AND TAKE A GOOD LOOK! WHAT DOES IT SAY? DOES IT SAY: "I'M ONLY A BEGINNER".... OR DOES IT SAY: "I'M AS GOOD, OR BETTER THAN MOST." THEN DON'T BE AFRAID TO SHOW IT TO PROFESSIONALS.

HERE'S A LITTLE SOMETHING TO REMEMBER ABOUT GETTING TOGETHER A PORTFOLIO.......

HERE'S A LITTLE SOMETHING TO REMEMBER ABOUT GETTING A PORTFOLIO TOGETHER: DON'T INCLUDE TOO MANY PHOTOS, AND KEEP IT AT ABOUT 12 PIECES. REMEMBERTOO MANY PHOTOGRAPHS ARE DEADLY AND BORING TO GO THROUGH!

AND THE MOST IMPORTANT POINT: SHOW THE TYPE OF PHOTOGRAPHS THAT THE EMPLOYER USES IN HIS BUSINESS..DON'T SHOW WEDDING PICTURES TO SOMEONE WHO NEEDS PRODUCT PHOTOGRAPHY! DOES THAT MAKE SENSE?

A FINAL WORD.
YOU CAN HAVE TALENT,
ORIGINALITY, A DEGREE,
A TERRIFIC PERSONALITY,
AND FANTASTIC
EQUIPMENT...BUT
IF YOU HAVE ALL
THESE ADVANTAGES
AND LACK PERSISTENCE,
YOU WILL FAIL IN
WHATEVER YOU DO.
AS A PHOTOGRAPHER
YOU CAN DRIFT WITH
THE TIDE AND BLAME
FATE FOR YOUR FAILURE,
OR PICK UP YOUR OARS
AND START ROWING.

SO THE FIRST RULE
OF SUCCESS IS TO
LET PEOPLE KNOW
THAT YOU EXIST.
GOOD LUCK!

THE PORTFOLIO

THE OBJECT OF A PORTFOLIO IS TO PROVE TO THE PERSON OR COMPANY, WHERE YOU ARE APPLYING FOR AN ASSIGNMENT OR JOB, THAT YOU ARE A COMPETENT PHOTOGRAPHER. *THERE IS NO OTHER REASON EXCEPT THAT!* NO ONE WILL ASK FOR YOUR DEGREE. I DO NOT WANT YOU TO MISUNDERSTAND.....I'M NOT SAYING TO NOT GET YOUR DEGREE...WHAT I AM SAYING IS YOU WILL NOT BE HIRED ON THE STRENGTH OF THAT ALONE. DEGREES ARE ONLY ANOTHER CREDENTIAL, AND NOT THE MOST IMPORTANT ONE. I HAVE NOTHING AGAINST THE DEGREE, ONLY AGAINST THE PEOPLE WHO FLASH IT IN THE PLACE OF ABILITY OR EXPER-IENCE IN THEIR FIELD. *REMEMBER – YOU WILL BE HIRED ONLY ON YOUR ABILITY AND NOT YOUR DEGREE...IN OTHER WORDS, A DEGREE DOESN'T MAKE YOU A PHOTOGRAPHER!*

ON THE OTHER HAND.....

IF YOU ARE A FANTASTIC PHOTOGRAPHER WITH IMAGINATION AND CREATIVITY...... AND ALSO HAVE A DEGREE, THEN THAT'S THE GREATEST!

IF YOU ARE LED TO BELIEVE OTHERWISE, YOU ARE IN FOR A RUDE AWAKENING....

248

WHAT IS A PORTFOLIO?

FIRST.....THEY ARE YOUR OWN PHOTOGRAPHS. THE ONES YOU DID PERSONALLY..... THE PROOF THAT YOU ARE A PHOTOGRAPHER. AND THEY MUST BE SHARP WITH NO OBJECTIONABLE GRAIN.

I KNOW THIS SOUNDS CORNY, AND A LOT OF PHOTO TEACHERS WILL PROBABLY TAKE ME TO TASK FOR THESE STATEMENTS.

HERE'S THE REASON:

CLIENTS DO NOT APPRECIATE SEEING THEIR PRODUCTS OUT OF FOCUS... OR BLURRED. *AND THEY HATE GRAIN.*

THE BACKGROUND CAN BE OUT OF FOCUS FOR WHATEVER KIND OF AN EFFECT YOU WISH, BUT THE CLIENT'S PRODUCT MUST BE SHARP. *THE ARTY STUFF IS USED <u>RARELY</u>, AND WITH CARE.*

SECOND

ALL YOUR PHOTOGRAPHS SHOULD BE GOOD PRINTS! THE BEST YOU CAN DO. JET BLACKS, A GOOD GRAY SCALE, AND NICE WHITES! THEY SHOULD ALSO BE FREE OF SCRATCHES, DUST & HAIRS!

UNLESS YOU'RE GOING FOR UNUSUAL EFFECTS!

CLIENTS LIKE UNUSUAL EFFECTS IF IT ISN'T OVERDONE. JUST TAKE IT EASY. *MAKE GOOD PRINTS!*

SPECIAL NOTE

IT HAS BEEN MY EXPERIENCE OVER THE YEARS, LOOKING AT PHOTOGRAPHER'S PORTFOLIOS, BOTH IN SCHOOL, AND THOSE APPLYING FOR THE JOBS IN INDUSTRY, THAT THERE ARE TOO MANY *"PEOPLE PICTURES."*

ANYONE CAN TAKE CANDID SHOTS OF PEOPLE DOING ALL SORTS OF THINGS IN ALL KINDS OF SITUATIONS....AND MANY OF THEM ARE EXCELLENT SHOTS.

HOWEVER

"PEOPLE PICTURES" DO NOT BELONG IN THE COMMERCIAL PORTFOLIO....UNLESS THE PEOPLE ARE INCLUDED IN THE PRODUCT SHOTS *!*

THE ART DIRECTOR WILL USUALLY SAY TO HIMSELF *"SO WHAT"* WHEN HE SEES "PEOPLE PICTURES."

SO WHAT

OK, NOW LET'S PUT TOGETHER YOUR PORTFOLIO!

PUTTING IT TOGETHER!

ALL PRINTS IN A PORTFOLIO ARE MOUNTED. A GOOD ILLUSTRATION BOARD OR MAT BOARD SHOULD DO NICELY. NEVER ON CORRUGATED CARDBOARD, SHIRTBOARD, RAILBOARD, OR OTHER SUCH THIN STOCK. *IT'S BAD NEWS!!*

IN THIS TYPE OF PRE-SENTATION OF YOUR PHOTOS, THE PICTURE IS MOUNTED WITH THE WHITE BORDERS CUT OFF.... *LIKE THIS!!*

KEEP ALL OF YOUR PHOTOGRAPHS THE SAME SIZE.

THEN WHEN YOU ARE THROUGH MOUNTING THEM, TAKE A BLACK MAGIC MARKER AND BLACKEN THE EDGES LIKE THIS. BE SURE THE PICTURE PART IS FACING AWAY FROM YOU, OR YOU WILL GET BLACK ON IT!

WAIT!

LET'S START
AT THE
BEGINNING!

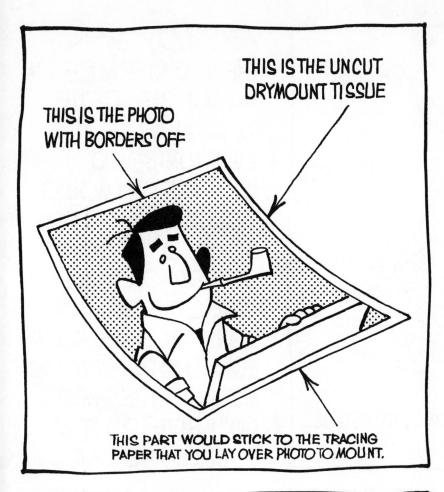

THIS IS THE PHOTO WITH BORDERS OFF

THIS IS THE UNCUT DRYMOUNT TISSUE

THIS PART WOULD STICK TO THE TRACING PAPER THAT YOU LAY OVER PHOTO TO MOUNT.

THE FIRST THING YOU WILL NOTICE IS THE DRYMOUNT TISSUE IS **THE SAME SIZE** AS THE PHOTOGRAPH, AND IF YOU CUT OFF THE WHITE BORDERS OF THE PHOTO IT WILL BE SMALLER THAN THE DRYMOUNT TISSUE.. UNLESS YOU HAVE BORDERLESS PRINTS.

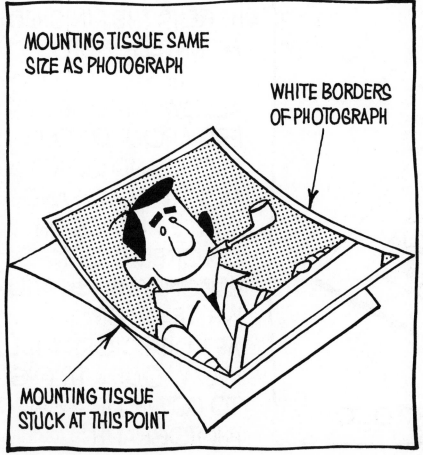

MOUNTING TISSUE SAME SIZE AS PHOTOGRAPH

WHITE BORDERS OF PHOTOGRAPH

MOUNTING TISSUE STUCK AT THIS POINT

TO SOLVE THIS PROBLEM, TACK THE MOUNTING TISSUE TO THE PHOTO WITH A TACKING IRON, IN THE CENTER, AND THEN CUT OFF THE WHITE BORDER.... THIS WILL TAKE OFF THE EXCESS DRYMOUNT TISSUE.

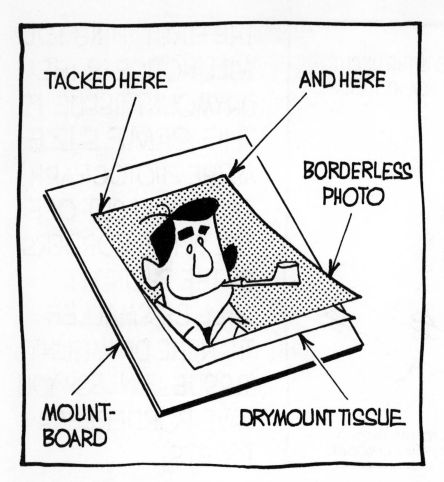

TACKED HERE

AND HERE

BORDERLESS PHOTO

MOUNT-BOARD

DRYMOUNT TISSUE.

READY?

THE NEXT STEP IS TO TACK THE TOP PART OF THE PHOTO AT TWO POINTS TO THE MOUNTBOARD ALONG WITH THE DRYMOUNT TISSUE, WHICH IS NOW STUCK TO THE CENTER OF THE PHOTO...WHICH MEANS IT WON'T SLIP. DON'T TACK ALL FOUR CORNERS BEFORE YOU MOUNT...THE PHOTO CAN'T "GIVE", SO IT WILL BUCKLE AND CREASE.

HERE IS THE FINISHED MOUNTED PHOTO.

ALLOW WIDE BORD-ERS AROUND YOUR PHOTO AND DO NOT MOUNT BLACK AND WHITE PHOTOS ON COLORED STOCK. USE ONLY BLACK AND WHITE OR GRAY...... ART DIRECTORS WILL KNOW YOU'RE TRYING TO COVER UP A BAD PHOTOGRAPH!

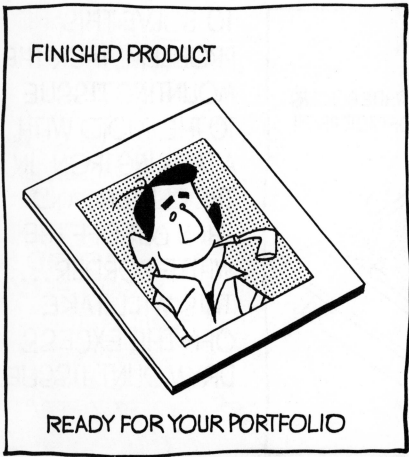

FINISHED PRODUCT

READY FOR YOUR PORTFOLIO

ANOTHER WAY TO PRESENT YOUR PHOTOS IN YOUR PORTFOLIO.... IS THIS :

LIKE THE FIRST WAY, THE HAPPY PHOTOGRAPHER NEEDS THIS DRY MOUNT PRESS..... AND WITH THE COMBINATION OF PRESSURE AND HEAT.....

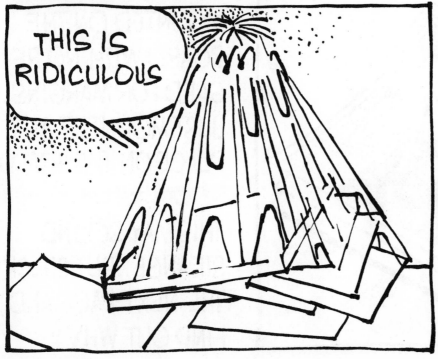

THIS IS RIDICULOUS

... AND THIS DRY MOUNT TISSUE BETWEEN THE PHOTOGRAPH AND MOUNTBOARD WILL MELT FROM THE HEAT AND PRESSURE AND STICK TO EACH. *DON'T TRY TO GET IT OFF AFTER IT'S MOUNTED.*

HERE'S HOW IT'S DONE....

YOU CAN TACK IT HERE AND HERE

PHOTO WITH MARGINS

DRYMOUNT TISSUE

THE DRYMOUNT TISSUE IS TACKED TO THE TWO EDGES OF THE PHOTO. ONLY IN THIS CASE, THE WHITE MARGINS ON THE PHOTO ARE LEFT ON..... SINCE THE DRYMOUNT TISSUE & THE PHOTO ARE BOTH THE SAME SIZE, *THERE IS NO PROBLEM.*

READY TO MOUNT PHOTO

MOUNTBOARD

THEN THE PHOTO IS MOUNTED ON THE BOARD WITH NO RE-GARD FOR MARGINS. JUST MOUNT IT ANY PLACE ON THE BOARD.

THIS MAY SOUND STRANGE..BUT CHECK THE NEXT PAGE AND FIND OUT WHY!

CUT RIGHT OFF ALONG WITH THE MOUNTBOARD

THEN DARKEN EDGES WITH A MAGIC MARKER

PICTURE IN SAD SHAPE

MAN WITH ONLY ONE PICTURE

HERE WE GO!

WHEN THE MOUNTING IS COMPLETED, ALL OF THE WHITE BORDERS OF THE PHOTO ARE CUT OFF, RIGHT ALONG WITH THE MOUNTBOARD! *MAKING THEM BOTH THE SAME SIZE!*

HERE IS A GOOD TIME TO MENTION MAKING TWO OF EVERY GOOD PRINT IN YOUR PORTFOLIO. AS LONG AS THE NEGATIVE IS IN YOUR CARRIER, MAKE THAT EXTRA ONE. THE ONES IN YOUR PORTFOLIO WILL GET FINGER PRINTS FROM ALL THE HANDLING AND SHOULD BE REPLACED.

259

REMEMBER!

ALWAYS USE A PIECE OF TRACING PAPER OVER THE PHOTOGRAPH AND MOUNTBOARD LIKE THIS! THIS PROTECTS THE PICTURE FROM DIRT BEING EMBEDDED IN IT FROM THE GREAT PRESSURE AND HEAT.

THEN PULL THE HANDLE OF THE PRESS DOWN ON THE WHOLE THING, LIKE THIS. BE SURE TO READ THE INSTRUCTIONS THAT CAME WITH THE PRESS FOR PROPER TEMPERATURE FOR DIFFERENT TYPES OF PAPER. *ASK YOUR INSTRUCTOR!*

IMPORTANT....

IF YOU LEAVE THE PRESS DOWN FOR TOO LONG OF A TIME, IT WILL BURN YOUR PHOTOGRAPH & TURN IT BROWN. IT CAN ALSO PREVENT A NICE BOND WITH THE MOUNTBOARD.

HERE ARE SOME EXAMPLES OF PRESENTING PHOTOS.......

HERE THE PHOTO IS MOUNTED WITH THE WHITE MARGINS LEFT ON.. AND THEN A MASK IS CUT FROM BLACK CRESCENT, OR POSTER BOARD, MAKING A PICTURE FRAME....WHEN THE FRAMES GET DIRTY FROM HANDLING THEY'RE EASY TO CHANGE. *AN ADVANTAGE !*

SIMILAR TO THE FIRST EXCEPT A WHITE MASK IS CUT OUT FOR THE CENTER FROM BRISTOL BD.

IN THESE, THE MARGINS ARE TRIMMED AND THEN MOUNTED ON MOUNTBOARD WITH NICE WIDE WHITE MARGINS. THE ONE IN THE MIDDLE HAS MORE AREA ON TOP FOR MORE IMPACT. THESE GET MORE DIRTY.

AND THEN THE BORDERLESS PRINT...LIKE THIS,
MOUNTED TO THE SAME SIZE MOUNTBOARD...

AND BE NEAT....

IF THERE IS ONE THING THAT SEPARATES THE PRO FROM
THE AMATEUR, IT IS *NEATNESS*. NO ART DIRECTOR IS
INTERESTED IN PRINTS WITH DIRT OR FINGERPRINTS
ALL OVER THEM... PLUS A FEW STAINS! I DON'T CARE
HOW PROFESSIONAL THEY ARE..AND I *MEAN THAT.*
THE COMPETITION IS TOO GREAT...THAT MEANS THAT THE
ART DIRECTOR CAN BE SELECTIVE. IF BOTH THE PORT-
FOLIOS WERE EQUAL, WOULD YOU HIRE THE ONE WITH
THE DIRTY PRINTS OR THE CLEAN ONES? *BIG CHOICE?*

INDEX

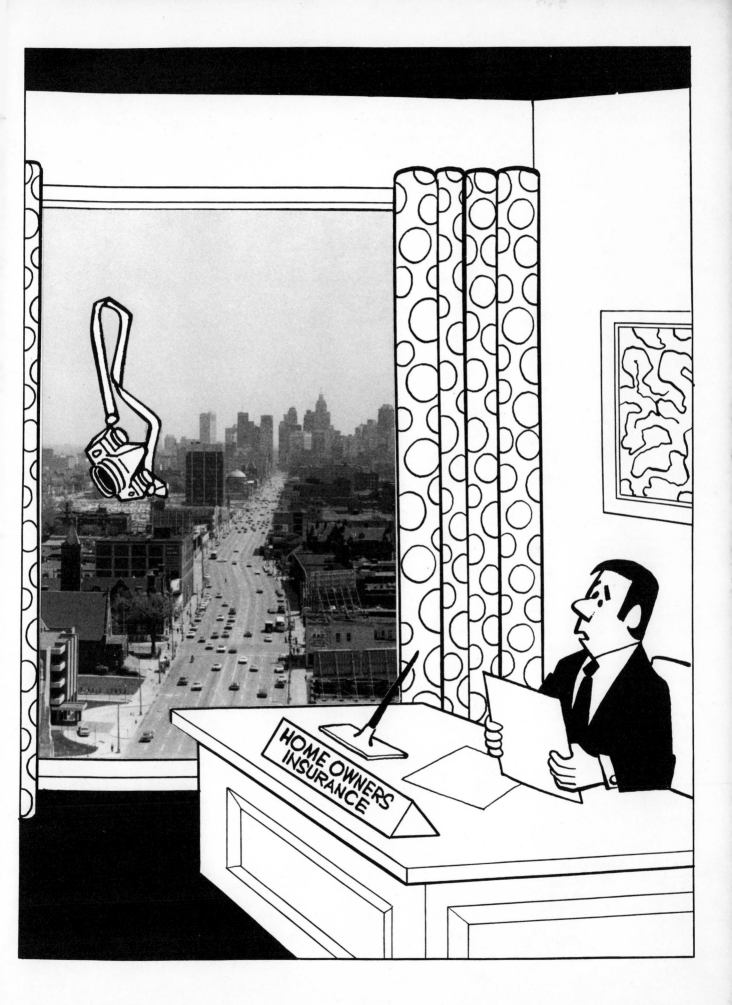